OM THE ELECTRIC POWER HOUSE ☀
ENTRAL AVE. LOOKING NORTH.

BOYLE HEIGHTS

Los Angeles
FROM THE AIR
THEN AND NOW

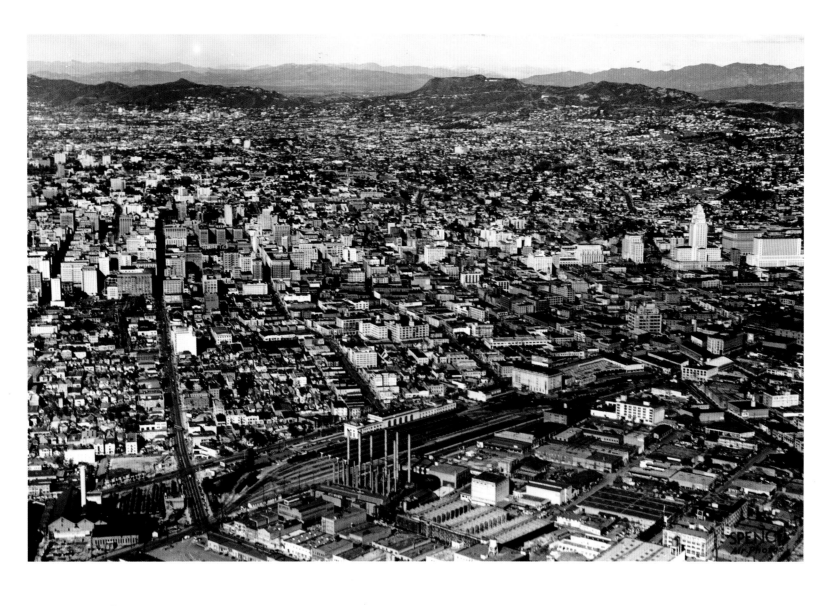

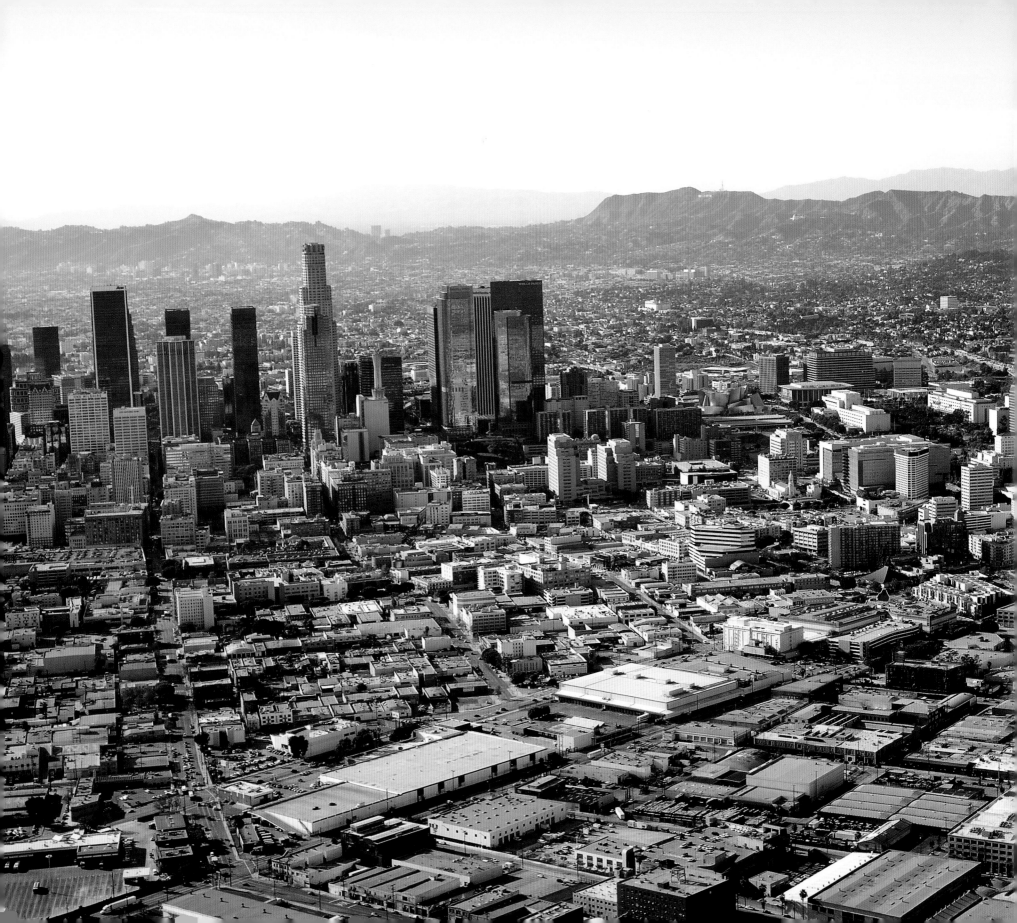

Los Angeles
FROM THE AIR
THEN AND NOW

Dennis Evanosky
and Eric J. Kos

THUNDER BAY
P·R·E·S·S

San Diego, California

Thunder Bay Press
An imprint of the Baker & Taylor Publishing Group
10350 Barnes Canyon Road, San Diego, CA 92121
www.thunderbaybooks.com

Produced by Salamander Books,
an imprint of Anova Books Ltd.
10 Southcombe Street, London W14 0RA, UK

"Then and Now" is a registered trademark of Anova Books Ltd.

 Library of Congress Cataloging-in-Publication Data

Evanosky, Dennis.
 Los Angeles from the air then and now / Dennis Evanosky.
 p. cm.
 ISBN-13: 978-1-60710-128-4
 ISBN-10: 1-60710-128-9
 1. Los Angeles (Calif.)--Aerial photographs. 2. Los Angeles (Calif.)--Pictorial works.
 3. Los Angeles (Calif.)--History--Pictorial works. 4. Historic buildings--California--Los
 Angeles--Pictorial works. 5. Los Angeles (Calif.)--Buildings, structures, etc.--Pictorial
 works. 6. Repeat photography--California--Los Angeles. I. Title.
 F869.L843E827 2010
 917.94'9400222--dc22
 2010019736

1 2 3 4 5 14 13 12 11 10

Printed in China

ACKNOWLEDGMENTS
Authors Eric J. Kos and Dennis Evanosky dedicate this book to the staff of the *Alameda Sun*
newspaper: Eric Turowski, Mimi Marte, Carrie Beavers, Michel Michel, Laurel Yeates and
Sam Felsing.

Photographer Karl Mondon would like to dedicate his portion of this book to his parents, Carl and
Gloria Mondon. Dad, for buying me that first camera and Mom, for not sharing your ridiculous fear
of heights. Finally, to pilot Jim Griffith, madman of the skies, couldn't have done it without you, sir.

PICTURE CREDITS
The publisher wishes to thank the following for kindly supplying the photographs that appear in
this book:

"Then" photographs:
All "Then" images in the book were supplied courtesy of the Los Angeles Public Library,
with the exception of the following: 7 (Library of Congress); 8–9 (Library of Congress, 6a17546);
10, 32, 48, 116, 132 (Bettmann/CORBIS); 11, 26, 56 (Getty Images); 12, 64, 74, 112 (Anova Image
Library); 108 inset (Corbis); 134–135 top (Library of Congress, 6a01753), 136–137 top (Library
of Congress, 6a19386).

"Now" photographs:
All "Now" images were taken by Karl Mondon.

Pages 1 and 2 show downtown Central City, then (Los Angeles Public Library) and now
(Karl Mondon).

Endpapers show: Bird's-eye view of Los Angeles, 1894 (Corbis).

Anova Books is committed to respecting the intellectual property rights of others. We have
therefore taken all reasonable efforts to ensure that the reproduction of all content on these
pages is done with the full consent of copyright owners. If you are aware of any unintentional
omissions, please contact the company directly so that any necessary corrections may be made
for future editions.

Introduction

The nearly concurrent innovations of flight and the portable camera revolutionized how people could visualize the places where they lived. For most major cities across the globe, this meant that their growth could now be recorded from the air—but for only a small fraction of their history.

Some early aerial views of Los Angeles came not from the airplane but from the heights of Signal Hill, Mount Baldy (San Antonio) in the San Gabriel Mountains, and Mount Lee in the Santa Monica Mountains. Oblique views from mountaintops are one way to see a place from above. Los Angeles sits in a bowl made of mountainsides, which afforded such wide-ranging views to Native Americans, European settlers, and pioneering photographers.

As one of the youngest metropolises in the world, Los Angeles has enjoyed the influence of the airplane-and-camera team for more than half its life as a major city. Beginning in 1912, fliers took off from the Griffith Park Aerodrome. One can imagine passengers aboard some of those first biplane flights carrying the late-model portable cameras that were rapidly increasing in popularity at the time.

From the rugged runways at Mines Field to the ultramodern Los Angeles International Airport, Los Angeles has long embodied the spirit of the jet set. Spanning broad fields of media, Will Rogers commanded more respect than just about any other Hollywood star in the early 1930s. His fascination with flying led to his friendship with Wiley Post, the first pilot to fly solo around the world. Rogers threw in with Post and found himself a victim of circumstance in 1935 when their plane crashed in the marshes while on a research trip to Alaska.

Many fliers like Post used Burbank's airport, which predates Los Angeles Airport by more than a decade. Amelia Earhart stopped by, as did Charles Lindbergh. Bob Hope kept his private plane there. For much of the twentieth century, Lockheed manufactured innovative fighting planes in its factory at that same airport.

The career paths of rock and movie stars intersect at Hollywood Boulevard and Vine Street in Hollywood, just down the street from Capitol Records and the onetime nexus of influential Hollywood radio. Both jobs entail a near-constant itinerary of flight plans for crossing the world for on-location shots, world tours, or purely whimsical reasons. San Fernando Valley native Ritchie Valens paid the ultimate price for this lifestyle in 1959 when his plane crashed during a tour to promote the hit singles he recorded in Hollywood. Throw in the millionaires who live bicoastal lives in Beverly Hills and New York, and the result is that Los Angeles International Airport has become one of the busiest in the nation, serving nearly sixty million passengers per year.

Los Angeles, with its somewhat limited modern history, prefers to look to the future, and to some, "La La Land" sets the pace. The city defines the progress of American culture through its Hollywood movies. The finest in American style are recognized on the sidewalks of Rodeo Drive and the red carpet at Grauman's Chinese Theatre. The city was the first to design an urban environment specifically for cars, and established the first freeway in the state. Los Angeles clearly embraced transportation of the future: the automobile and airplane.

Like an ongoing affair exposed in the tabloids, the city of Los Angeles has had a long-standing relationship with flight and the camera. To this unsung partnership, we offer *Los Angeles from the Air Then and Now*.

The book pairs the exquisite modern digital photography of Karl Mondon with the art of many of Los Angeles's best aerial photographers, preserved in collections at the Los Angeles Public Library, the Getty Image Collection, and the Library of Congress. From individual talents in the earliest days of flight to media reporters steeped in ink, these photographers captured a city expanding through a patchwork of development and annexation.

Los Angeles has absorbed many of the smaller towns around it through the provision of basic services to create today's vast, sprawling city. Throughout its history, Los Angeles moved its borders outward and, in some cases, around other cities that strove to remain independent. The concept of Los Angeles as a discrete city eludes the common observer.

To outsiders, the cities of Beverly Hills, Burbank, Pasadena, and Santa Monica cannot easily be divorced from the essence of Los Angeles. The city reached a finger south to the safe harbor of San Pedro, extending its influence into adjoining Palos Verdes and the large city of Long Beach.

With respect to Los Angeles's sphere of influence, we've taken into consideration these impressive places and a few others that lie outside the official city borders.

Our journey will carry us from the Hollywood sign to the Watts Towers, from Forest Lawn Memorial Park to the Santa Monica Pier, and from the heights of the Griffith Observatory to the depths of the La Brea Tar Pits. We'll play a game at the Rose Bowl and light the Olympic torch at the Los Angeles Memorial Coliseum. We'll catch a race at Santa Anita Park and a symphony at the Hollywood Bowl. We'll visit the neighborhoods of the "Platinum Triangle" and cruise the Sunset Strip and Miracle Mile. We'll stop to recall lost icons like the Brown Derby restaurant and Radio City.

No book about Los Angeles would be complete without homage to the likes of Louis B. Mayer, Walt Disney, Humphrey Bogart, and Marilyn Monroe. In many places throughout *Los Angeles from the Air Then and Now* you'll find a film to remember. As we take off from the various airports that have served Los Angeles, sit back and enjoy the scenery below.

LOS ANGELES: A HISTORY

Right: *An 1871 panoramic map showing the history and origins of Los Angeles, with the old Spanish ranchos that bordered the sea, from Rancho Las Bolsas in the south to Rancho San José de Buenos Ayres in the north.*

THE FIRST LA WOMAN

Humans have lived in the Los Angeles area since about 8000 BC. The first settlers we know of were seafaring tribes who used tar from the La Brea Tar Pits to strengthen their boats so they could travel out into the Pacific Ocean.

Excavators discovered the remains of one of these people, a woman, in 1914 in the La Brea Tar Pits. The remains of a dog and a grindstone lay nearby, possibly burial goods. Known to history as the "La Brea Woman," she is thought to have died around 9,000 years ago. Her skull was fractured, and some speculate that she may have met her end from a blow to the head—perhaps Los Angeles's first homicide victim.

The Hokan-speaking people replaced these first settlers around 3000 BC. In turn, those who spoke a Uto-Aztecan tongue supplanted them.

CABRILLO'S FLEET

The Spanish first arrived in 1542, with Captain Juan Rodríguez Cabrillo in command of three sailing ships: the flagship *San Salvador*, the *La Victoria*, and the *San Miguel*.

On June 27, 1542, Cabrillo had set out from Navidad in New Spain, today's Mexico. He was searching for the elusive Strait of Anian, the same Northwest Passage to the Orient that had already eluded the Englishman John Cabot on the other side of the North American continent in 1497.

When Cabrillo and his crew arrived, he could not have been aware that some 5,000 Native Americans populated today's Los Angeles Basin. Nor could he have known that between 250,000 and 300,000 Native peoples were living in what the Spanish called Alta (Upper) California. Nor were they much interested; they sailed on.

The Spanish visited the area again sixty years later when Captain Sebastián Vizcaíno arrived in 1602 with three ships, the *San Diego,* the *Santo Tomas*, and the *Tres Reyes*. When the small fleet sailed through today's Santa Barbara Channel, it received some visitors. "A canoe came out to us with two Indian fishermen, who had a great quantity of fish,

rowing so swiftly that they seemed to fly," Vizcaíno reported to the Spanish Crown. He also described a later visit from five Native Americans of the Chumash tribe, who rowed out to his ship in another canoe: "Four men rowed, with an old man in the center singing with the others responding to him."

LA REYNA DE LOS ANGELES

The Spanish showed little interest in the area and would not return until 1769, when Gaspar de Portolá's expedition passed through. Franciscan padre Juan Crespí, Portolá's diarist, kept a diary in which he noted a spot as ideal for founding a pueblo. On August 2, 1769, the date of the Feast of Our Lady of the Angels of the Porciúncula, Crespí recorded the name of the place as El Rio y Valle Nuestra Señora de los Angeles de la Porciúncula to remember that they stopped here on that feast day; *de la Porciúncula*, which the townspeople later dropped from the name, means "of the small portion" and recalls a gift of a small portion of land that Saint Francis of Assisi received from the Benedictine monks outside Assisi.

Two years later, Junípero Serra founded Mission San Gabriel Arcángel in the city that still bears the mission's name. The mission was built on land that the native Tongva tribe called Sibagna.

In 1781 the Spanish founded El Pueblo de la Reyna de los Angeles, or "the Town of the Queen of the Angels." Tradition says that forty-four people—twenty-two adults and twenty-two children—set out from Mission San Gabriel with a military escort and a pair of padres on September 4, 1781. Their destination was a spot that Father Juan Crespí had chosen in 1769. Today, Angelenos recognize September 4, 1781, as the official date of the founding of the city of Los Angeles.

History recalls these earliest European settlers as *pobladores*, or colonists. When the pobladores settled the pueblo, they named the native Tongva people they came across *Gabrielinos*, for Mission San Gabriel Arcángel.

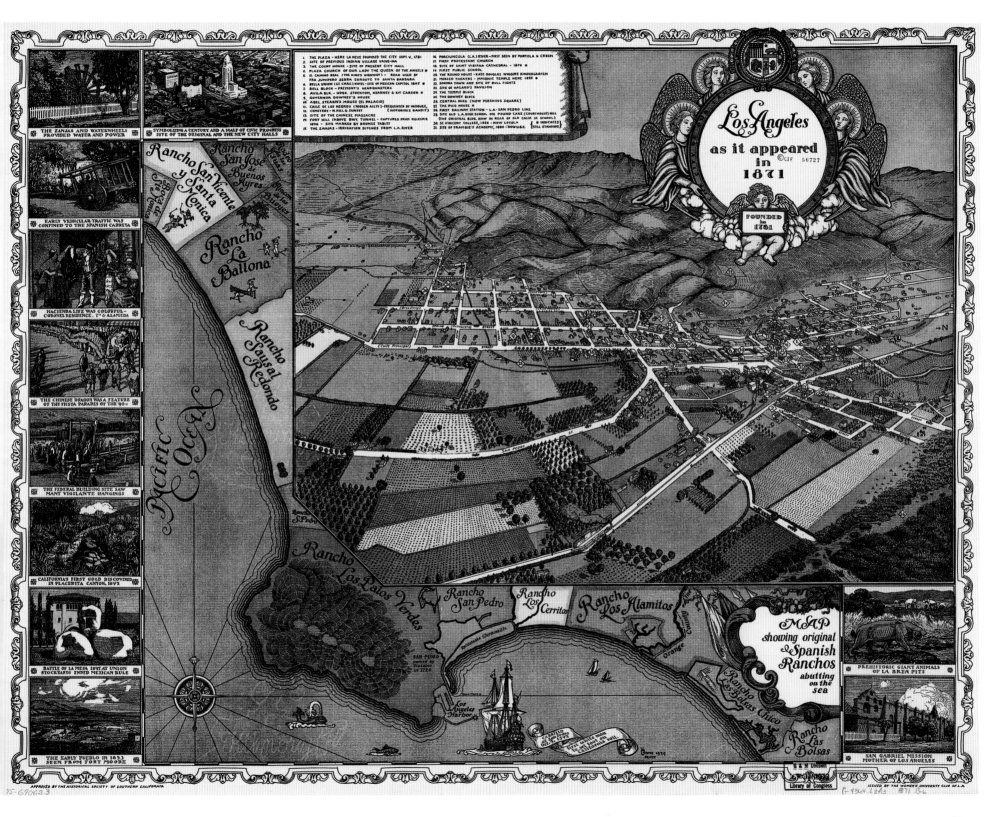

Los Angeles as it appeared in 1871

FOUNDED in 1781

MAP showing original Spanish Ranchos abutting on the sea

Below: *Beverly Hills awaits development in the late 1920s. The movie colony was already in residence by 1928, when Harold Lloyd built a mansion in Benedict Canyon, followed by John Barrymore and Robert Montgomery. Beverly Hills had already become home to the stars.*

GABRIELINOS

The survival and success of these townspeople depended greatly on the nearby prosperous Gabrielino village of Yaanga, whose residents supplied the newcomers with food and material for everyday living. The Native Americans also worked for and intermarried with the pobladores.

The Gabrielinos spoke a language called Kizh (or Kij) and traded with other Native Americans as far east as the Colorado River. They believed in creative supernatural forces and worshipped Chinigchinix as their creator, as well as the virgin goddess Chukit. They drank *tolguache*, a hallucinogenic made from salt water and "sacred datura," or jimsonweed. The Gabrielinos used the concoction to break hexes, induce dreams, and protect them from evil.

The pueblo grew as soldiers and civilians arrived and stayed. In 1784 a chapel sprang up on the plaza. Two years later, the pobladores received the title to their land. In the early nineteenth century, twenty-nine buildings were gracing the plaza. By 1821 Los Angeles had come into its own as a successful farming community known for its wine grapes.

MEXICO CEDES CALIFORNIA

Angelenos celebrated Mexico's 1821 independence from Spain, which made them *ciudadanos*, or citizens with rights

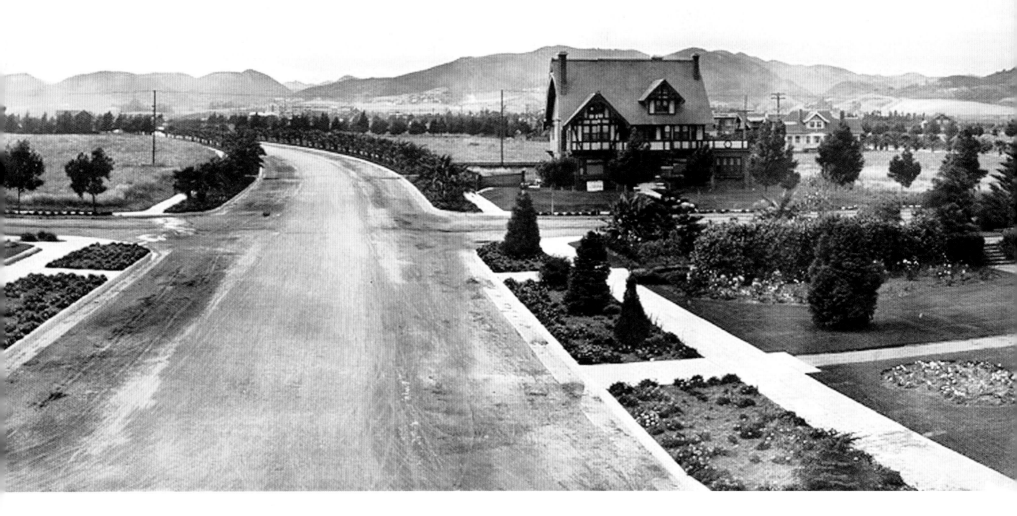

under the law. They flocked to the plaza to swear allegiance to the new government and watched as the Mexican flag replaced the Spanish colors.

In 1833, twelve years after Mexico's independence from Spain, the government secularized the missions. This move brought on the ranchos and opened the region to cattle ranching with its lucrative hide-and-tallow trade. By 1841 the arrival of more people from Mexico and parts of the United States swelled the number of area residents to 1,650, a thousand more than the population in 1821.

On August 6, 1846, the Americans invaded. Commodore Robert F. Stockton anchored off the village of San Pedro, marched inland, and occupied Los Angeles. One week later, Stockton appeared on the plaza with John C. Frémont and a band playing "Yankee Doodle." Stockton's troops occupied the plaza and Governor Pico's home. By October, with the American soldiers gone, the Angelenos decided that they had had enough. They dug up a cannon that they had buried earlier for safekeeping, primed it, and opened fire on U.S. troops. Fourteen Americans were killed, and the Angelenos suffered no casualties. History remembers the event as the Battle of Dominguez Rancho.

Stockton replied by marching north from San Diego with 600 soldiers. Frémont marched south from Monterey with 400 men. Both armies entered Los Angeles and settled the matter without bloodshed.

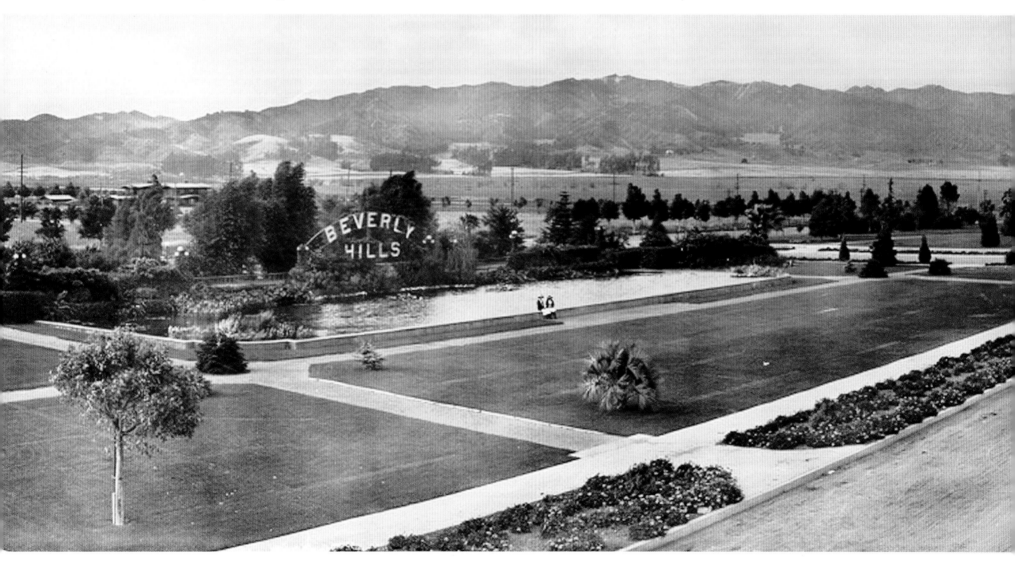

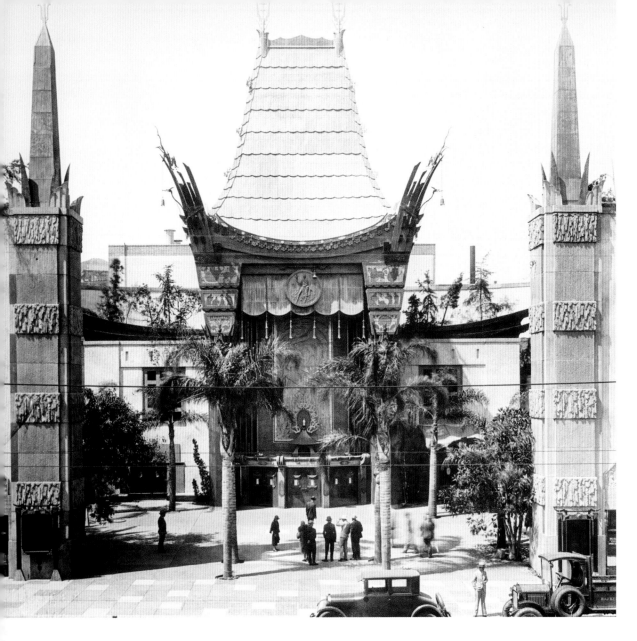

Above: *The front courtyard of Grauman's Chinese Theatre as it appeared in May 1927, four days after its opening. The debut movie was Cecil B. DeMille's* The King of Kings. *Sid Grauman's success with the Egyptian Theatre just down the street allowed him to invest $2 million in the most lavishly appointed movie theater yet seen. It featured temple bells, pagodas, and stone "Heaven Dogs" imported from China.*

On January 13, 1847, the town's military commander, Andrés Pico, met with Frémont at a ranch in what is now Studio City. There they signed the Treaty of Cahuenga, which ended California's participation in the Mexican-American War. Just over one year later, the Treaty of Guadalupe Hidalgo put a formal end to the war. The treaty required Mexico to cede territory that included California to the United States. Twenty days before the treaty was signed, James W. Marshall had gone to check on a mill that he was helping to build on the American River in northern California. He noticed something glistening in the water. What he picked up that day would change everything.

GOLD FEVER

The discovery of gold brought on the Yankees; many went to the mines before coming to Los Angeles. New arrivals in the now-American town of Los Angeles found themselves in a quandary. California's military governor, Bennett C. Riley, had ruled that no one could buy or sell any land not on the city map. So in July and August 1849, Lieutenant Edward O. C. Ord and his assistant William Rich Hutton surveyed and mapped the city. Their map opened property in Los Angeles for sale. Subsequent surveys created a new civic center south of the plaza.

Miners on their way from Mexico to the gold fields of northern California also stopped off in Los Angeles. Many of these prospectors came from Sonora and settled in an area north of the plaza; so many of them lived there that locals called the spot "Sonoratown." During the gold rush, Los Angeles acquired a second, more positive moniker as "Queen of the Cow Counties" for all the beef it supplied to the miners in gold country.

Los Angeles was officially incorporated on April 4, 1850. On September 9 of that same year, California was admitted to the Union as the thirty-first state.

THE RAILROAD COMES TO TOWN

In 1869 Los Angeles saw its first railroad when John G. Downey and Phineas Banning built the twenty-one-mile San Pedro Railroad that ran from San Pedro to Los Angeles.

In the 1870s, Los Angeles was still little more than a village of 5,000. The town grew at a moderate pace; the arrival of the Central Pacific Railroad in 1876 connected the area to San Francisco and the rest of the United States. Five years earlier, Banning had excavated a channel out of the mudflats of San Pedro Bay in order to build a port that would link the railroad to the city.

In 1885 the Santa Fe Railroad's subsidiary, the California Southern Railroad, began to offer Angelenos a more direct connection to the East Coast. The Los Angeles Railway Company began to provide streetcar service to the city in August 1895. Henry E. Huntington acquired the line three years later. Streetcars would run in Los Angeles until March 31, 1963, when the last line shut down.

By 1900 Los Angeles had more than 100,000 residents. In the early twentieth century, two innovations would radically change the city's landscape and shape its future: the airplane and the motion picture.

TINSELTOWN

The twentieth century brought radical changes to Los Angeles. One of these had Angelenos flocking to movie theaters such as Grauman's to crane their necks at the silver screen. Another caused them to crane their necks in wonder at the amazing flying machines in the sky.

The Great San Francisco Earthquake and Fire that struck in the early morning hours of April 18, 1906, played an important role in the Los Angeles area's filmmaking and entertainment industry. The American Mutoscope and Biograph Company, or just "Biograph," had established itself in San Francisco. After the temblor and ensuing firestorm devastated the city, Biograph decided to take its talents and equipment south and set up shop on West Pico Boulevard in Los Angeles.

Biograph was the first film company to shoot a motion picture set in Los Angeles. On July 12, 1906, the company produced *A Daring Southern California Holdup*. Biograph never looked north again; the company stayed in Los Angeles until it closed in 1928.

Other studios followed. In 1909 William Selig brought the Selig Polyscope Company west from Chicago. Three years later, nickelodeon owner William Fox founded the Fox Film Corporation, which would later become Paramount Pictures. RKO Pictures also had its start in 1912; it evolved from the Mutual Film Corporation. RKO competed as the smallest studio of the majors, but hit movies like *King Kong* and *Citizen Kane* kept the company in the black.

HOORAY FOR HOLLYWOOD

In 1910 Hollywood's city fathers changed the name of Prospect Street to Hollywood Boulevard when the town was annexed to the city of Los Angeles.

The Beverly Hills Hotel came on the scene in 1912, two years before the town itself was incorporated. Not long thereafter, stars like Gloria Swanson, Will Rogers, Charlie Chaplin, and Buster Keaton called Beverly Hills home.

The same year the Beverly Hills Hotel was completed, Richard A. Rowland and Louis B. Mayer teamed up to found a company that would become Metro-Goldwyn-Mayer, or MGM, with its roaring lion. The studio produced blockbusters like *Mutiny on the Bounty* and *A Night at the Opera* as well as *Gone with the Wind* and *The Wizard of Oz*.

While Los Angeles exported its entertainment industry around the world, a second phenomenon had taken enough shape to demand a permanent presence: the airplane. Fields where farmers once cultivated wheat, barley, and lima beans morphed into Mines Field in 1923, and then into Los Angeles International Airport in 1949.

Walt Disney got his start in a small office building in 1923. Warner Bros. Studios opened three years later; both studios are in Burbank. At the same time, huge crowds began to enjoy football at the Rose Bowl in Pasadena, which was dedicated on January 1, 1923. That same year, a group of real-estate agents changed the face of Mount Lee when they unveiled a sign sporting 45-foot-tall letters reading "Hollywoodland."

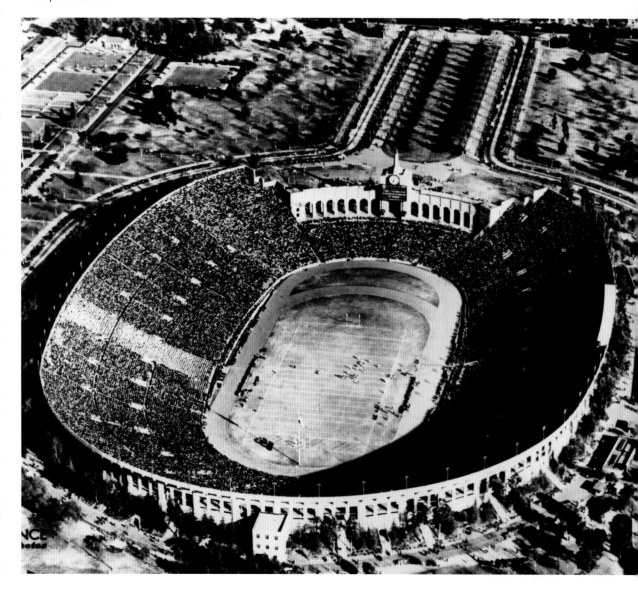

Below: *The Los Angeles Memorial Coliseum was commissioned in 1921 as a memorial to the veterans of World War I. When it opened in 1923, it boasted a seating capacity of 75,144. In 1930, with the impending 1932 Olympic Games on the horizon, the stadium's capacity was expanded to 101,574. In 1968 it was rededicated to the veterans of all wars.*

Below: *The Matterhorn in Anaheim, Walt Disney's hollow version of the Swiss mountain, was one attraction in the groundbreaking Disneyland theme park, which opened its doors in 1955. In 1959 the park introduced the Matterhorn Bobsled ride, and visitors could also take a cable car that passed through a tunnel in the center.*

LIFE IN THE AIR AGE

In the 1920s, the motion picture and aviation industries flocked to Los Angeles, and the city's continuing growth ensured that its residents suffered less during the Great Depression. An air show appropriately opened the United Airport in Burbank on Memorial Day weekend in 1925. The Burbank facility was the largest commercial airport in the Los Angeles region at the time.

In 1930 construction began on the Westwood campus of the University of California, Los Angeles, on the old 384-acre Wolfskill Rancho. In 1932, with a population surpassing one million people, the city hosted the Summer Olympics, which showcased the burgeoning city to the rest of the world.

Olympic Stadium later became the Los Angeles Memorial Coliseum, and its torch remains lit during other Olympics and for special occasions. Just after the conclusion of the 1932 Olympics, construction began on the Griffith Park Observatory, which opened in 1935 and has been one of the city's most popular attractions ever since.

BEYOND WORLD WAR II

During World War II, Los Angeles was a boomtown that grew faster than any other major metropolitan area in the country. The fabric of the city suffered, however. For example, of the 120,000 ethnic Japanese sent to relocation camps, 80,000 came from the Los Angeles area. The Port of Los Angeles facilities at Long Beach and San Pedro served as the center of military activity in the area. Many believed that if the Japanese ever bombed or attacked the United States, they would zero in on Los Angeles.

The postwar years brought on urban sprawl, and the city expanded into the San Fernando Valley. Baseball fans rejoiced in 1957 when the Brooklyn Dodgers moved to Los Angeles. The Forum opened in 1967 when the NBA's Lakers and the NHL's Kings came to town. In 1968 all the world looked to Los Angeles in sadness when Sirhan Sirhan assassinated Bobby Kennedy at the Ambassador Hotel. That same year Los Angeles became one of the birthplaces of the Internet when UCLA computer programmer Charley Kline sent the first ARPANET message from Los Angeles to the Stanford Research Institute in Menlo Park.

In 1984 Los Angeles hosted the Olympic Games for a second time. Despite a boycott by fourteen Eastern Bloc countries led by the Soviet Union, the games proved to be financially successful, garnering a profit of $250 million, which makes it one of the most profitable of any of the modern Olympics.

Pope John Paul II visited the city in 1987, greeted by a crowd of 63,000 at Dodger Stadium. Two years later, the *Los Angeles Herald-Examiner* folded, leaving only one major daily newspaper, the *Los Angeles Times*, to cover such events.

The 6.7 magnitude Northridge earthquake shook the city on January 17, 1994, causing $20 billion in damage and killing seventy-two people and injuring at least 9,000 others. Production in Hollywood shut down temporarily, major roads were damaged, and schools were closed, but the city bounced back quickly.

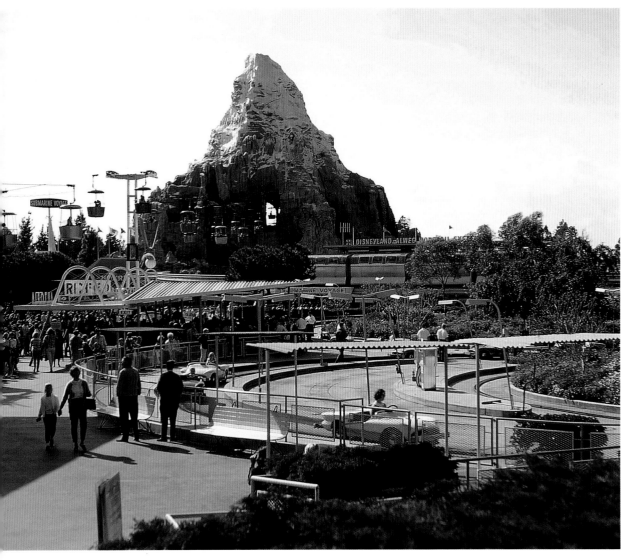

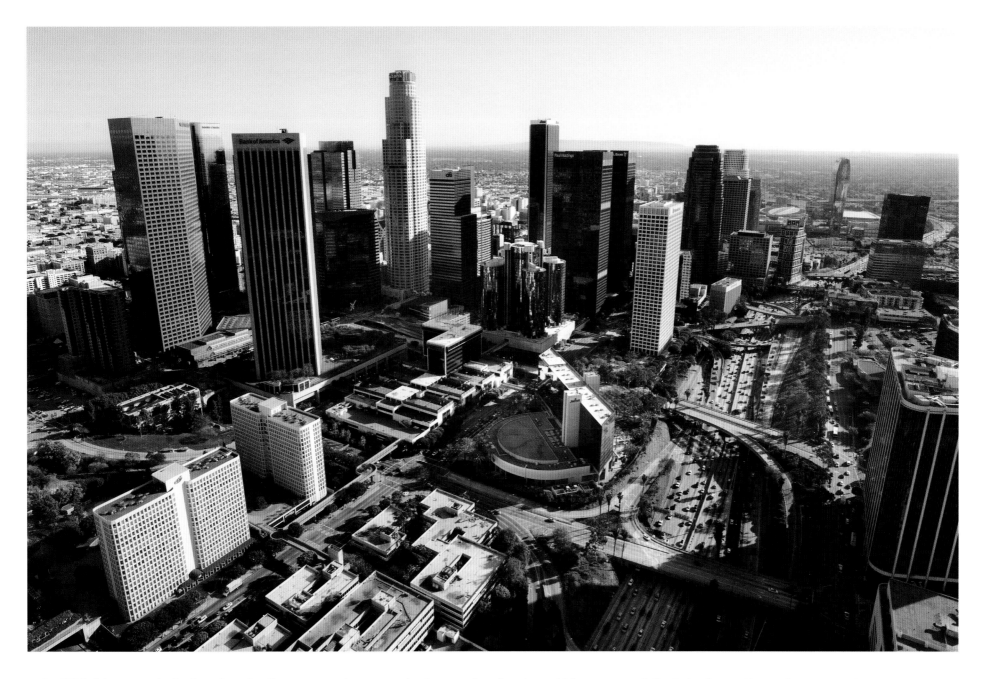

In 2000 things nearly took a turn for the worse when Hollywood and the San Fernando Valley sought independence from the big city in an effort to regain control over their local governments. Voters defeated their efforts to secede from the city, however.

On July 1, 2005, Antonio Villaraigosa was sworn in as the first Latino mayor of Los Angeles since 1872.

As it occasionally does, history came full circle for Angelenos in 2010 when the Angels Flight Railway opened for business after a nine-year hiatus. The railway had begun life in 1901 as the Los Angeles Incline Railway. After many stops and starts over the years, the little railway reopened on March 15, giving the citizens of Los Angeles one more thing to remind them of their rich past.

Above: *The commanding structures of downtown Los Angeles as they face the twenty-first century.*

UNITED / BOB HOPE AIRPORT

United Airport opened with this air show on Memorial Day weekend in 1930 at its current site northwest of central Burbank. The airport was known by several names over the years, but when the United Airports Company of California completed the initial Spanish Revival terminal, the airport took its name. Four years later, the facility was renamed Union Air Terminal after United was broken up due to antitrust regulations. Several aviation pioneers—including Amelia Earhart, Charles Lindbergh, and Wiley Post—frequented the facility, said to be the first multimillion-dollar airport in the country. By this time, the airport had risen to become the primary civil airport serving Los Angeles, and continued to do so through World War II. Los Angeles Airport took over the lion's share of commercial air traffic in 1946.

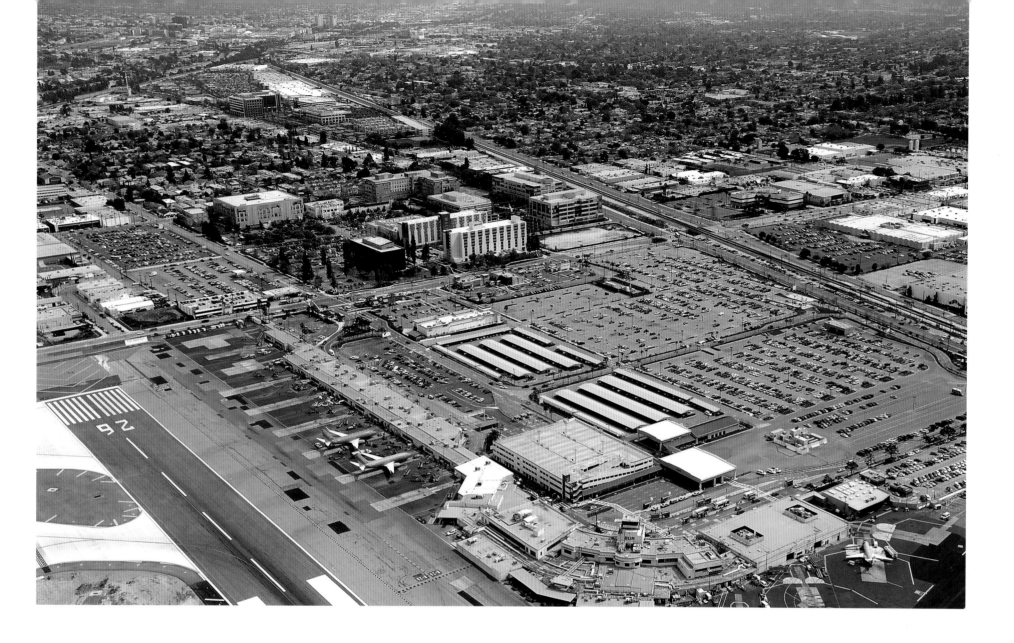

Left inset: This photo shows the same airport in the 1950s, when it was known as Lockheed Air Terminal. The nearby Lockheed Aircraft Company purchased the airport in 1940. Lockheed allowed commercial traffic to continue even while launching prototypes at the site. Lockheed built P-38 fighters, Hudson bombers, and B-17 bombers for the war effort. The P-80 Shooting Star earned the distinction of being the first jet fighter to see action and the first to shoot down an enemy jet in the Korean War. During the Cold War, Lockheed manufactured the famous U-2 spy planes. Well past its fighting days, the airport received a more glamorous name in 1967 when it became Hollywood-Burbank Airport in an attempt to increase business. Lockheed sold the airport to the Burbank-Glendale-Pasadena Airport Authority in 1978.

Above: The year 2003 proved momentous for Burbank's airport, as it marked the 100th anniversary of the Wright brothers' first flight. That same year, beloved comedian Bob Hope, a resident of nearby Toluca Lake who kept his own aircraft at the airport, also turned 100. Hope was well known as a booster for the USO, a traveling performance group that entertained U.S. troops overseas. Bob Hope Airport took its new name on December 17, 2003, just a few months after Hope died. By 2006 the airport had the capacity to serve five million travelers annually on more than seventy daily flights. The Lockheed buildings were demolished in the 1990s and the site is now a burgeoning commercial development with major chain restaurants and businesses.

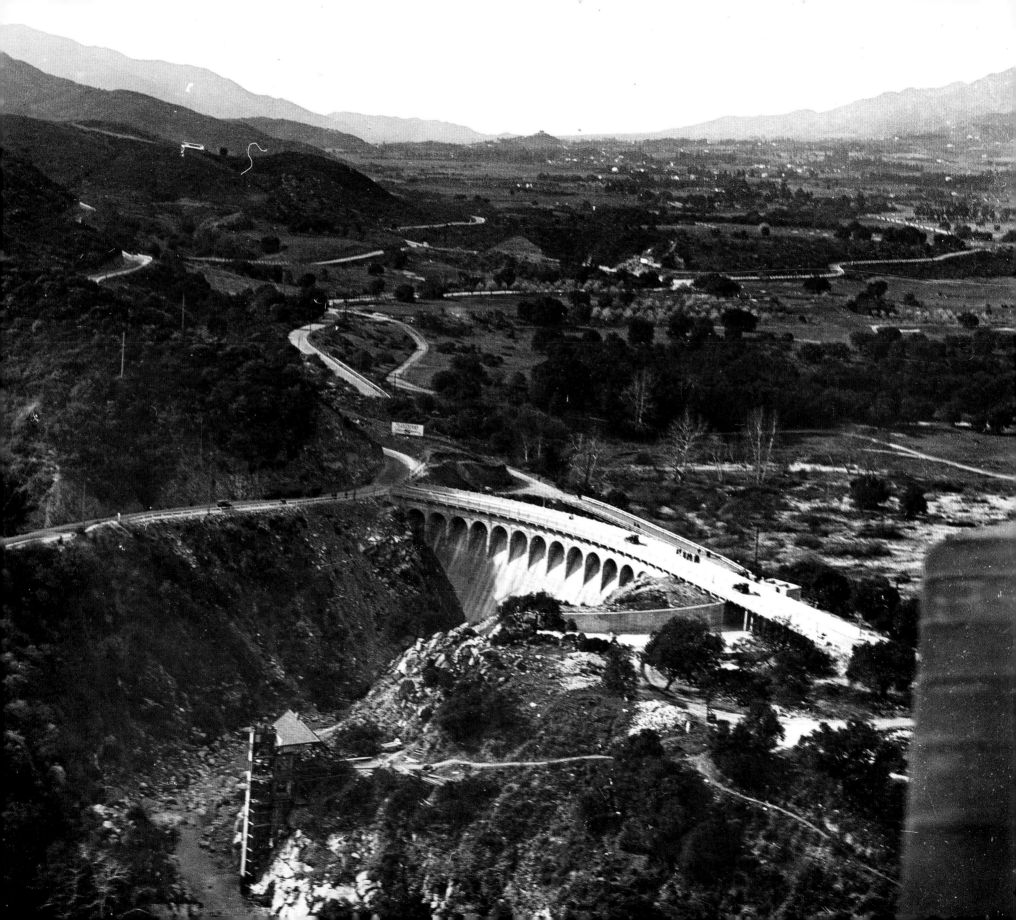

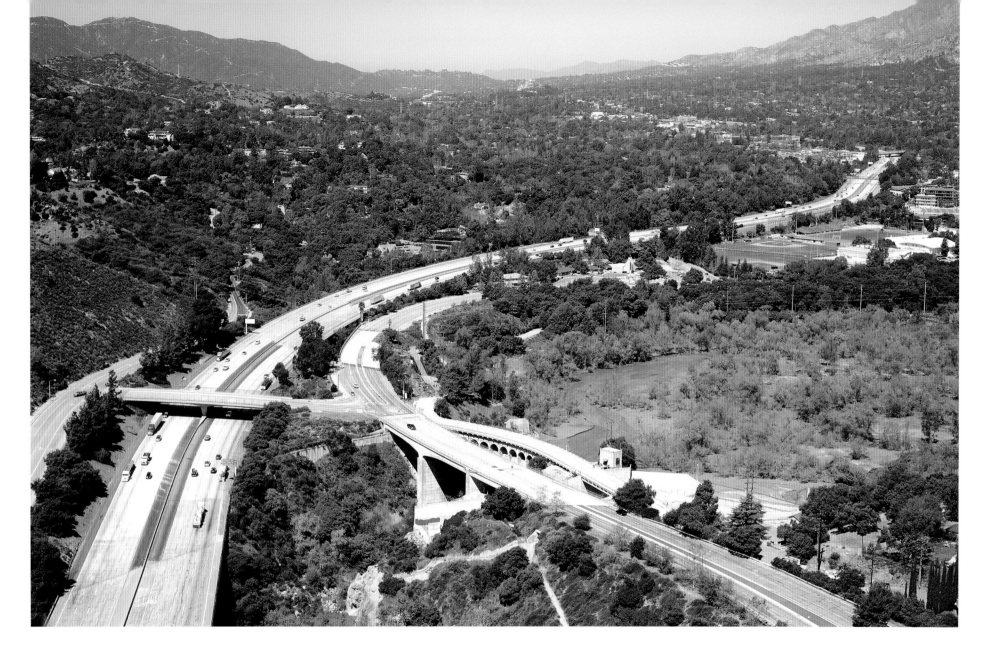

DEVIL'S GATE DAM

Left: In 1920 flood engineers from the Los Angeles County Flood Control District built Devil's Gate Dam in the Arroyo Seco, the first flood-control dam in Los Angeles County. Named for a rock outcropping that resembles the face of a devil, Devil's Gate Gorge is located in Pasadena between La Cañada Flintridge and Altadena. The gorge is the narrowest spot in the Arroyo Seco. Despite its name, which means "dry creek" in Spanish, the Arroyo Seco floods regularly, and early settlers made a point of situating the nascent pueblo of Los Angeles out of the path of floodwaters racing to join the Los Angeles River. In the early 1900s, as the city expanded into these areas, flooding caused devastation.

Above: After the dam was completed in 1920, most of the trouble was averted, but the flood of 1938 lay ahead. The flood caused such extensive damage, the Red Cross has called it the fifth-largest flood in history. There were 250 miles of flooded land, from Riverside to San Bernardino and from the Santa Ana River to Newport Beach, along with Anaheim and Fullerton. The U.S. Congress later passed the Flood Control Act of 1941, a comprehensive flood-control plan for the area. The act authorized the U.S. Army Corps of Engineers to reshape Los Angeles County's natural hydrology into a system of concrete conduits. In this view, a local road almost completely obscures the Devil's Gate Dam.

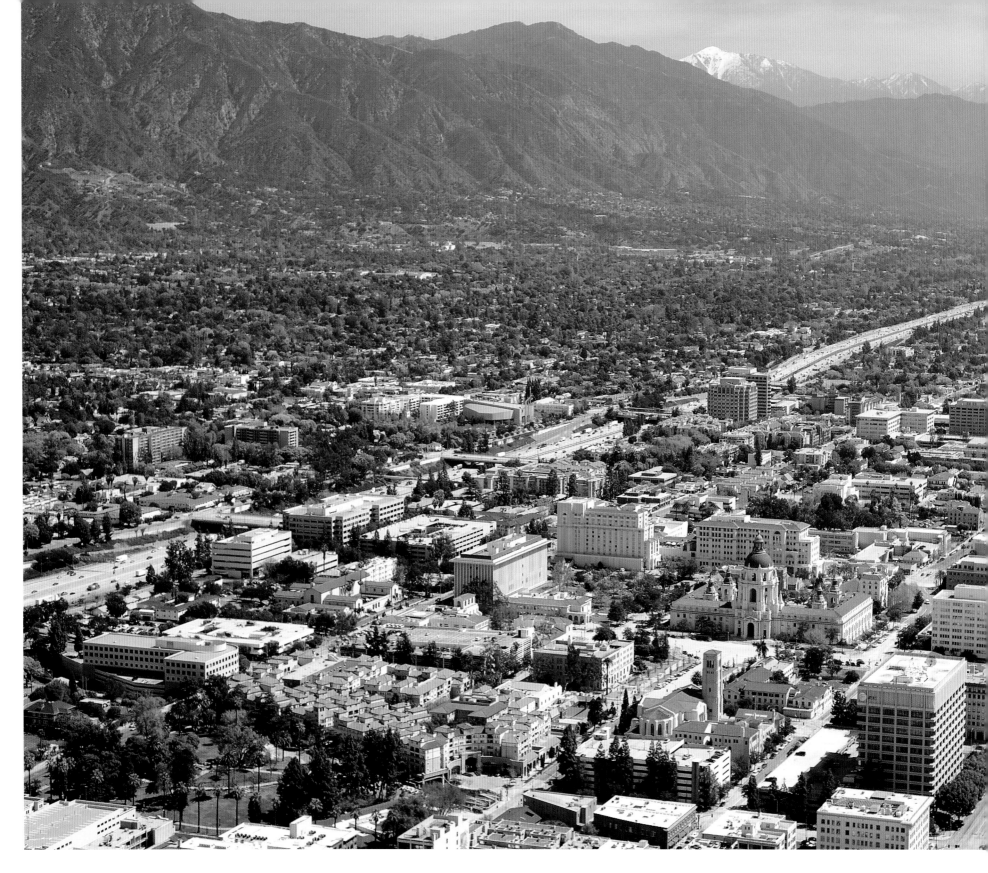

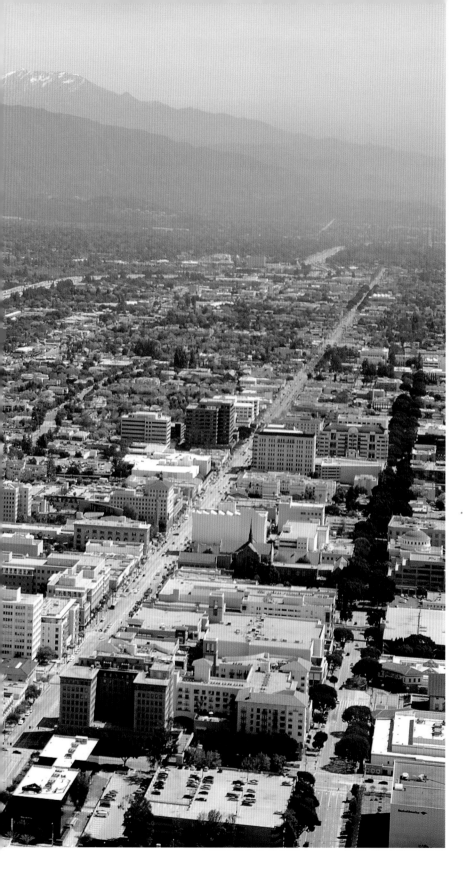

PASADENA

Left: Pasadena, a city of about 135,000 residents, stretches off to the east along the Foothill Freeway. Manuel Garfias retained the title to the land grant that encompassed the city when California became a state in 1850, and began selling parcels to the city's first Anglo settlers, Dr. Benjamin Eaton and Dr. John S. Griffin. The name Pasadena comes from the Minnesota Chippewa language, and means "of the valley." The fine climate was recognized by doctors, and it soon gained popularity as a winter resort for wealthy Easterners. From the 1880s through the Great Depression, the real-estate boom in the area could be attributed to those seeking improved health. By 1940 Pasadena anchored one end of California's first freeway, the Arroyo Seco Parkway, which connects to Los Angeles. The striking tower of the 1927 City Hall building can be seen at the bottom center of this photo. Just below City Hall is the bell tower of the Pasadena Grace Church.

Below: City Hall, built for $1.3 million, forms the centerpiece of the city's civic center. San Francisco architects Bakewell and Brown designed the building with its signature dome stretching twenty-six feet from its base and spanning fifty-four feet in diameter. Long a favorite location for filmmakers, City Hall makes an appearance in Charlie Chaplin's 1940 classic *The Great Dictator*.

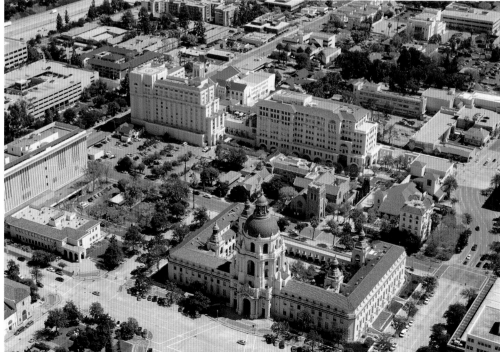

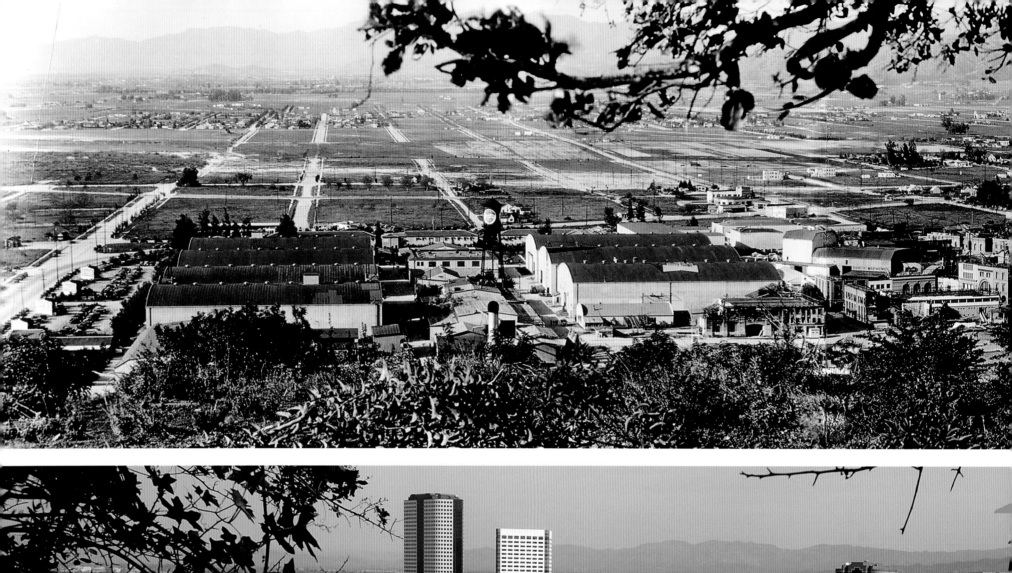
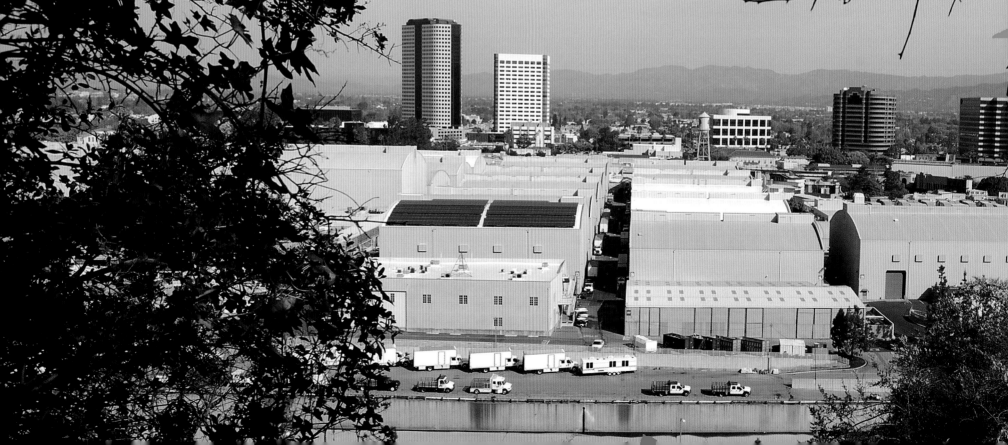

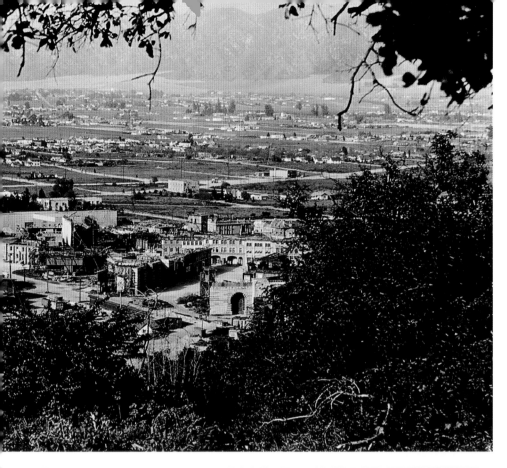

WARNER BROS. STUDIOS

Top: A pair of large Spanish land grants—Rancho San Rafael and Rancho La Providencia—originally made up the land that citizens of Burbank now call home. In 1867 Dr. David Burbank purchased the ranchos, which he converted into his own large ranch. In 1926 First National Pictures built a studio on a plot of farmland in Burbank on a seventy-eight-acre site on Olive Avenue near Dark Canyon. Two years later, about the time that Bert Longworth climbed the hill to take this photograph, another company had acquired the property. Warner Bros. had already been producing films in its first studio on Sunset Boulevard in Hollywood, now home to the television station KTLA. The company had just come off the financial success of *The Jazz Singer*, the historic first talking picture. Flush with cash, Warner Bros. took over the First National Pictures site and began turning out movies at a feverish pace—eighty-six features in 1929 alone. One of their back lots actually stood on the spot that Dr. Burbank called home in the late nineteenth century.

Bottom: Once settled in Burbank, Warner Bros. launched the careers of Humphrey Bogart, James Cagney, and Ingrid Bergman. During World War II, fearful of being mistaken for the nearby Lockheed aircraft factory, Warner Bros. had its studio camouflaged. In the 1950s, actors such as Marlon Brando, James Dean, and Judy Garland worked on the studio's soundstages. The likes of Paul Newman and Warren Beatty came along in the 1960s. The studio thrived in film and, increasingly, television production, eventually becoming the biggest producer of television programs in Hollywood. Shows taped here include *Full House*, *Friends,* and *Two and a Half Men.* In 1971 Warner Bros. became a part of Warner Communications, which merged with Time, Inc. in 1989. In 2000 Time Warner merged with America Online, which was the largest-ever media company merger at $163 billion.

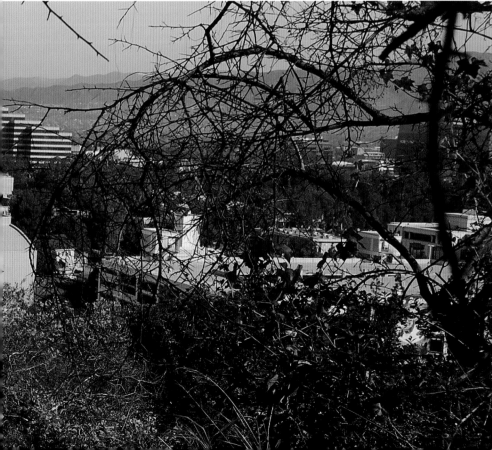

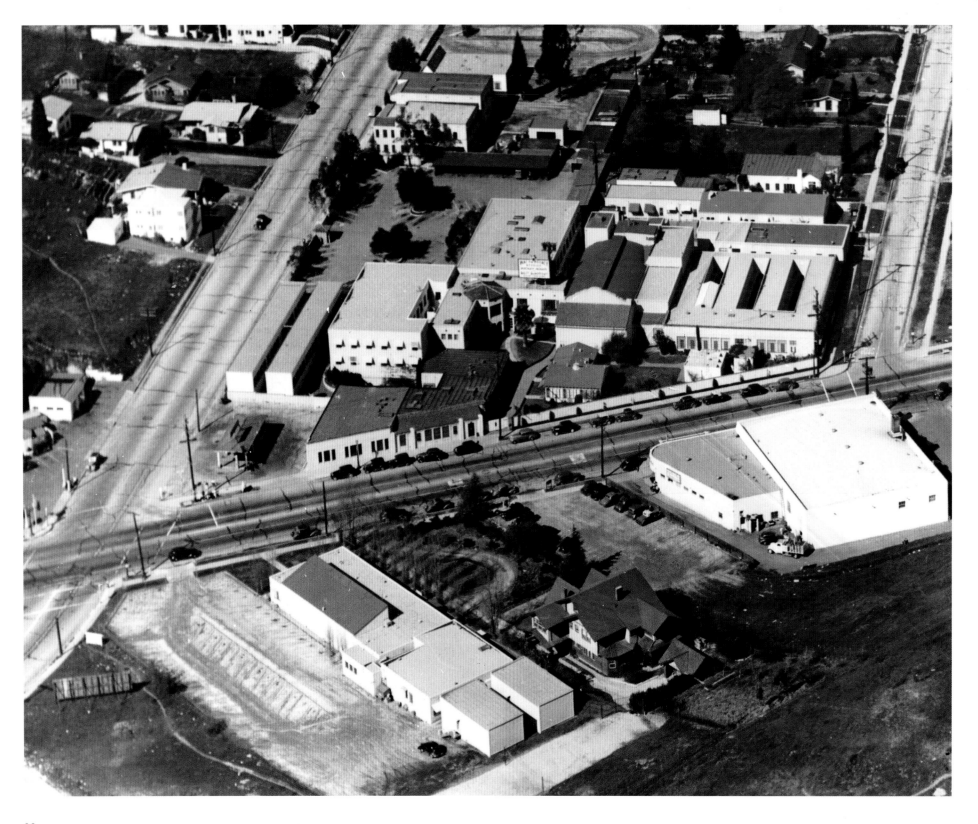

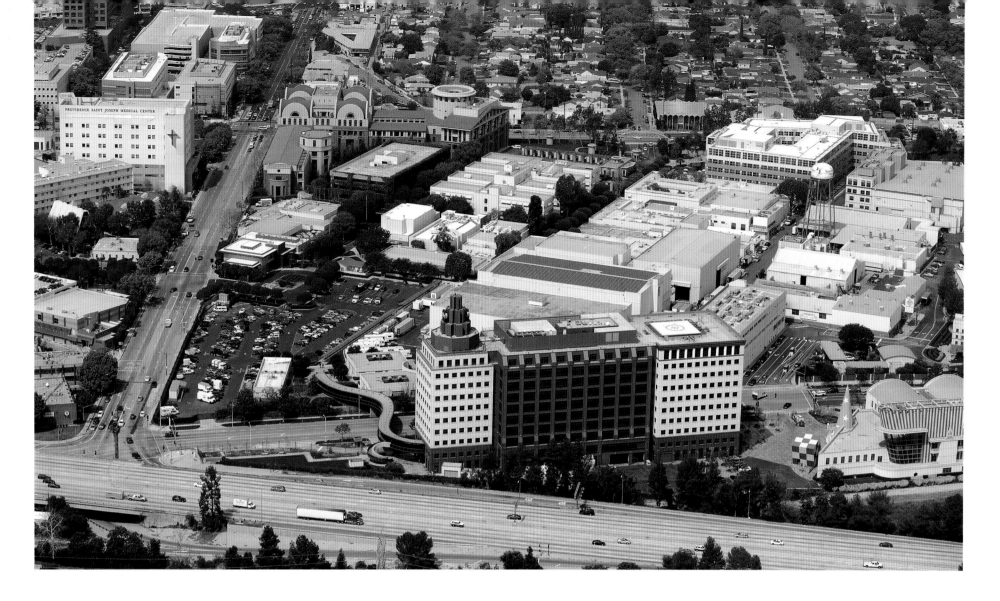

DISNEY STUDIOS

Left: The Walt Disney Company started in 1923 in the rear of a small office occupied by Holly-Vermont Realty in Los Angeles. Pioneer animator Walt Disney worked with his brother Roy to create the initial series of shorts known as the Alice Comedies. Within five years, Mickey Mouse was born. On December 21, 1937, Disney's innovative first full-length animated feature, *Snow White and the Seven Dwarfs*, appeared to critical acclaim and worldwide success. With profits from *Snow White*, Disney made a deposit on these fifty-one acres in Burbank and designed a studio specifically for making animated films, seen here in 1938. Walt involved himself in every aspect of the studio's construction, from the building's layout to the design of the animators' chairs. The animation building formed the center of the state-of-the-art campus. From this central location, animators could easily access the inking and painting building, the camera building, the sound studios, and the editing building.

Above: Walt Disney's company has spent the past eight decades producing some of the best-loved children's films of all time, including *Pinocchio*, *Fantasia*, and *The Lion King*. Through the years, Disney won thirty-one Academy Awards for his work. The campus expanded across the street in 1995, adding the ABC Building in the foreground, connecting it to the old campus with a blue serpentine pedestrian bridge. Just to the right, Mickey's sorcerer's hat decorates the Feature Animation Building. In 2006, with the future of animation linked now to computer graphics, the Walt Disney Company purchased the successful computer graphics animation firm Pixar Inc. for $7.4 billion. The first Pixar film produced by the Disney Studios, *Ratatouille*, won the 2007 Academy Award for Best Animated Feature. In 2010 Pixar's *Up* received an impressive five Oscar nominations.

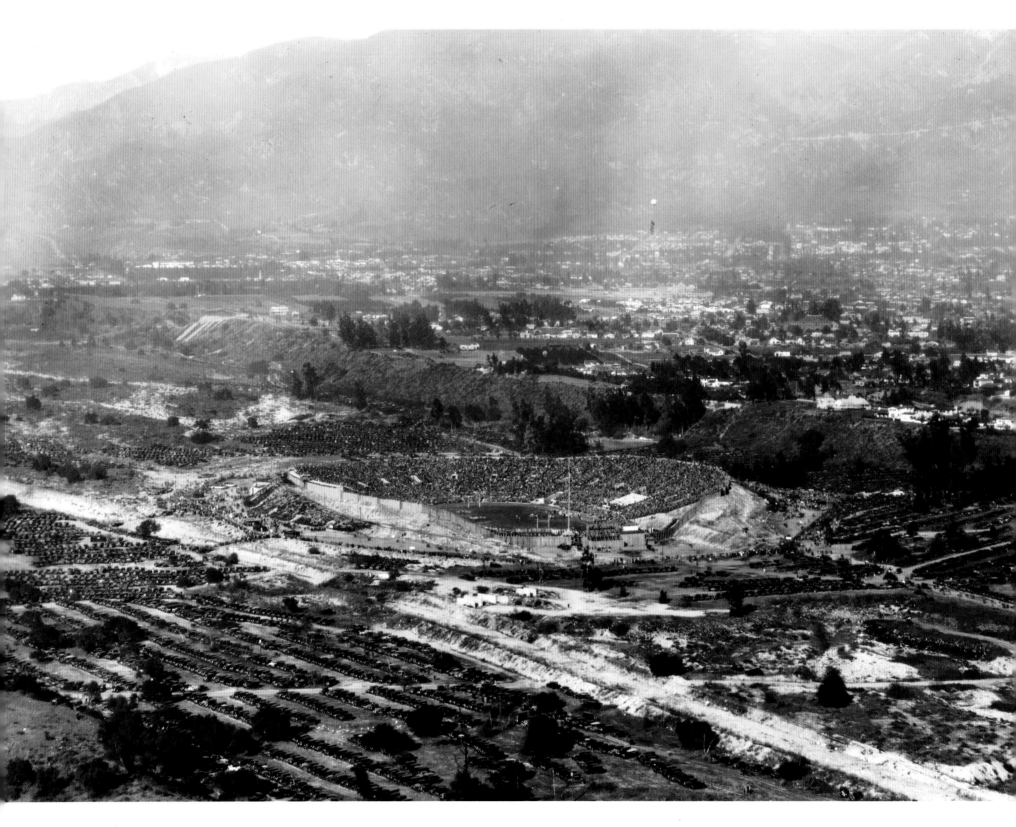

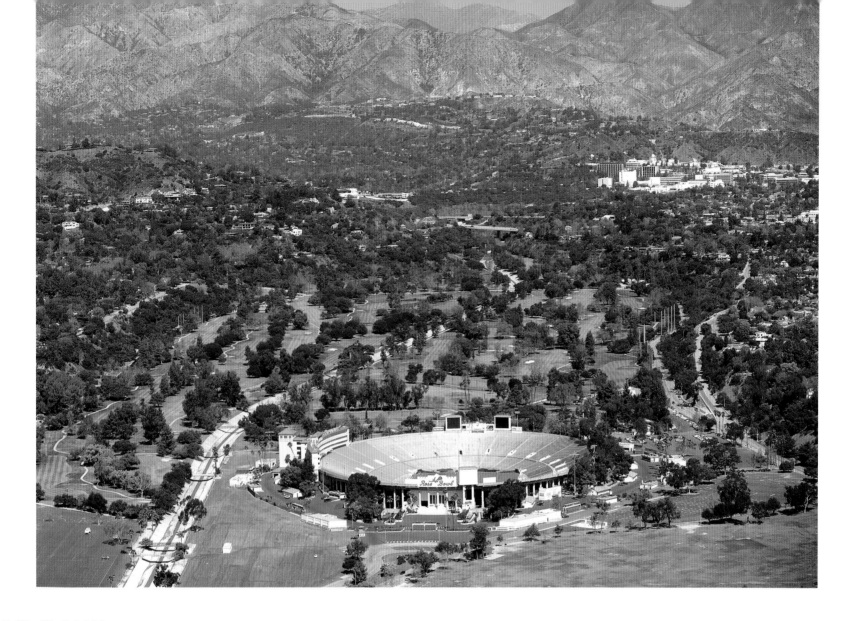

ROSE BOWL

Left: An aerial photographer snapped this picture sometime between 1923, when the Rose Bowl opened, and 1929, when builders closed the stadium's original horseshoe shape in order to give the venue additional seating capacity. Architect Myron Hunt designed the stadium using the Yale Bowl in New Haven, Connecticut, as a model. A committee selected the Arroyo Seco riverbed as the location for the stadium. In the first game played in the Rose Bowl on October 28, 1922, the University of California defeated the University of Southern California, 12–0. Originally called the "Tournament East-West Football Game," the first New Year's Day Rose Bowl game had taken place in Pasadena's Tournament Park in 1902, with the University of Michigan beating Stanford University, 49–0. Stanford's players walked off the field with eight minutes left. The score was so lopsided that the game wasn't played again until 1916.

Above: The annual bowl game, known as the "Granddaddy of Them All" because it was the first college bowl game to be played, became so popular that organizers added extra seating by closing off the original horseshoe shape, allowing some 76,000 fans to attend the game. Subsequent additions increased the Rose Bowl's capacity to 92,542. Today, the Rose Bowl is part of college football's Bowl Championship Series, which rotates the national title game among five bowl games each year. Almost as famous as the football game is the Tournament of Roses Parade in downtown Pasadena, which is held each year on New Year's Day. The parade's elaborate floats now feature high-tech computerized animation. Millions of television viewers around the world make watching the parade on New Year's Day a tradition.

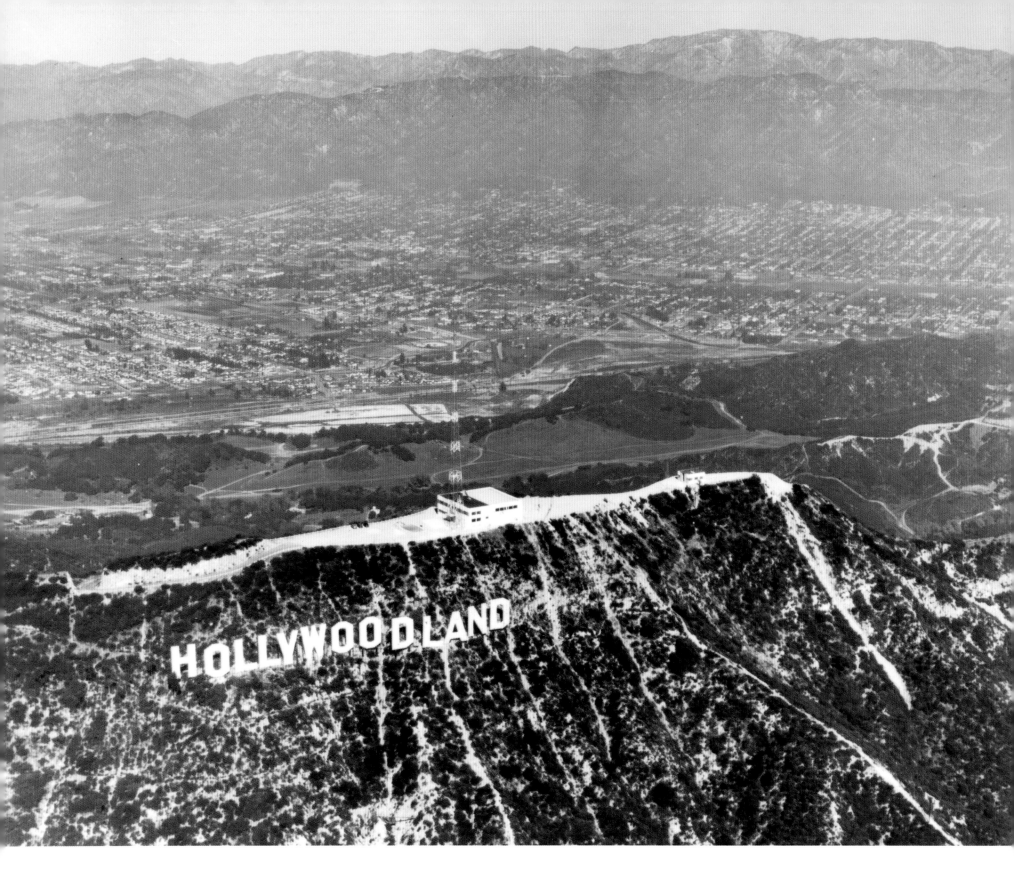

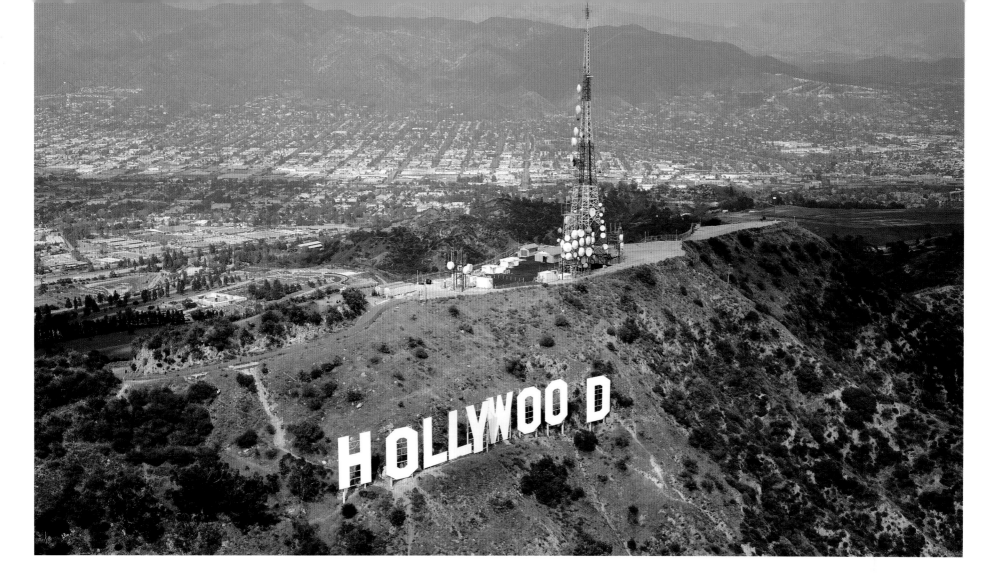

HOLLYWOODLAND SIGN

Left: By the time this picture was taken in 1935, the Hollywoodland sign had been gracing Mount Lee in the Santa Monica Mountains for thirteen years. The letter H has seen the most action over the years. In 1932 the despondent actress Peg Entwhistle jumped from the letter to her death. In the 1940s Albert Kothe, the man entrusted with caring for the sign, got drunk, swerved off the road, and collided with the same H in his Model A Ford. The Hollywood Chamber of Commerce contracted with the City of Los Angeles to repair the sign. The contract required that workers remove the "land" portion of the sign to better reflect the city of Hollywood. The contract also stipulated that the chamber pay to illuminate the sign, so they opted to eliminate the lightbulbs instead. The sign continued to deteriorate over the years. Eventually the first O splintered and broke in two, and the third O fell down, leaving the sign reading "HuLLYWO D."

Above: The forty-five-foot-tall white letters spelling out "Hollywood" are arguably Los Angeles's most recognizable landmark. During the 1960s, the Hollywood Kiwanis Club raised enough money to repair the sign. Soon after Kiwanis spent the last of their funds, one of the Os crashed down the hill. In 1978 shock rocker Alice Cooper spearheaded a public campaign to restore the landmark when he donated $27,000 to replace the missing O. Cooper reportedly made the donation in memory of his longtime friend Groucho Marx. Other Hollywood residents, including Hugh Hefner, Andy Williams, and Gene Autry, followed suit, with each sponsoring one letter. The intensely deteriorated sign was then replaced with a more permanent structure. Donors provided the balance of the funding. The new version of the sign was unveiled on Hollywood's seventy-fifth anniversary, November 14, 1978. Maintenance and refurbishment are now ongoing. In 2005 workers stripped the letters back to their metal base and gave them a fresh coat of white paint.

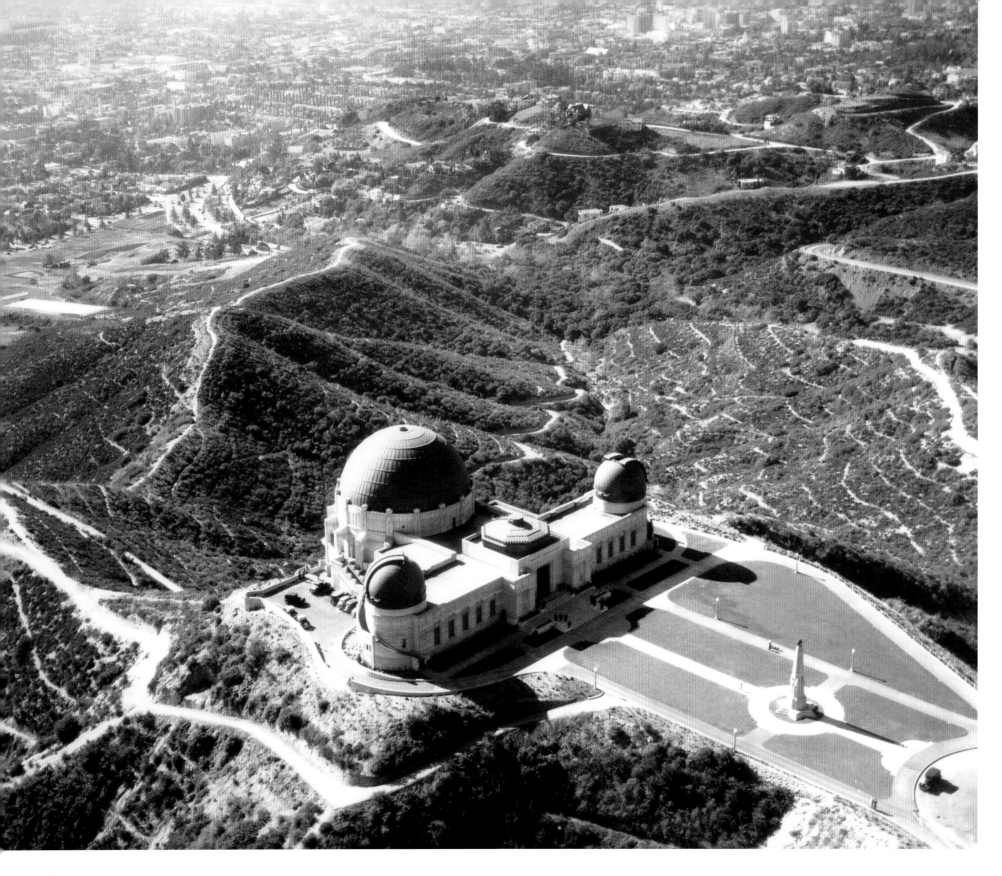

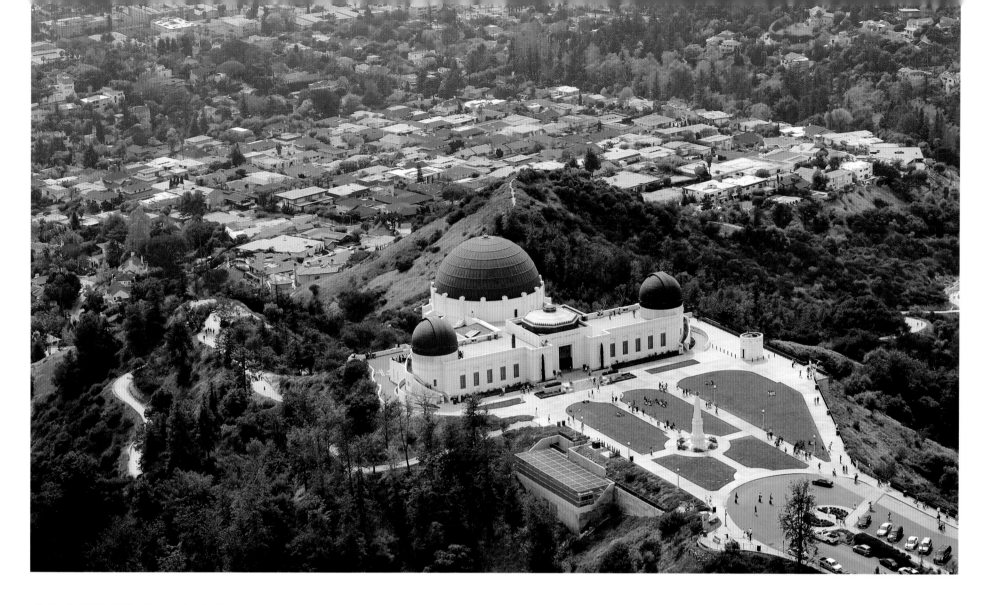

GRIFFITH OBSERVATORY

Left: Colonel Griffith J. Griffith donated 3,015 acres to the City of Los Angeles in 1896 for the creation of a "great park." After making a fortune in Mexican silver mines, Griffith had invested in Southern California real estate. He visited the world's largest telescope at the new research observatory established at Mount Wilson, north of Los Angeles, in 1904. The telescope so impressed him that, in 1912, Griffith offered Los Angeles $100,000 to build an observatory atop Mount Hollywood. Griffith's plan included an astronomical telescope open to free viewing, a hall of science, and a movie theater. The Griffith Observatory has graced the south-facing slope of Mount Hollywood in Griffith Park since 1935, when this photograph was taken. Colonel Griffith died in 1919, fourteen years before construction on the site began.

Above: During World War II, a large air-raid siren was set up next door and squadrons of naval aviators learned to navigate by the stars in the planetarium. Cosmologist Fritz Zwicky, who discovered dark matter, neutron stars, and supernovas, used the telescope for his research several times in the 1950s. The 1980s and 1990s brought unprecedented crowds to the Griffith Observatory, with attendance reaching an annual average of about two million visitors. The copper domes of the observatory were shined up to a "penny finish" in 1984, a year before the celebration of the building's fiftieth anniversary. Major astronomical events such as Halley's Comet in 1986 and the impact of Comet Shoemaker-Levy 9 with Jupiter in 1994 raised the observatory's profile even further. A 1990 master plan for restoration and expansion closed the observatory for four years. In 2006 the Griffith Observatory reopened to the public after undergoing a complete renovation.

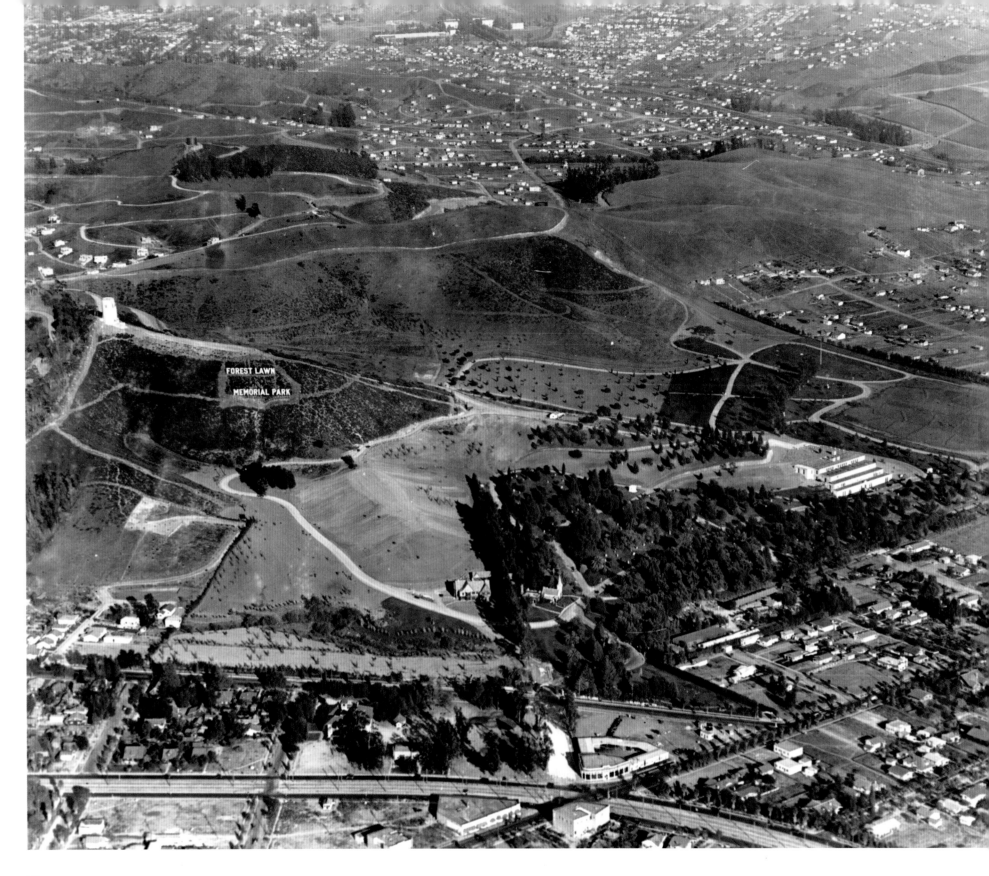

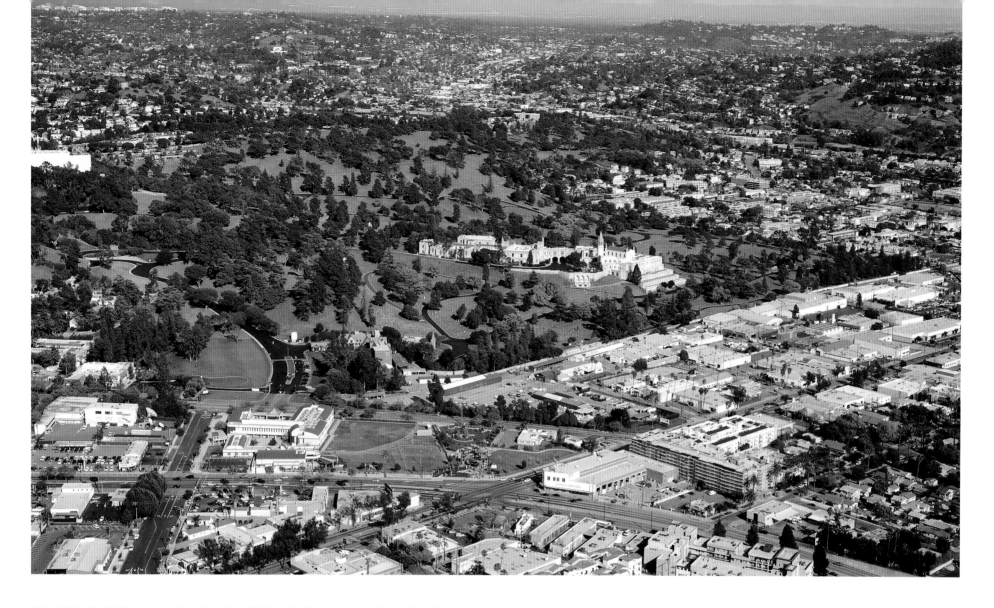

FOREST LAWN MEMORIAL PARK

Left: This photograph was taken as the Grand Mausoleum atop the highest hill in Forest Lawn Memorial Park was under construction; only Azalea Terrace, dedicated in 1920, had been completed. Construction on the Grand Mausoleum began in 1917, the year Dr. Hubert Eaton took over the 300-acre cemetery. The cemetery's property, along with all of Glendale, was once part of Jose Maria Verduga's Rancho San Rafael. Before it became a cemetery, the property was used as a location for early motion pictures, including the battle scenes in *Birth of a Nation*. Nestor Studios built a shantytown on the property while filming Westerns. In 1906, when the city of Glendale was incorporated, a group of San Francisco businessmen met to establish Forest Lawn Memorial Park, a chain of six nonprofit cemeteries. The property that Eaton took over in Glendale had been a cemetery since 1913. His idea was to rid cemeteries of "unsightly, depressing stone yards filled with misshapen monuments."

Above: Every year, more than a million people visit the graves of celebrities interred at Forest Lawn Memorial Park. Thousands of schoolchildren take field trips to the cemetery to learn about those who are buried there—a list that now includes singer Michael Jackson—as well as the noteworthy artworks on site. Forest Lawn has no vertical markers to suggest it is a cemetery, but rather boasts trees, lawns, fountains, and statuary that hint at a joyous existence after death. The three nonsectarian chapels at Forest Lawn are replicas of famous European churches. Forest Lawn has been the site of more than 30,000 weddings, including that of Ronald Reagan and Jane Wyman. While spiritual symbols are prevalent, some patriotic elements—such as the Court of Freedom, with its large mosaic of the signing of the Declaration of Independence, and a thirteen-foot statue of George Washington—also decorate the scene. The main gates are said to be the world's largest wrought-iron gates.

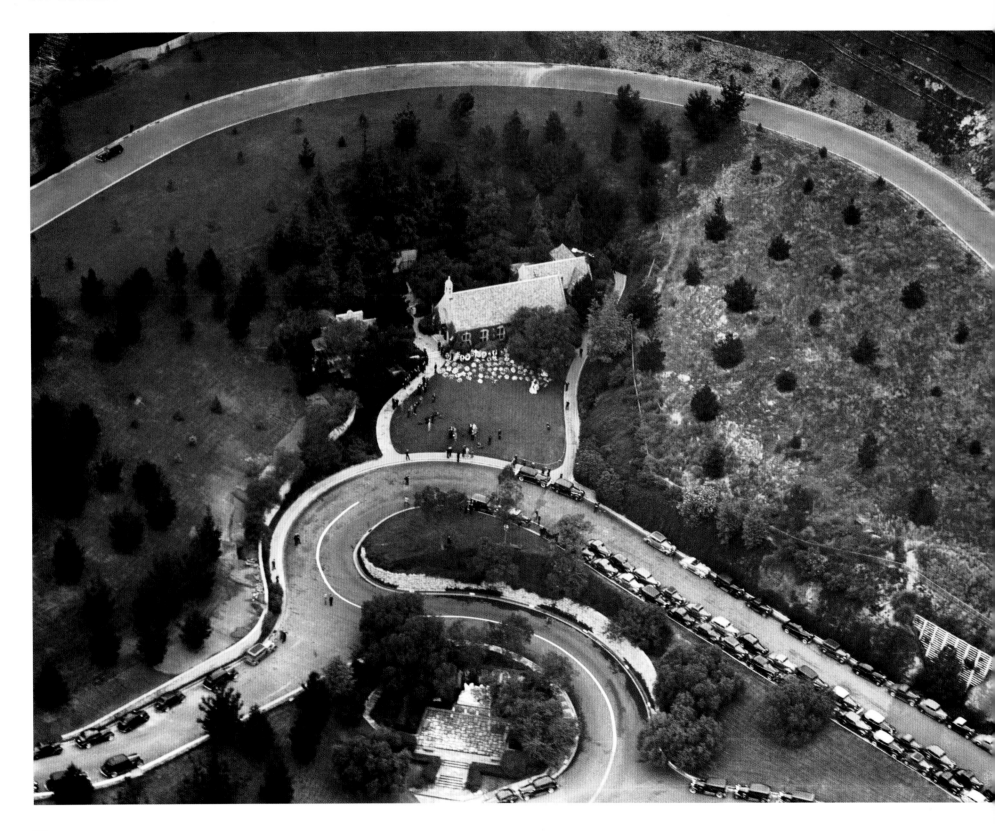

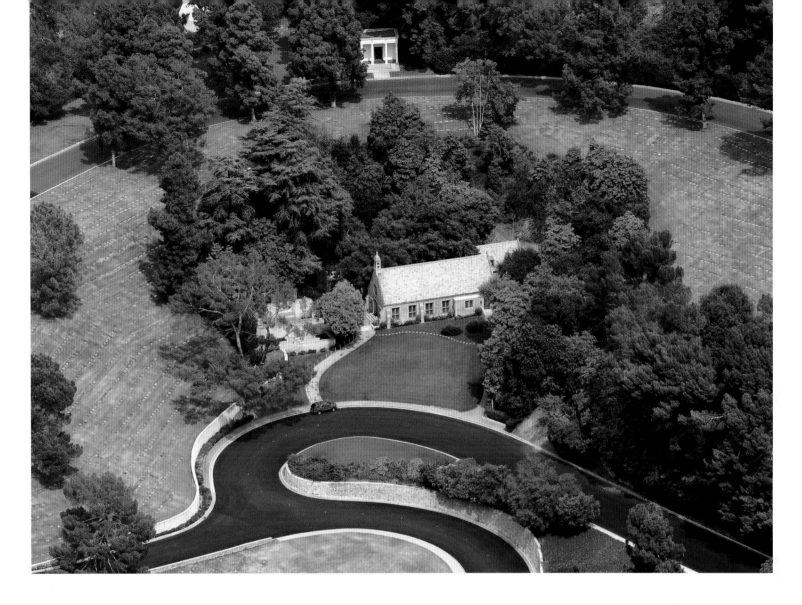

JEAN HARLOW FUNERAL

Left: Two days after her premature death on June 7, 1937, actress Jean Harlow received a lavish funeral at Forest Lawn Memorial Park in Glendale. Harlow's interment started the tradition of blockbuster funerals. At the age of twenty-six she had been Hollywood's first blonde bombshell. Her big break came in 1930 when Howard Hughes cast her in his World War I aviation epic *Hell's Angels*. Harlow collapsed on the set of the film *Saratoga*. She had suffered from medical problems, including a kidney disease likely brought on by the scarlet fever she had contracted as a teenager. She died of cerebral edema and uremic poisoning caused by a buildup of waste products in the blood. More than 250 invited guests attended the funeral, including Clark Gable, Spencer Tracy, Lionel Barrymore, and the Marx brothers. Ironically, Marilyn Monroe was considering the lead in *The Jean Harlow Story* when she died in 1962.

Above: The Wee Kirk o' the Heather Chapel at Forest Lawn Memorial Park has changed little since Jean Harlow's funeral. The chapel is considered an exact replica of the village church at Glencairn, Scotland, and has been used not only for funerals but for weddings as well. Television star Regis Philbin and his wife, Joy, are among those who tied the knot here. The Wee Kirk o' the Heather is not the only church at Forest Lawn; others include the Church of the Hills, modeled after the First Parish Church in Portland, Maine; and the Little Church of the Flowers, inspired by a village church at Stoke Poges, England. Other prominent people rest at the cemetery's Great Mausoleum, which is a replica of Campo Santo in Genoa, Italy. Forest Lawn is a private cemetery and has long upheld a policy of preventing gawkers, tourists, and die-hard fans from disturbing the rest of their favorite deceased stars.

Citrus farming dominated the landscape in 1910 when this picture of the San Rafael hills and a fire burning in the San Gabriel Mountains was taken. A massive boulder with an indentation that cast a bird-shaped shadow at certain times of day was referred to by early settlers as "Eagle Rock." In 1911 the whole neighborhood took on that name. Occidental College was built nearby in 1914, and much of the activity of the town centers on college life. A core of counterculture writers, artists, and filmmakers has occupied the town since the 1920s. Notable early residents included Aldous Huxley and John Steinbeck. City fathers, under considerable political pressure, annexed the small town to Los Angeles after the arrival of Owens Valley water.

EAGLE ROCK

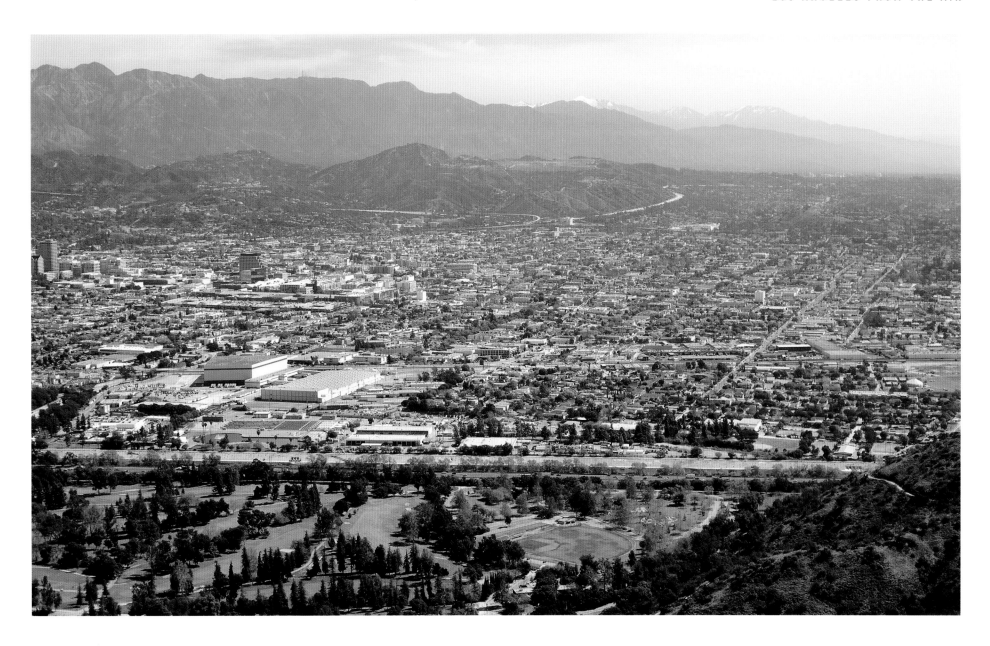

Los Angeles began diverting water from the Owens River in 1923. Eagle Rock became part of Los Angeles in order to use the new water supply but retained its original preannexation city hall and library, which is a Carnegie library built in 1915. Many of the homes built in Eagle Rock are historically significant examples of architecture done in the craftsman, Art Deco, and Spanish Mission styles. Eagle Rock has been experiencing gentrification for the last few years as young urban professionals are finding themselves priced out of surrounding neighborhoods. A strong creative community remains; Monty Python's filmmaker and animator Terry Gilliam (an alumnus of Occidental) called Eagle Rock home. President Barack Obama attended Occidental College from 1979 to 1981 before transferring to Columbia University. Given their proximity to Hollywood and their Anytown, U.S.A., atmosphere, Eagle Rock and Occidental College have served as shooting locations for many productions, including the Marx brothers' *Horse Feathers*, Michael J. Fox's *Teen Wolf*, Quentin Tarantino's *Reservoir Dogs*, and the television show *Beverly Hills 90210*.

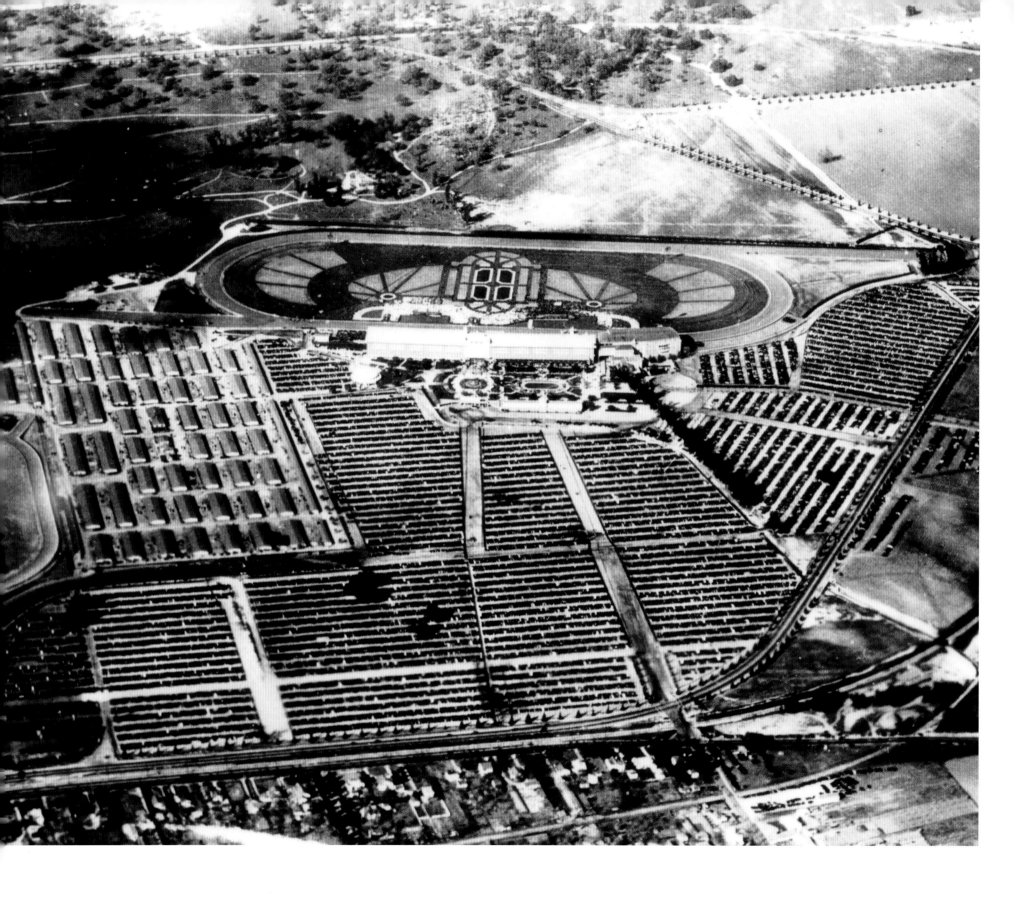

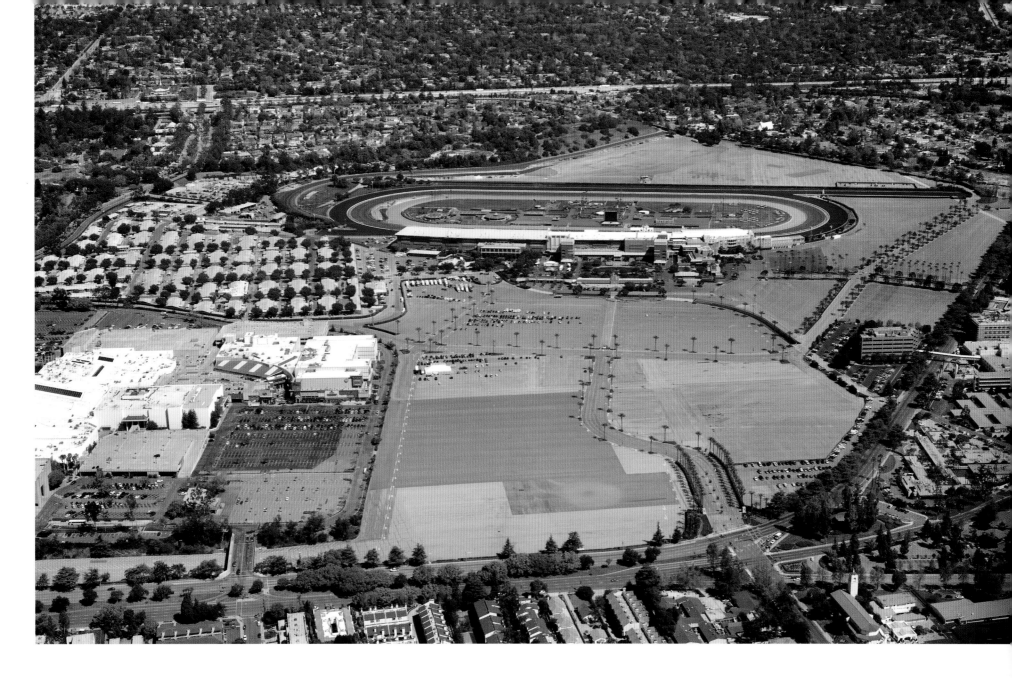

SANTA ANITA PARK AND TRACK

Left: In 1933 film director Hal Roach and San Francisco dentist Charles "Doc" Strub formed the Los Angeles Turf Club and raised funds to build a horse-racing track. They chose Santa Anita Park in Arcadia, just east of Los Angeles and originally part of Rancho Santa Anita. The track began life on Christmas Day 1934. Architect Gordon B. Kaufman designed the Art Deco–style main building for the track. Under Strub's direction, Santa Anita implemented innovations in thoroughbred horse racing that remain as standards today. The track began the practice of using starting gates and photo finishes for every race.

Above: In 1940 the famous racehorse Seabiscuit won the Santa Anita Handicap in his last start here. Two years later, World War II brought an end to horse racing and the government used the facilities as a Japanese internment center. Santa Anita reopened as a racetrack in 1945. A downhill turf course was added in 1953. During the 1960s, major renovations included a much-expanded grandstand as well as major seating additions. In 1974 the Westfield Santa Anita Mall was built on the site of the old barns and training track. Santa Anita hosted the 1984 Olympic equestrian events. Today it has a turf course measuring nine-tenths of a mile and a one-mile synthetic "cushion" main track. The cushion track hosted its first live race on September 26, 2007. Visitors to Santa Anita Racetrack can relive the days of Seabiscuit aboard the Seabiscuit Tram.

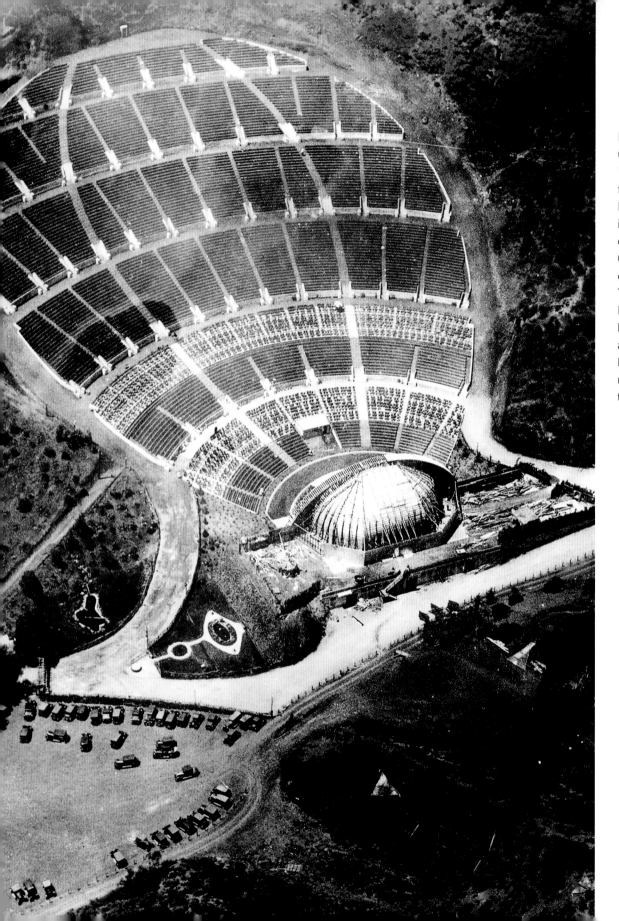

HOLLYWOOD BOWL

Earthquakes and erosion, not man, carved a bowl into Bolton Canyon long before musicians began performing here. On July 11, 1922, music lovers set up wooden benches on the canyon's hillside for the first time to listen to Alfred Hertz and the Los Angeles Philharmonic Orchestra. The sixty-acre canyon offered acoustics in an outdoor setting that rivaled any that humans could have designed. The Hollywood Bowl, seen here in 1929, also hosted Christine Stevenson's religious plays. The bowl has had a number of band shells over the years; some of them lasted only months. These included two designed by Frank Lloyd Wright's oldest son, Lloyd Wright. The first shell and amphitheater structures were built in 1926; Wright stepped in for the 1927 season. While many a bright modern star has performed at the stage, the diminutive French opera star Lily Pons set the Hollywood Bowl's attendance record on September 8, 1937, when 26,410 opera aficionados paid to hear her sing.

Known for its architecturally and acoustically significant band shell, the bowl now seats 17,376. During the 1970s and 1980s, noted architect Frank Gehry brought the latest technology in lighting and sound to the band shell. Gehry adapted Wright's 1927 design, which didn't fully accommodate a modern orchestra. Today, the Hollywood Bowl welcomes close to a million visitors annually to its music programs. The band shell has undergone several renovations and improvements over the years. In 2003 the architectural firms of Hodgetts & Fung Design Associates and Gruen Associates began rebuilding the shell to better integrate lighting and sound technology into the design, and enlarging the stage area to accommodate an even larger orchestra. Their aim is to preserve the spirit of the shell's original, highly recognizable design. The grounds around the bowl are open and free for the public to enjoy in the daytime.

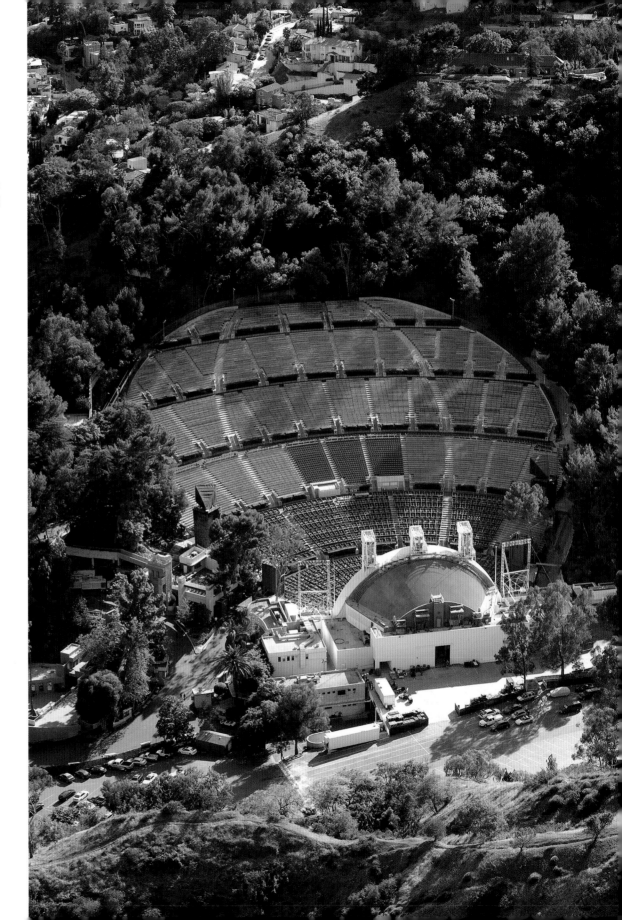

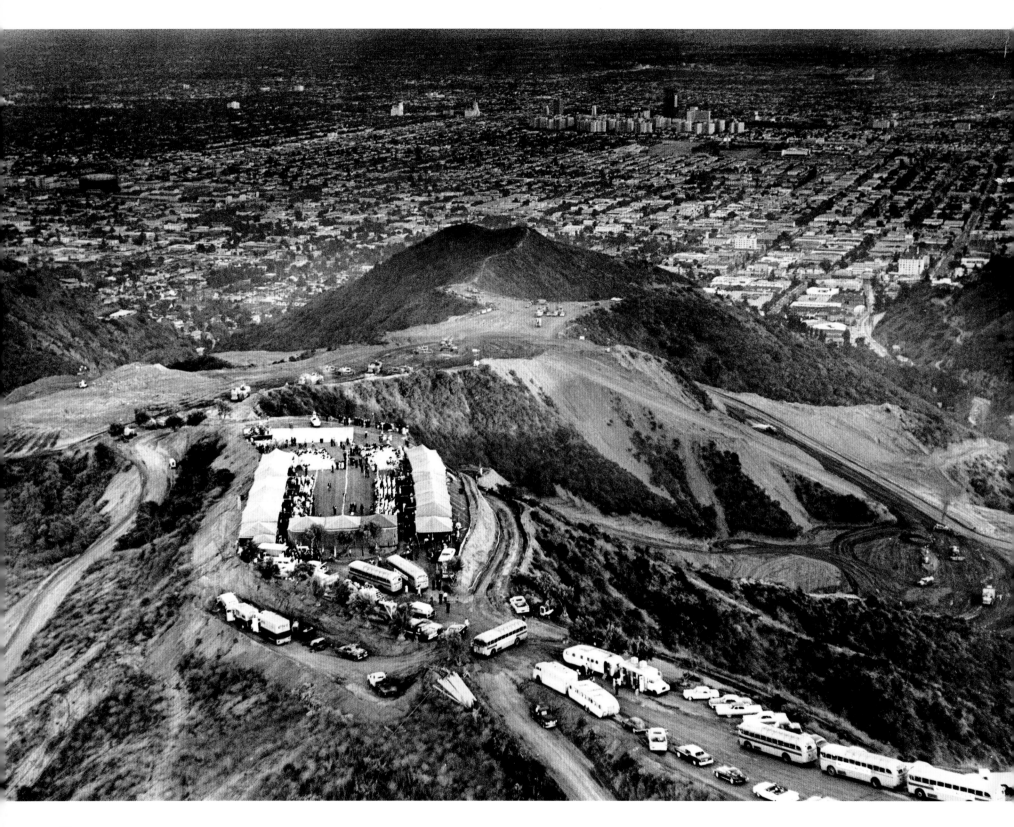

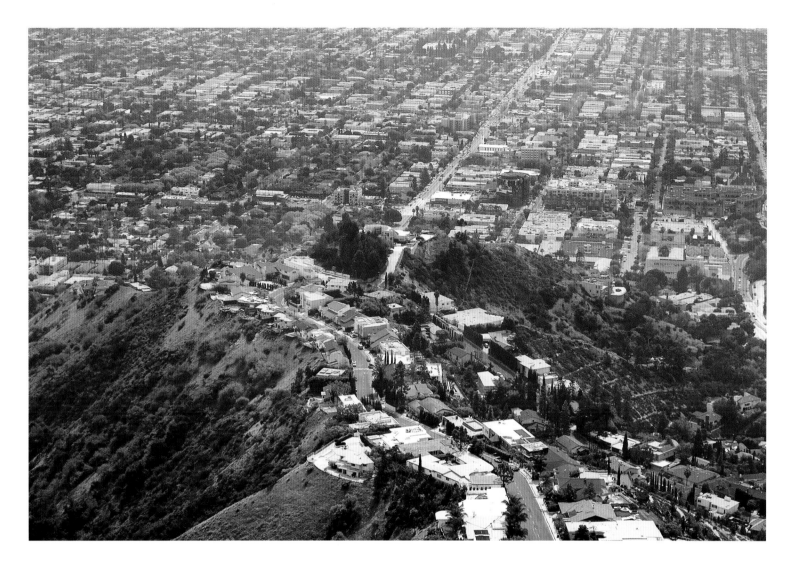

MOUNT OLYMPUS, LAUREL CANYON

Left: This aerial view taken on June 28, 1963, shows Mount Olympus as the first of 2,500 guests arrive at the hilltop's "housewarming party." The 300-acre development boasted $150,000 homes some 1,500 feet above sea level near Laurel Canyon Boulevard and Mulholland Drive. This view looks southeast toward the Park La Brea Towers at the top right. The neighborhood was attractive to movie stars who sought a place to escape the city life, including silent movie star Tom Mix. During the 1960s, the neighborhood garnered a counterculture cache as rock musicians such as Frank Zappa, Jim Morrison, the Byrds, and Buffalo Springfield moved in. The home immortalized in Joni Mitchell's song "Our House" stood in Laurel Canyon. Mitchell's third album, *Ladies of the Canyon*, was a reflection of the area and its inhabitants.

Above: The bohemian spirit of the 1960s continues in Laurel Canyon today. Many of the residents of those early days gather for an annual photograph that features an increasing number of gray hairs. In 1981 Laurel Canyon was the site of one of the worst sets of murders in California history. Four leaders of the Los Angeles cocaine trade known as the Wonderland Gang, named for Wonderland Avenue in the neighborhood, were bludgeoned to death in a grisly scene that implicated adult movie star John Holmes. The story of the murders was retold in the 2003 movie *Wonderland*. Laurel Canyon has been home to more sedate movie stars over the years, including Orson Welles, Meg Ryan, and Steve Martin, as well as not-so-sedate rock stars such as Trent Reznor, Marilyn Manson, and Iggy Pop. Many have come to recognize this view as one of the iconic views of downtown Los Angeles.

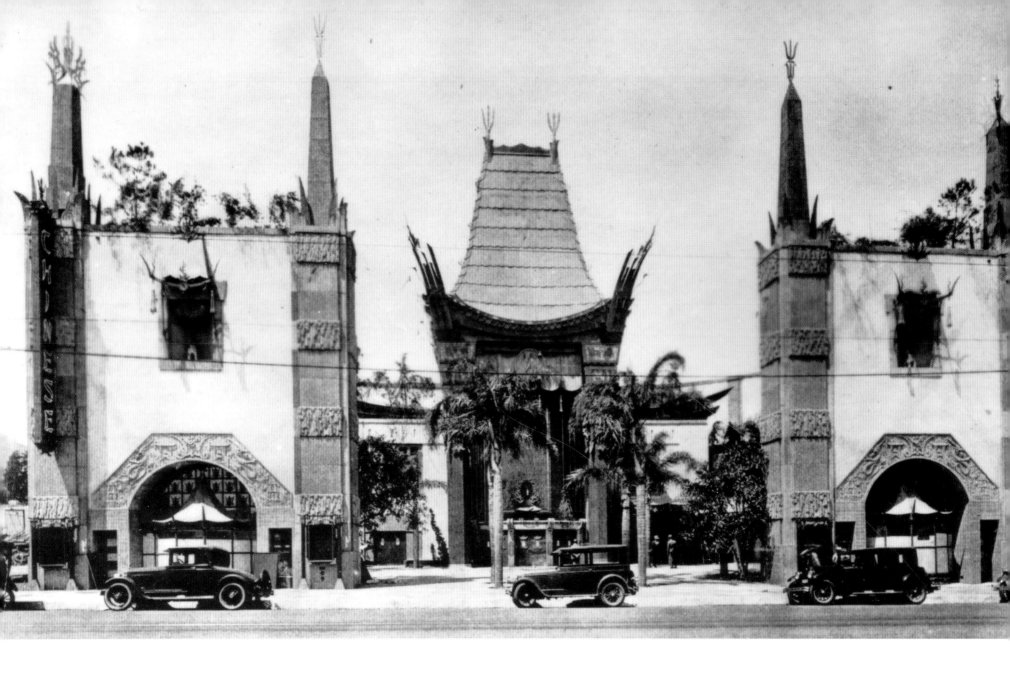

Grauman's Chinese Theatre opened on May 18, 1927. It was commissioned following the success of the nearby Grauman's Egyptian Theatre, which had opened five years earlier. At a cost of $2 million, the theater was to be Sid Grauman's masterpiece. The theater opened with the premiere of Cecil B. DeMille's film *The King of Kings*. The opening attracted thousands of people, and the crowd became unruly as fans tried to catch a glimpse of arriving movie stars and celebrities. Grauman spared no expense on the theater's decor. He imported temple bells, pagodas, and other artifacts from China with special permission from the U.S. government. The first footprint ceremony took place on April 30, 1927, when Mary Pickford and Douglas Fairbanks pressed their feet into squares of wet cement.

GRAUMAN'S CHINESE THEATRE

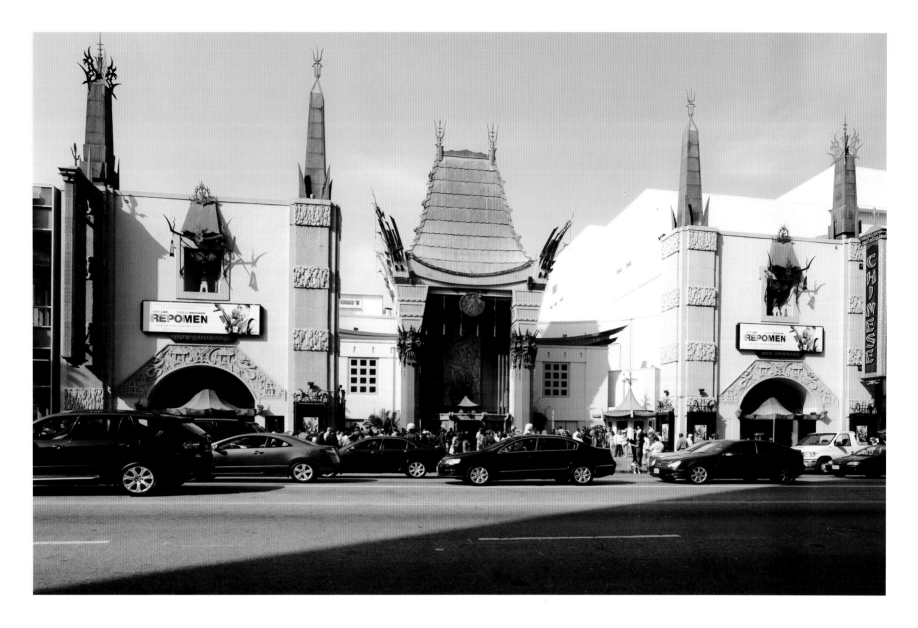

Ever since that sidewalk-shaping event in 1927, the stars of yesterday and today have left their footprints in the sidewalks near the theater. Little has changed at 6925 Hollywood Boulevard. Grauman's remains a much sought-after venue for studio premieres, and more than four million tourists visit its cement handprints and footprints in the forecourt every year. The theater is steeped in Hollywood tradition. The two original giant "Heaven Dogs" brought from China still guard the theater's entryway. Following the Northridge earthquake of 1994, an extensive retrofit design was implemented. Of late, the theater has been undergoing a major restoration, timed with the opening of the new Mann Chinese 6 Theatre and the Hollywood and Highland Mall. No visit to Hollywood is complete without stepping off the red carpet and walking through the golden doors of this movie palace of the stars.

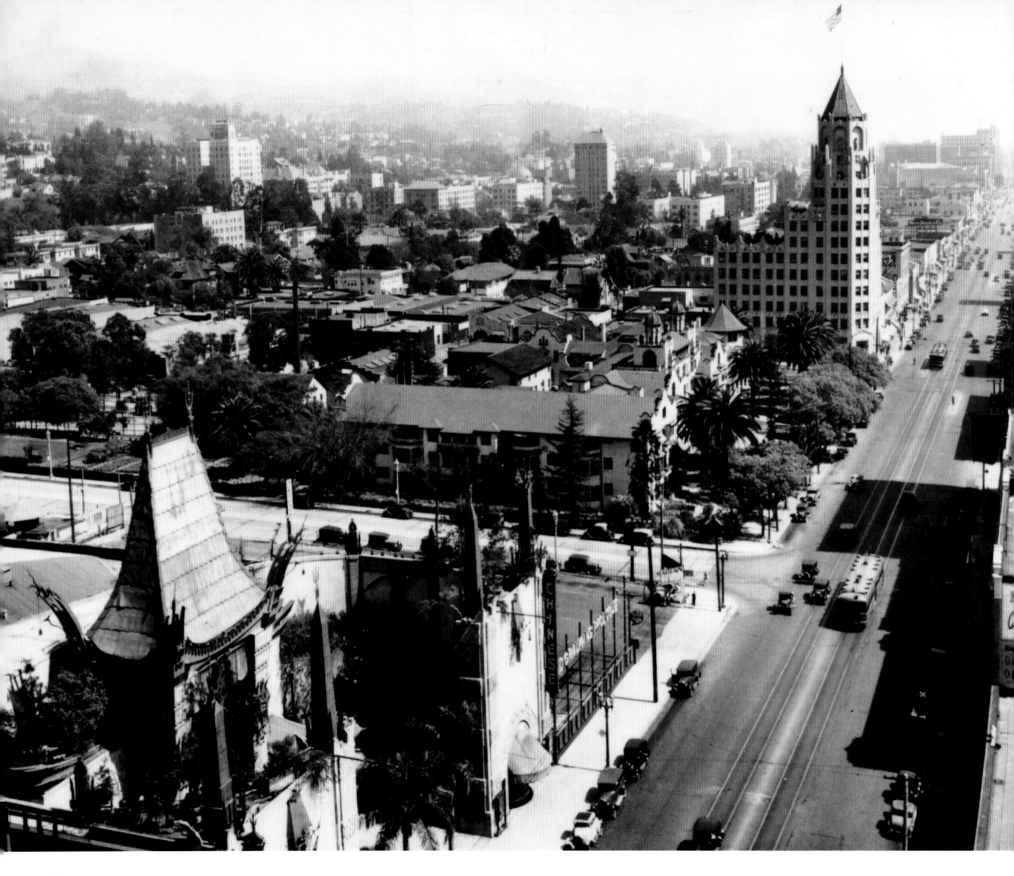

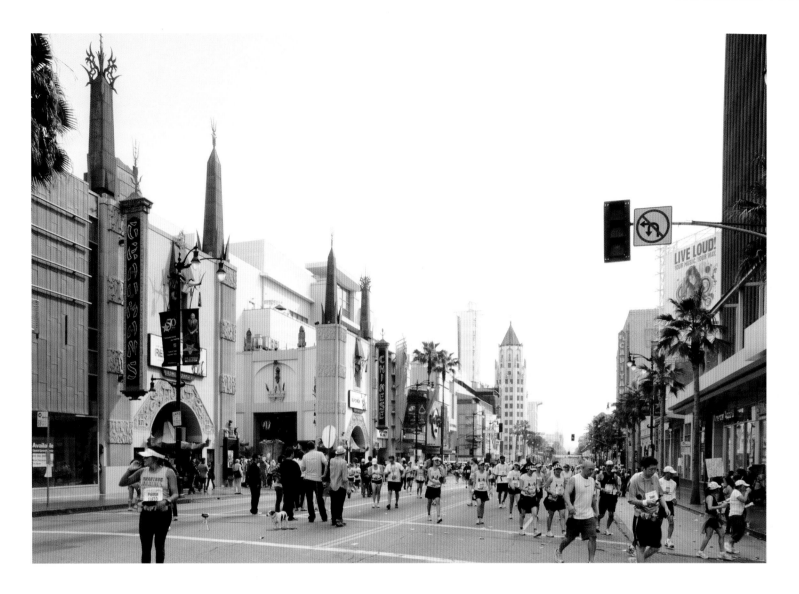

HOLLYWOOD BOULEVARD

Left: Grauman's Chinese Theatre, the Hollywood Hotel, and the Southwest Trust and Savings Building stand on the north side of Hollywood Boulevard near North Highland Avenue in this 1930s photo. In 1902 Hobart Johnstone Whitney built the Hollywood Hotel, the oldest of the three structures, when Hollywood Boulevard was a dirt road lined with pepper trees. Whitney was the pioneer Realtor who coined the name "Hollywood." His grave at the Hollywood Forever Cemetery is inscribed "The Father of Hollywood." The architectural firm of Meyer and Holler designed Grauman's Chinese Theatre, which opened on March 27, 1927. The firm also designed the thirteen-story Southwest Trust and Savings Building, which opened the same year. A pair of Pacific Electric streetcars was plying Hollywood Boulevard when the picture was taken.

Above: Participants in the Los Angeles Marathon stream past Grauman's Chinese Theatre. A child of the 1984 Olympics that was held in Los Angeles, the marathon has been an annual event since 1986. Seen here are just some of the million-plus spectators who come to cheer on the runners. In 2007 the marathon featured a new course that begins at Universal Studios, Hollywood, and runs past landmarks like Grauman's. The Hollywood and Highland Mall that replaced the Hollywood Hotel, and the tower of the Southwest Trust and Savings—today's First National Bank Building— provide a backdrop for the runners. Today, rather than catching the streetcar, visitors to Hollywood Boulevard board the Metro Red Line and disembark at the Hollywood/ Highland station, located just below the shopping center of the same name.

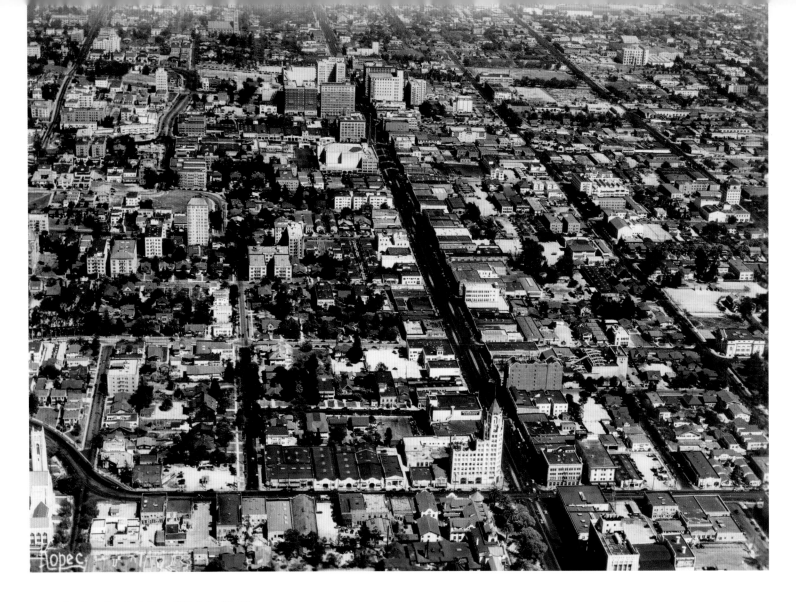

HOLLYWOOD BOULEVARD

Above: This aerial view captured Hollywood Boulevard as it appeared in the late 1930s. The photographer was looking east toward Vine Street from North Highland Avenue. North Highland swung into the picture on the left, where the First United Methodist Church pokes its steeple into the photograph. The Gothic/Art Deco–style Southwest Trust and Savings Building at Hollywood and North Highland stood as the tallest building in the city until 1932, when the Los Angeles City Hall was built. The Hollywood Hotel was located across Highland, below the Southwest Trust and Savings Building in the photograph. Grauman's Egyptian Theatre was to the east and across from the bank. In 1922 the Egyptian Theatre staged Hollywood's very first premiere with *Robin Hood*, starring Douglas Fairbanks.

Right: Highway 101, which locals call the Hollywood Freeway, intrudes into the photograph in the upper left. The freeway opened in the 1950s to replace the streetcars that once plied Hollywood Boulevard; it carries traffic from downtown Los Angeles, past the Hollywood Bowl, up through Cahuenga Pass, and into the San Fernando Valley. The Capitol Records Building, built in the late 1950s, is at the top left, near the freeway. The Hollywood and Highland Center stands where visitors once spent the night at the Hollywood Hotel. Today, much of the movie industry has dispersed into surrounding areas like the Westside neighborhood, but support industries such as editing, effects, props, postproduction, and lighting remain in Hollywood. During the 1960s and 1970s, Hollywood suffered serious decline. Many starstruck hopefuls found that Tinseltown had lost its sheen when they arrived at the place where dreams come true.

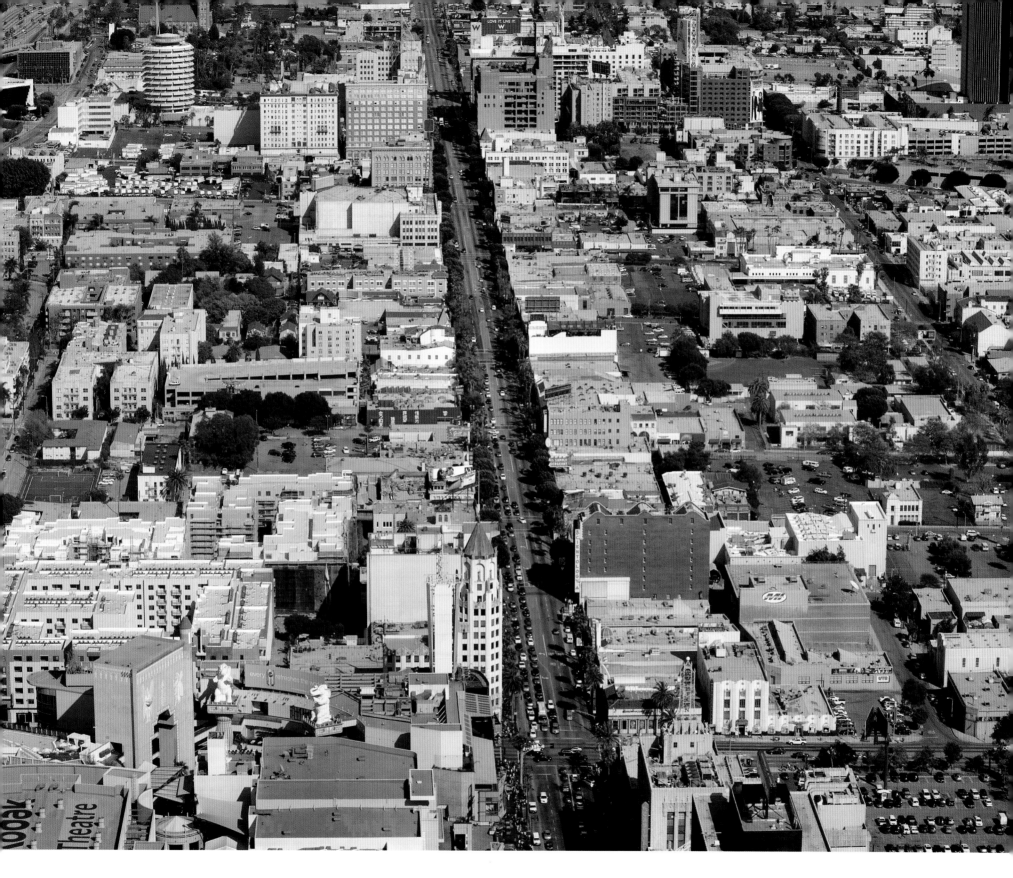

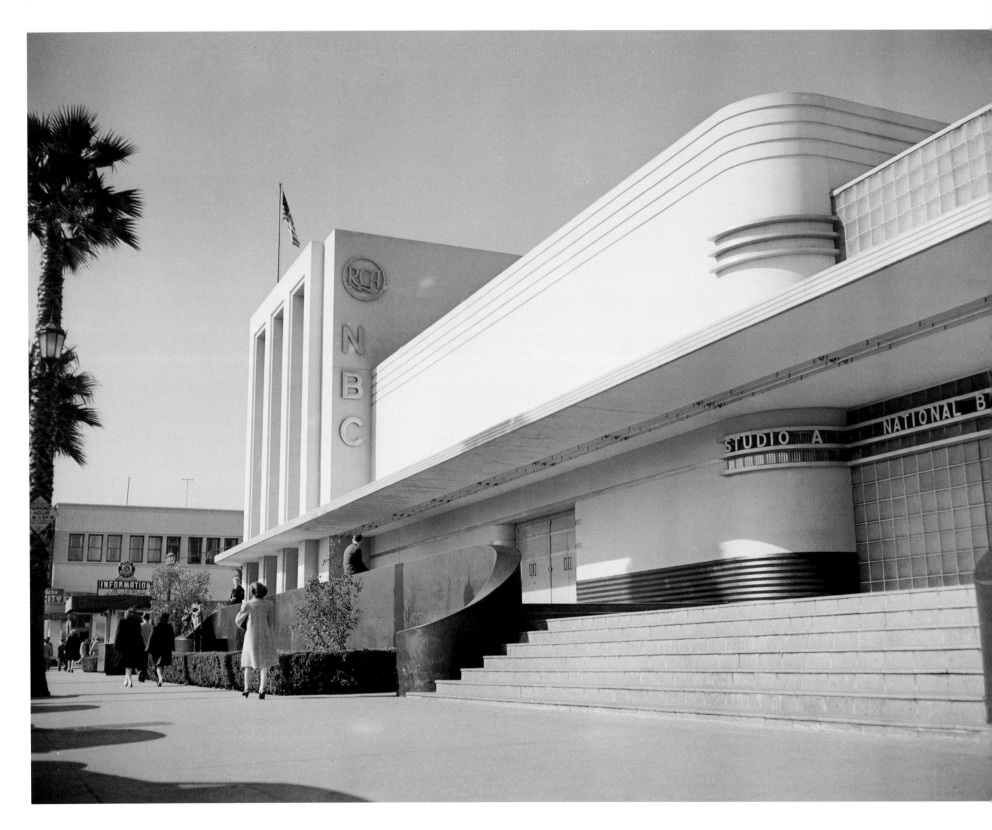

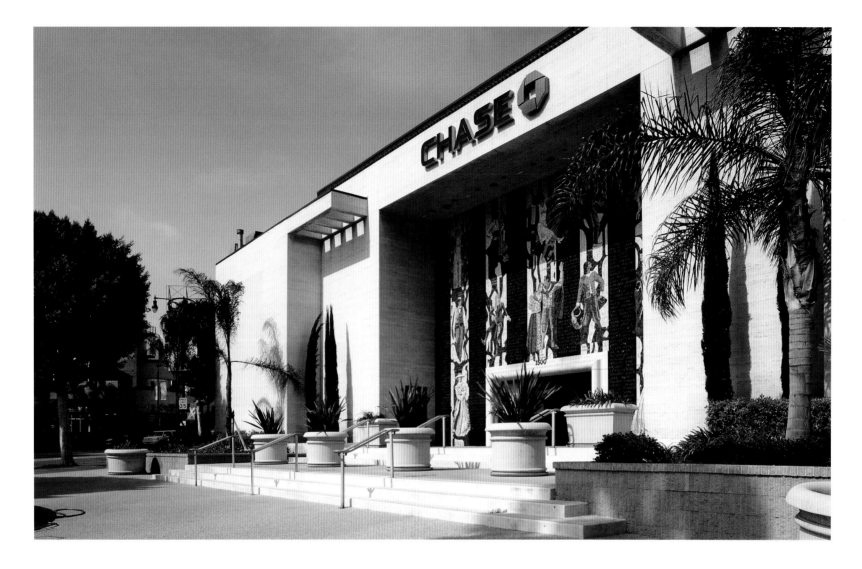

NBC BUILDING

Left: The National Broadcasting Corporation (NBC) opened its Art Deco–style studios between Sunset and Hollywood boulevards at Vine Street in 1938, about the time of this photo. This building replaced a 1927 facility in San Francisco that had managed the company's West Coast operations since its founding. In a reference to a nickname from its New York studio, NBC placed the words "Radio City" on the front of the building. Soon the area around the building was known as Radio City. Many radio studios and businesses sprang up, and radio was king of Hollywood—at least for a while. Hollywood's radio stations had the benefit of convenient access to stars like Bing Crosby, Jack Benny, and Bob Hope. A block away, the Columbia Broadcasting System (CBS) opened and the American Broadcasting Corporation (ABC) studios set up shop a few doors north on Vine.

Above: The days of visitors to Radio City's touring studios, giant control rooms, and other behind-the-scenes features of radio production are long gone. NBC launched a television station—KNBH, now KNBC—from this building in January 1949. The studio became obsolete in the era of color television and KNBC moved to its new Burbank facilities in 1962; the building was demolished two years later. Today a banking giant, rather than a broadcast heavyweight, occupies the space. The juxtaposition of the words "Hollywood" and "Vine" still keep their cachet. Nearby Capitol Records calls its Web site www.hollywoodandvine.com, and tourists from all over the world come to have their photographs taken beneath the street signs that mark one of the world's most recognizable intersections.

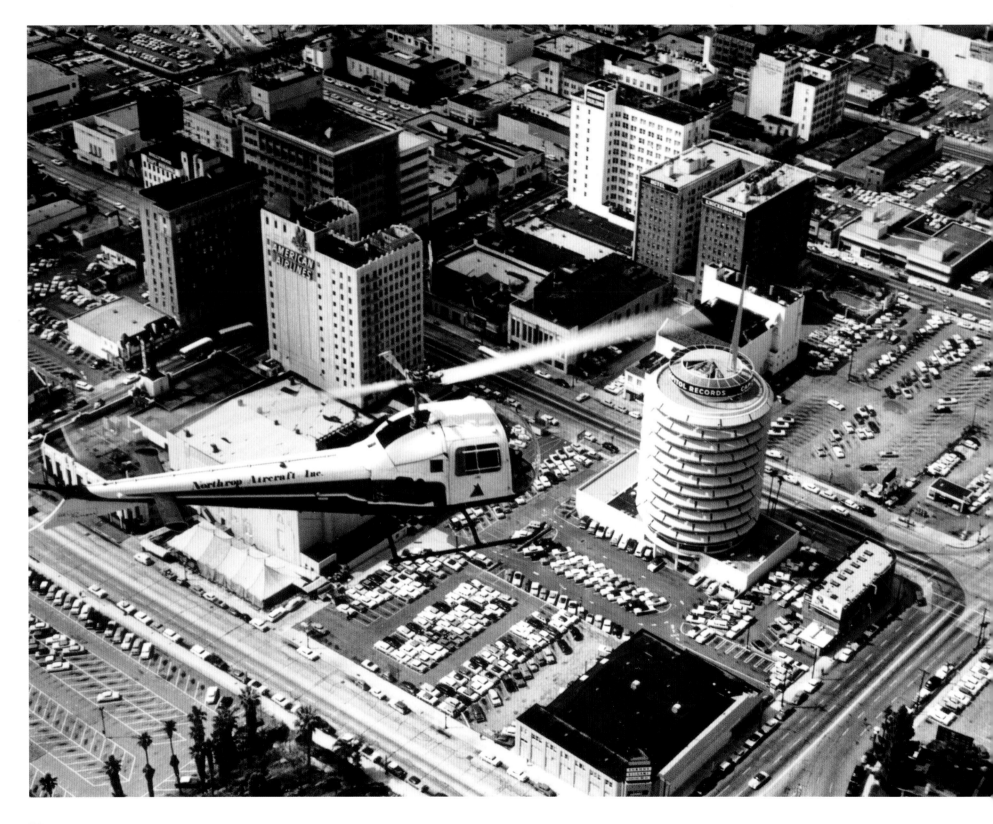

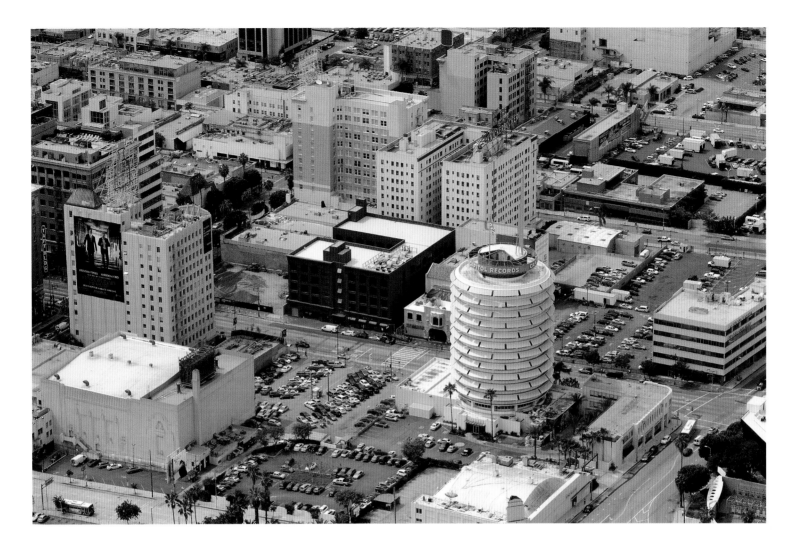

CAPITOL RECORDS BUILDING

Left: Architect Welton Becket designed the Capitol Records Building—also known as the Capitol Records Tower—shown here in a 1959 photograph. When the British company EMI acquired Capitol Records in 1955, it ordered construction of the building just north of the intersection of Hollywood Boulevard and Vine Street. While not designed as such, the wide, curved awnings around the cylindrical building and the spike on the roof make the structure resemble a stack of vinyl 45-rpm records on a turntable. The thirteen-story earthquake-resistant tower was the world's first circular office building. When the construction was completed in April 1956, Capitol Records president Alan Livingston decided to subtly advertise the company as the first record company on the West Coast. He set the blinking light atop the tower to spell out the word "Hollywood" in Morse code. He invited Samuel Morse's granddaughter, Lyla Morse, to flip the switch on the light at the opening ceremony.

Above: Little has changed in the landscape that makes up Vine Street between Hollywood Boulevard and Yucca Street. Today, the iconic office tower still houses the operations of Capitol Records, which singer Johnny Mercer founded in 1942. The building boasts studio facilities that include an echo chamber considered one of musical visionary Les Paul's engineering marvels. In 1992 the Morse code blinking pattern was changed to read "Capitol 50" to honor the label's fiftieth anniversary. The pattern has since returned to blinking out "Hollywood." In June 2008, a controversy erupted over a plan to build a condominium complex next door, igniting fears that noise from the building's construction would compromise the legendary echo chambers. The tower hasn't escaped cameos on the silver screen. In the 1974 film *Earthquake*, the tower collapses. In September 2006, EMI sold the building to a New York–based developer. It is now on the National Register of Historic Places.

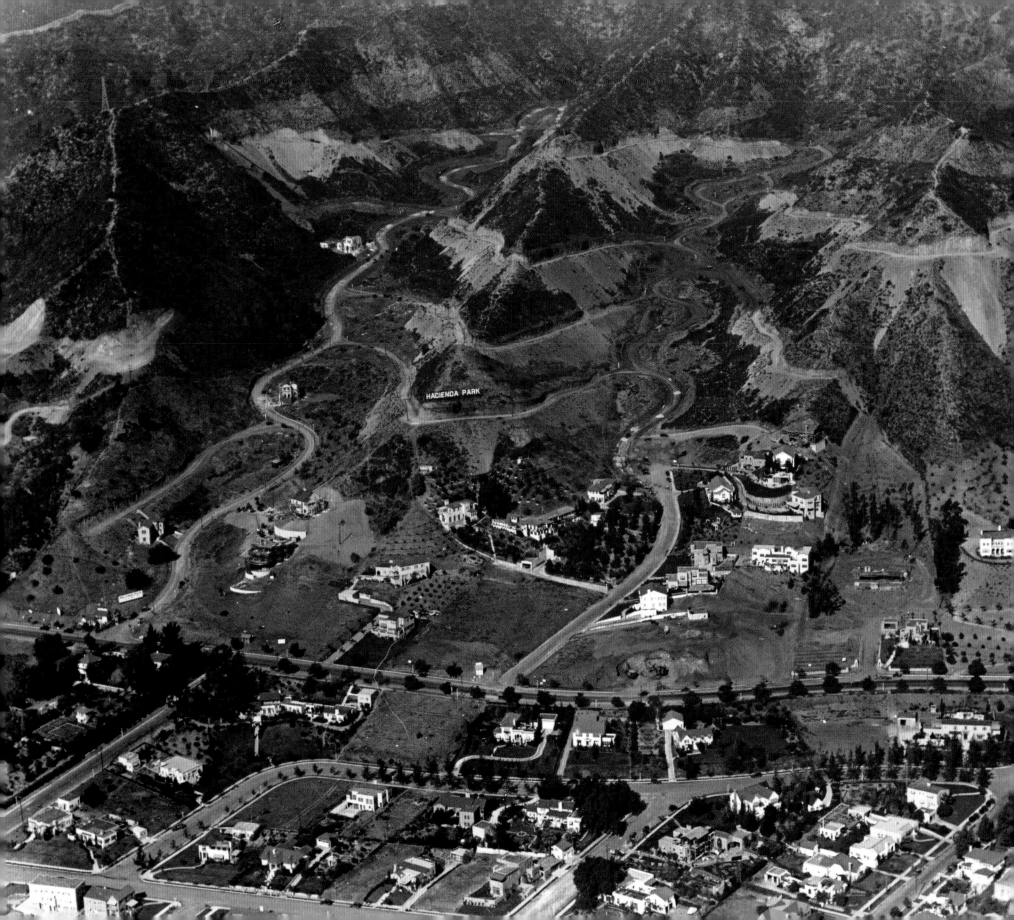

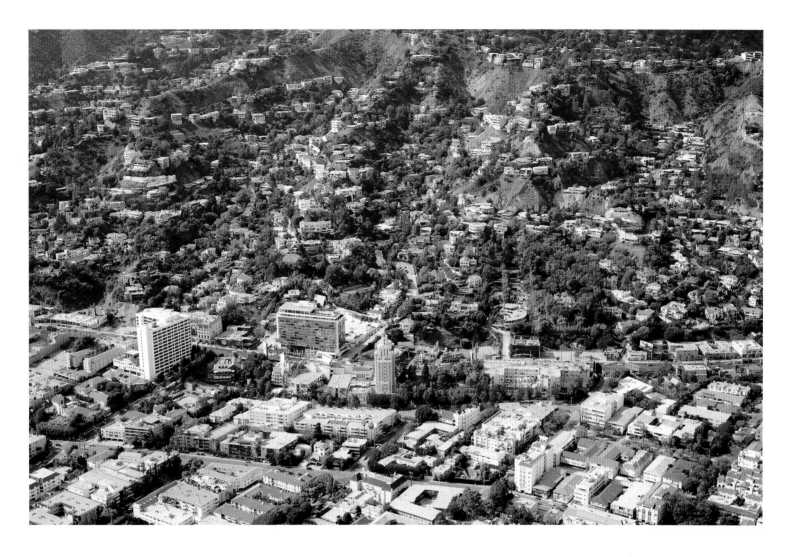

SUNSET BOULEVARD

Left: Roads are already snaking their way into nearly barren hills in this 1924 photograph. The hills form part of the Santa Monica Mountains, which stretch forty miles from the Hollywood Hills to Ventura County. The mountains form a natural barrier between the San Fernando Valley and the Los Angeles Basin. Sunset Boulevard defined the southern boundary of the Hollywood Hills neighborhood. North Kings Road stretched north from Sunset Boulevard into barren hills. Developers had already laid out the neighborhood, building Delongpre Avenue to parallel Sunset just to the south, starting at Sweetzer Avenue before it looped into Fountain Avenue. Sunset Boulevard lay in unincorporated Los Angeles County during the Roaring Twenties, which gave rise to its wilder nature. During Prohibition, clubs served alcohol to movie stars away from the watchful Los Angeles Police Department. Prohibition left its mark, however. By the time Prohibition was lifted, nightclubs had established themselves on the "Strip."

Above: The intersection of North Kings Road at Sunset Boulevard is now part of the Sunset Strip, which stretches along Sunset Boulevard from Sierra Drive in the west to Harper Avenue, which lies just one block to the east of North King. The Strip is known as the center of nightlife and is commemorated in a trio of pop-culture creations: Billy Wilder's Academy Award–winning movie *Sunset Boulevard*, Andrew Lloyd Webber's musical of the same name, and the 1960s television series *77 Sunset Strip*. Sunset Boulevard once extended farther east, but the portion east of Figueroa on the north end of downtown Los Angeles was renamed César Chávez Avenue to honor the late Mexican American labor leader. Along its nearly twenty-two miles, the boulevard passes near some of the finest addresses in the Los Angeles area, including Echo Park, Silver Lake, Los Feliz, Hollywood, West Hollywood, Beverly Hills, Holmby Hills, Bel-Air, Brentwood, and Pacific Palisades.

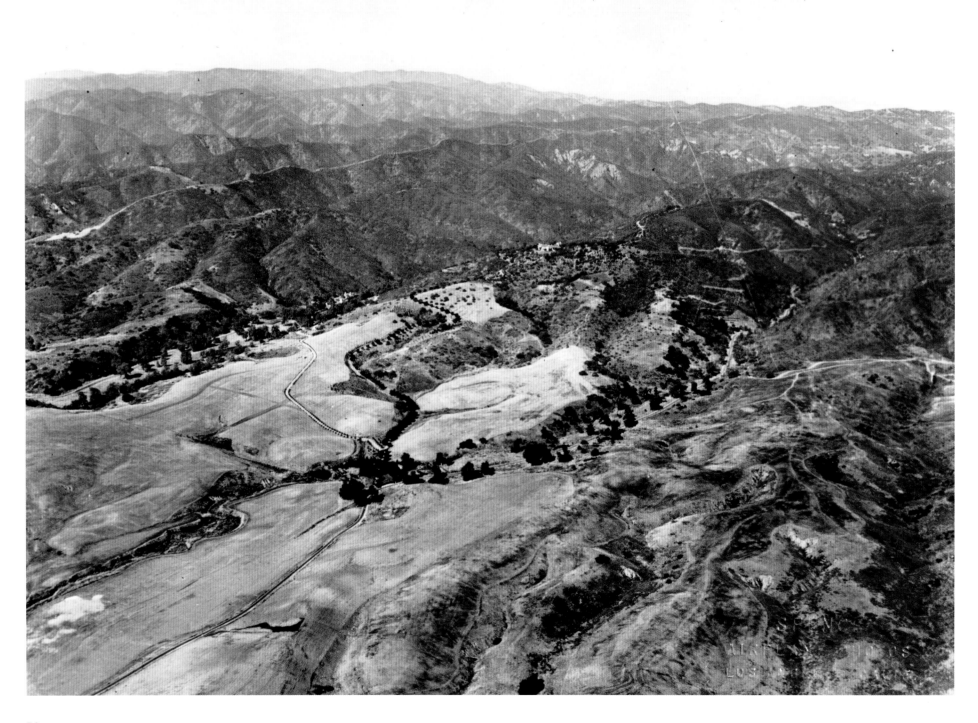

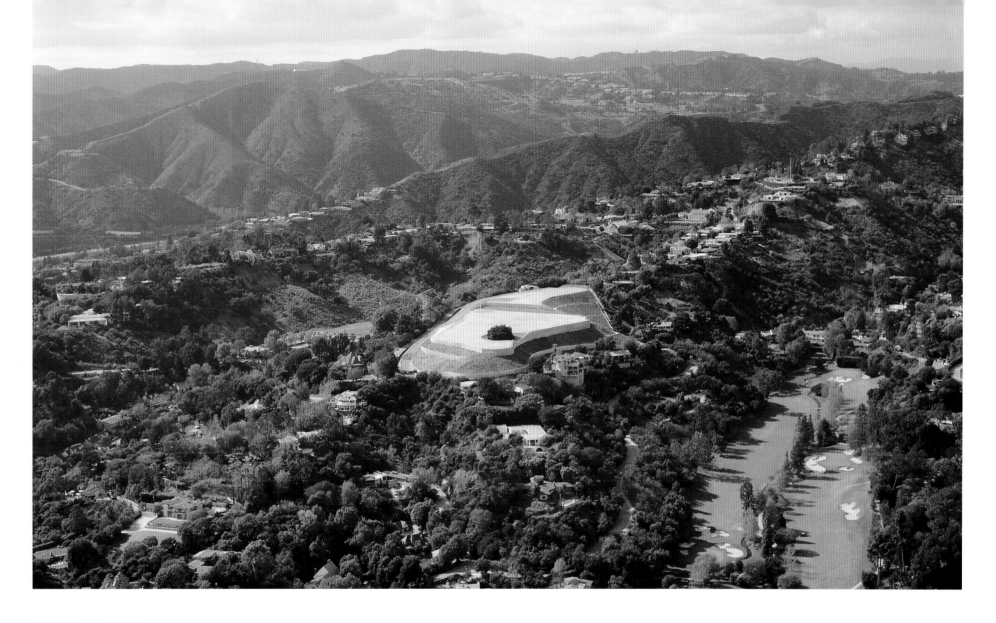

BEL-AIR

Left: Jay Morris "Jake" Danziger purchased a 600-acre slice of the Wolfskill Ranch in 1918 and built a Spanish-style mansion on his property. In 1922, about the time that Spence Air Photos Inc. snapped this picture, developer Alphonzo Bell purchased the estate. He named it and the adjoining 3,900 acres in his portfolio Bel-Air. Bell then hired engineer Wilkie Woodward to plan the subdivision. The project boasted underground utilities and estates with a minimum size of one acre. When Bel-Air opened in October 1922, residents could enjoy riding their horses on fifty miles of bridle paths. They lived in comfort, knowing that iron gates that still mark an impressive entry to their upscale neighborhood protected them from outsiders. Locals dubbed the 1961 fire that swept this area "A Tragedy Trimmed in Mink." The fire did $30 million in damage, scorching 16,090 acres and destroying more than 484 homes.

Above: The Chalon Project, with its panoramic views of Los Angeles and beyond, stands front and center here. The project boasts "contiguous dual flat pads," with a long, stately main drive and, naturally, a separate service drive/entry at the rear. The asking price was a mere $65 million. The upper lot allows for a 40,500-square-foot house, including a guesthouse. The lower lot allows for an approximately 55,000-square-foot auxiliary structure. To top it off, the new owner could boast of living on Chalon Road, arguably the most prestigious address in exalted Bel-Air, which joins Beverly Hills and Hornby Hills to form the "Platinum Triangle"—the most opulent neighborhoods in Los Angeles. Most of Bel-Air's nearly 8,000 residents live in a faux gated community. Many of the homes lie hidden behind hedges or fences and cannot be viewed from the street. No sidewalks have been built specifically to discourage pedestrians.

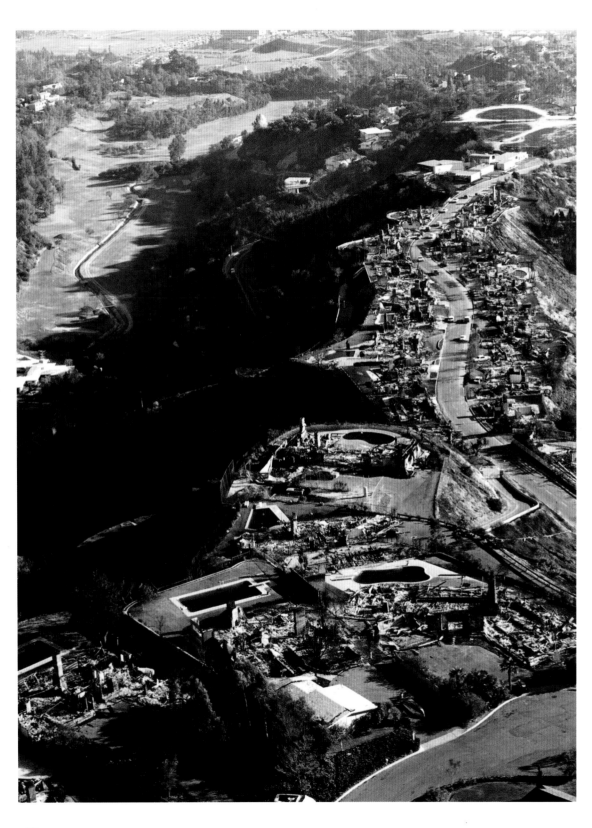

BEL-AIR FIRE

Fifty-mile-an-hour winds fanned a fire that began on the north slope of the Santa Monica Mountains on November 6, 1961. The windstorm blew flames that raced through tinder-dry vegetation across Mulholland Drive and down the south slope into Stone Canyon. Intense heat and the high-velocity winds it created pushed the fire around and through natural and man-made barriers. In the end the flames consumed some 6,090 acres of valuable watershed and incinerated 484 homes and twenty-one other buildings. J. R. Eyerman of Time-Life Pictures snapped this photograph that shows the fire's devastating aftermath in the hills about the Bel-Air Country Club. Eyerman's picture looks southwest with Linda Flora Drive and Orum Road in the foreground. Chalon Road stretches out to the circular drive in the distance. Chalon and Bellagio roads run just beneath the property on the left. Bellagio Road leads to the Bel-Air Country Club. The fairways to Bel-Air's prestigious George Thomas–designed golf course lie below Bellagio Road on the left.

Recovery is evident today. New homes have replaced the burned-out ruins the blaze created; golfers still play their rounds on the Bel-Air Country Club's golf course below. Chalon Road remains one of the most prestigious addresses in Bel-Air, which joins Beverly Hills and Hornby Hills to form the "Platinum Triangle." The circle that Chalon Road described in the 1961 fire has become the Chalon Project, arguably one of the more talked-about real-estate deals in recent memory. Developers created 11100 Chalon Road from three separate properties that encompass about eight acres. They hoped to sell the property for $65 million, but the poor real-estate market has driven the price to a more affordable $49 million. The project's contiguous dual flat pads with a long stately main drive and, of course, a separate service drive at the rear await a buyer. The upper lot allows for an approximately 40,500-square-foot house, including a guesthouse. The lower lot allows for a 55,000-square-foot auxiliary structure.

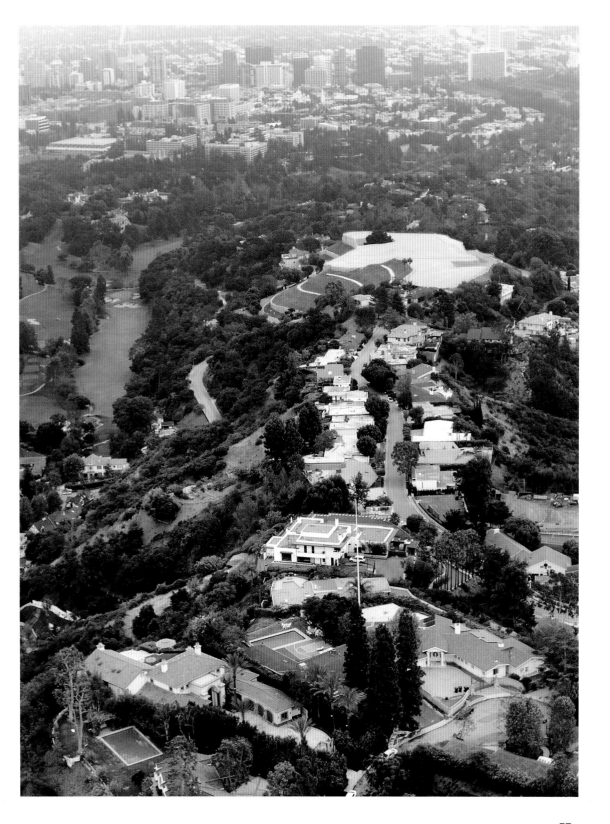

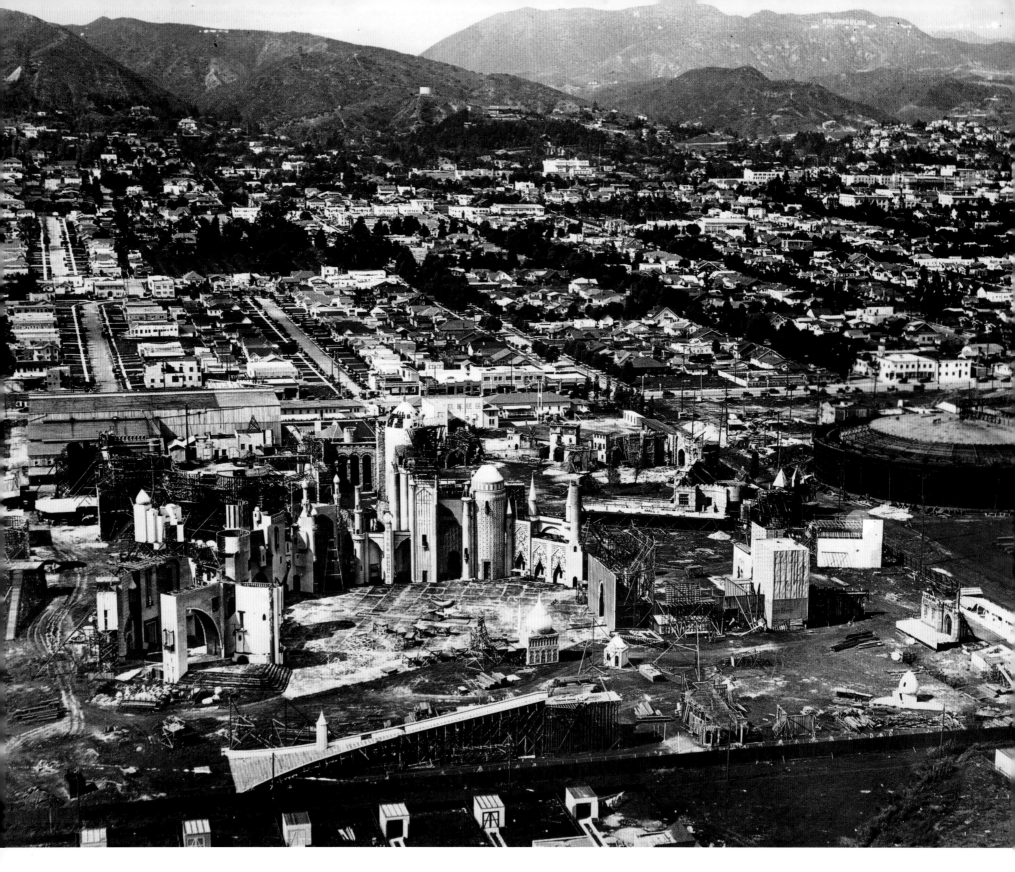

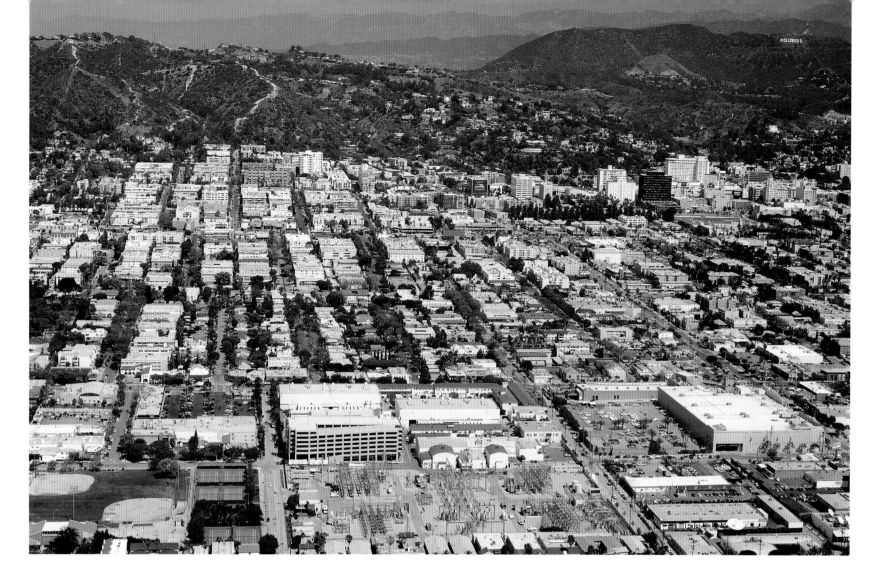

PICKFORD-FAIRBANKS STUDIOS

Left: The castle of the set for the movie *Robin Hood* helps date this photograph to 1922. This studio began as Hampton Studios when Jesse D. Hampton opened it to house his growing production company around 1918. Once Hampton moved to another locale, the "first couple" of Hollywood at the time, Mary Pickford and Douglas Fairbanks, purchased the studios. In 1919, along with Charlie Chaplin and D. W. Griffith, Pickford and Fairbanks founded United Artists and used this studio as a base of operations. The partnership was designed to give them creative control over their own productions. The stars set themselves a rigorous production schedule that was nearly impossible to maintain, as films were expected to run longer; the addition of sound soon made things even more hectic. Regardless, the studio released the classics *Robin Hood* and *The Thief of Baghdad*. The company added Howard Hughes, Walt Disney, and Samuel Goldwyn as independent producers, but still the business struggled. During World War II the group turned primarily to advocacy, forcing fair practices on large studios.

Above: The green-roofed studio buildings can be seen in the foreground. Since the days of Fairbanks and Pickford, the studio has changed hands many times. During the 1950s, United Artists' partner Samuel Goldwyn took over the facility, named it after himself, and it produced hits such as *Wuthering Heights*, *West Side Story*, *Guys and Dolls*, *Some Like It Hot*, and *The Little Foxes*. Warner Bros. purchased the studio in the 1980s and called it Warner Hollywood. Now featuring seven soundstages, the studio continues to be active, producing mostly television series. The studio was sold again in 1999 to BA Studios, a company that rents production facilities to Warner Bros. and other firms. Today the site is simply called "the Lot." Plans for the location include extensive renovations and the addition of an office tower. The television station KTLA also leases part of the facility.

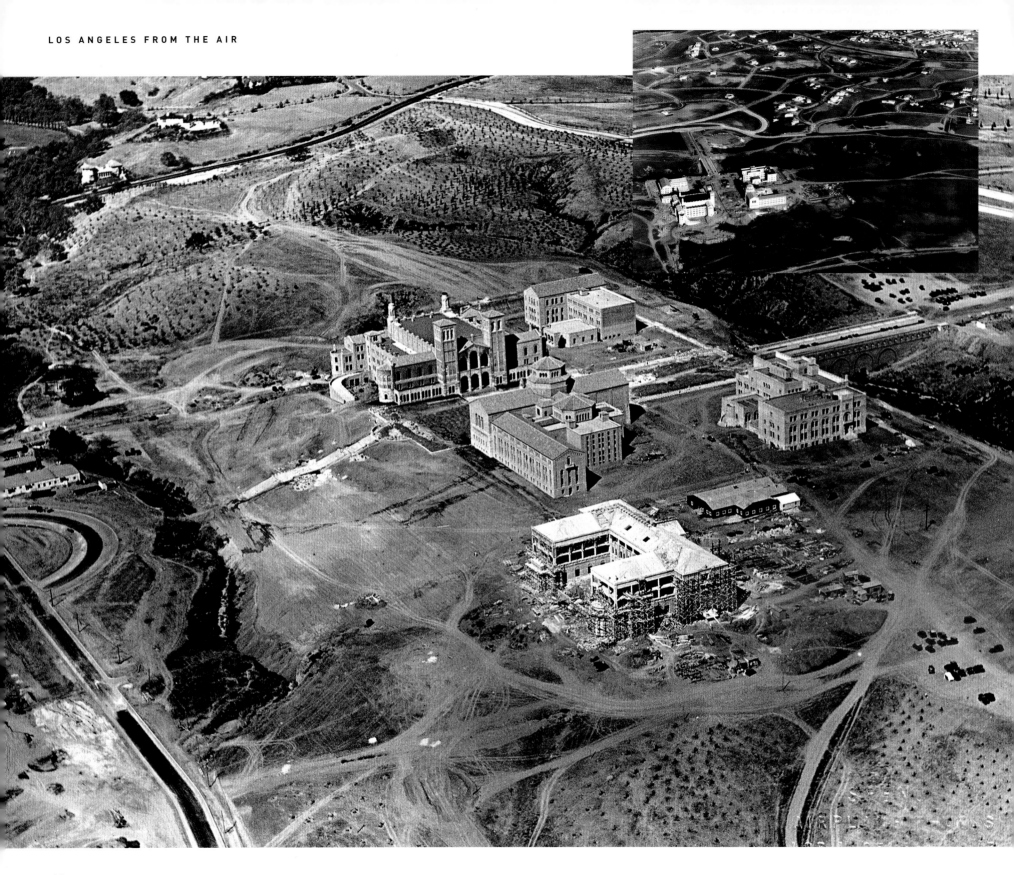

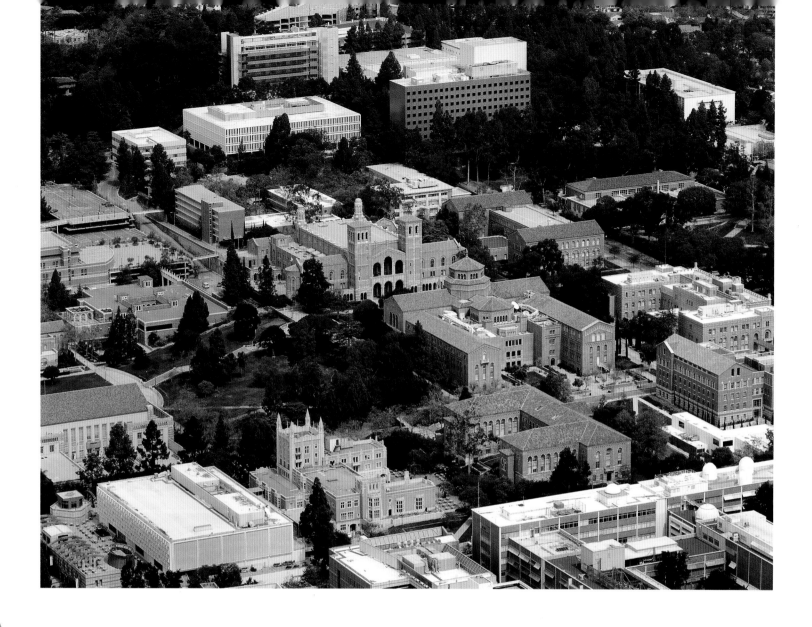

UCLA

Left: The University of California, Los Angeles (UCLA), seen here in 1929, is a public university founded in 1919. The school grew so fast that just a decade after its founding, it needed a larger campus. The new campus was undergoing construction in 1929, the year of this photograph. Architects designed all five campus buildings in the Romanesque Revival style. The first class to graduate at the new Westwood campus had 5,500 students. The first master's degrees were awarded in 1933, and the first doctorate in 1936. Royce Hall with its pair of steeples is seen at left center of the main photo; the domed Powell Library sits across from it. Haines Hall and Kinsey Hall are behind them, on the left and right respectively. The inset view of the nascent UCLA was taken from the Goodyear blimp in 1929; the view looks to the southeast.

Above: One nickname for UCLA is "Under Construction Like Always." The student population continues to grow, and construction and renovation projects are nearly continuous. Royce Hall and the Powell Library still anchor the heart of the campus. Currently underway are expansions of the life sciences and engineering research complexes. With its 8.2 million volumes, the UCLA library system stands among the top ten libraries in the United States. The school boasts more applicants than any other university in the nation. With just four buildings at its onset, the campus now has 163 buildings to serve its student body. Campus amenities include sculpture gardens, fountains, museums, and, a mile from campus in Bel-Air, a Japanese garden. Later additions to the campus landscape include Pauley Pavilion, which opened in 1966 and seats 12,500.

UCLA AND WILSHIRE BOULEVARD

The main photo shows a row of Wilshire Boulevard's skyscrapers in all their glory running along the right-hand side. In the foreground lies the green swath of the Los Angeles National Cemetery, final resting place of several Medal of Honor recipients, more than a hundred buffalo soldiers, and Nicholas Porter Earp, father of the famous Wild West lawman Wyatt Earp. The UCLA campus spreads out behind the cemetery with the Ronald Reagan UCLA Medical Center's matching office buildings standing out in white. The row of skyscrapers begins at the western end with the Federal Building, 11000 Wilshire Boulevard, home to the FBI's Los Angeles field office and the local passport agency. A striking new residential tower, Beverly West Residences, stands out at the eastern end of the row. This set of skyscrapers lies distinctly separate from Wilshire's Miracle Mile, which is just outside the photograph to the right. The Los Angeles Country Club separates these buildings from the more famous set closer to Hancock Park. The photo below shows the view toward the sea.

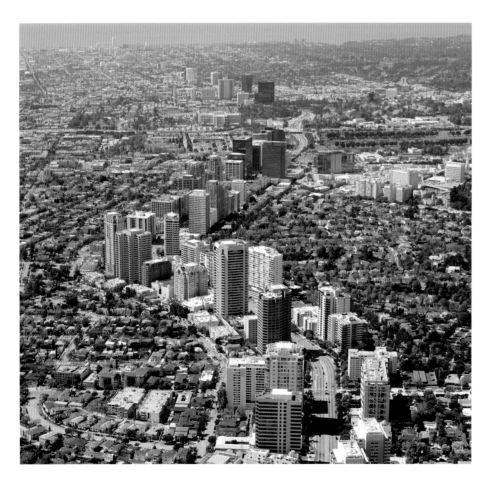

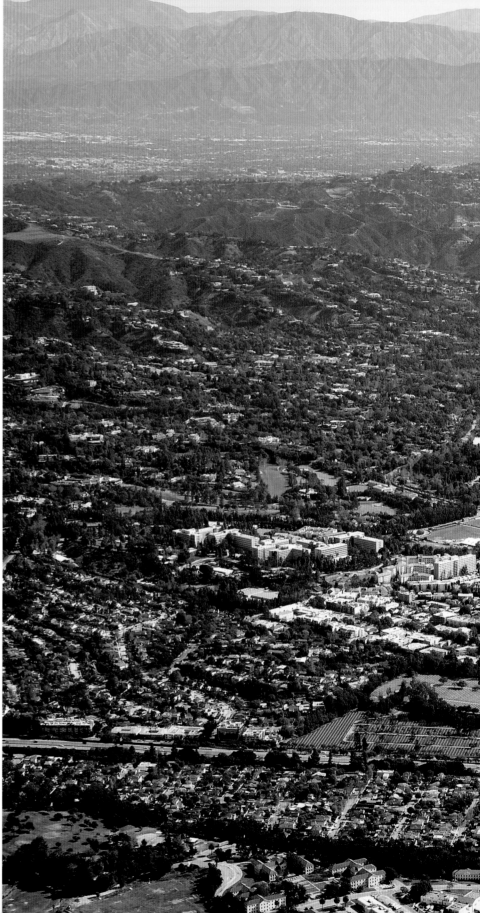

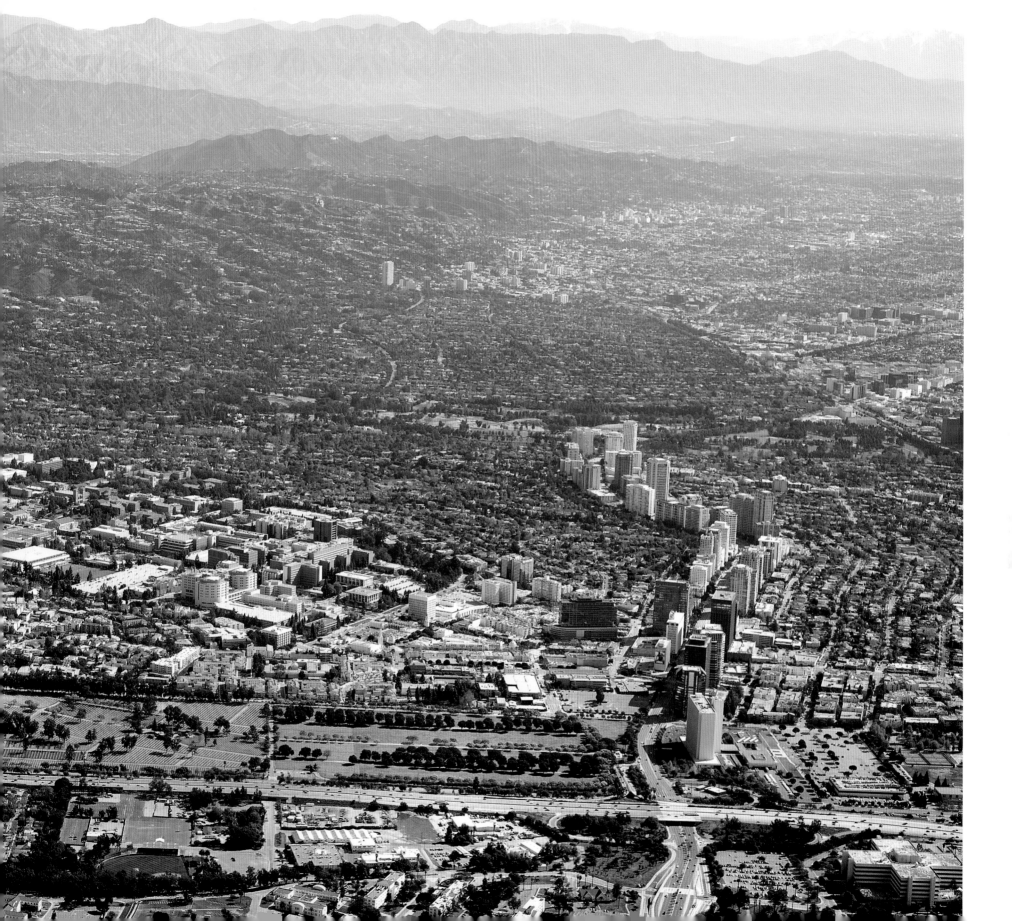

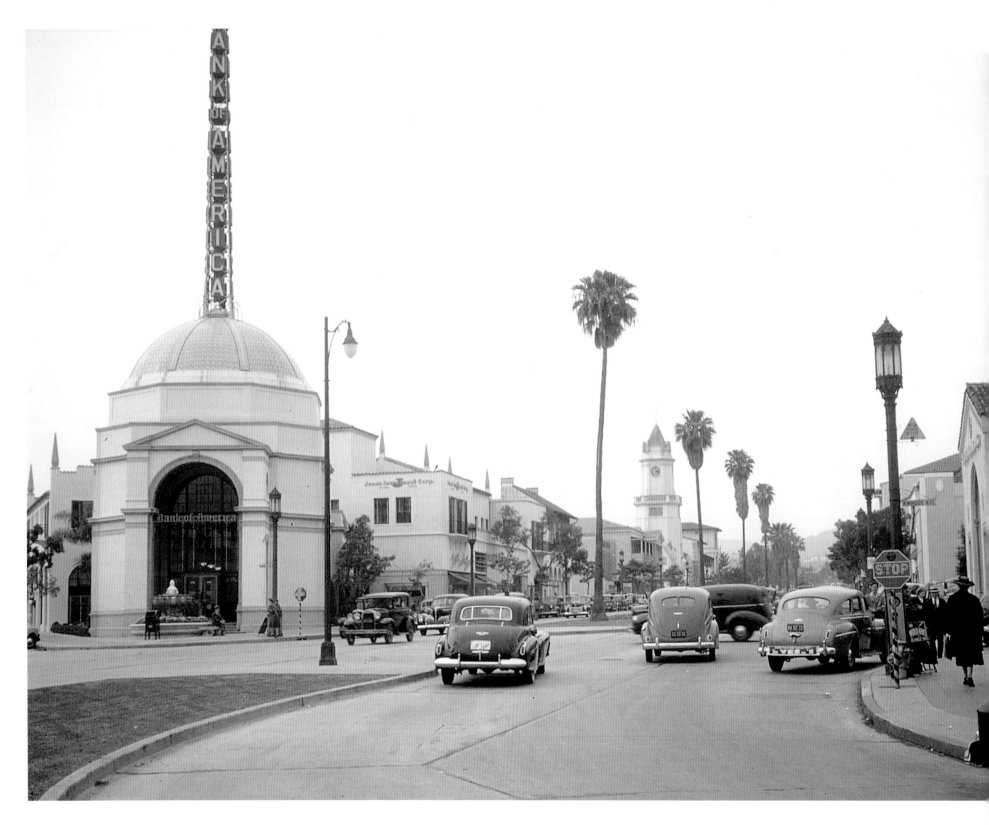

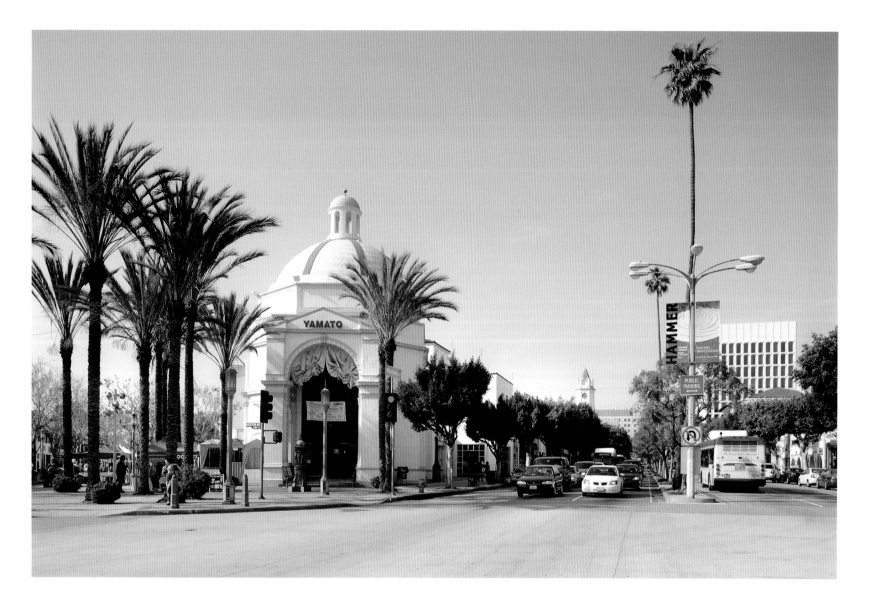

BANK OF AMERICA

Left: The Bank of America occupied the Janss Investment Company Building—also called the Janss Dome—when this photograph was taken in 1941. The building, at the intersection of Westwood Boulevard with Kinross and Broxton avenues, served as the headquarters of the Janss Investment Corporation, the developer of Westwood Village. The company sold 350 acres adjoining their village of Westwood to the cities of Los Angeles, Santa Monica, and Beverly Hills for the new campus of UCLA. The land was partially donated at the price of $1.2 million, just a quarter of their true value. The cities then donated the land back to the state. The Bank of America branch shown here was a target of frequent student protests during the 1960s.

Above: The Janss Dome has found other uses. For a while it served as the first male dormitory for the university. The building has housed a Glendale Federal Savings Bank, a record store, a clothing store, and a restaurant. A key landmark of Westwood, it was dedicated as a Los Angeles Historic-Cultural Monument in 1988. In 1990 the building was turned into the clothing store Contempo Casual; a Wherehouse Music store later occupied the premises. In 1998 restaurateur Michael Chow remodeled the building for his Eurochow restaurant. Today, the Janss Dome is home to the Yamato Japanese restaurant.

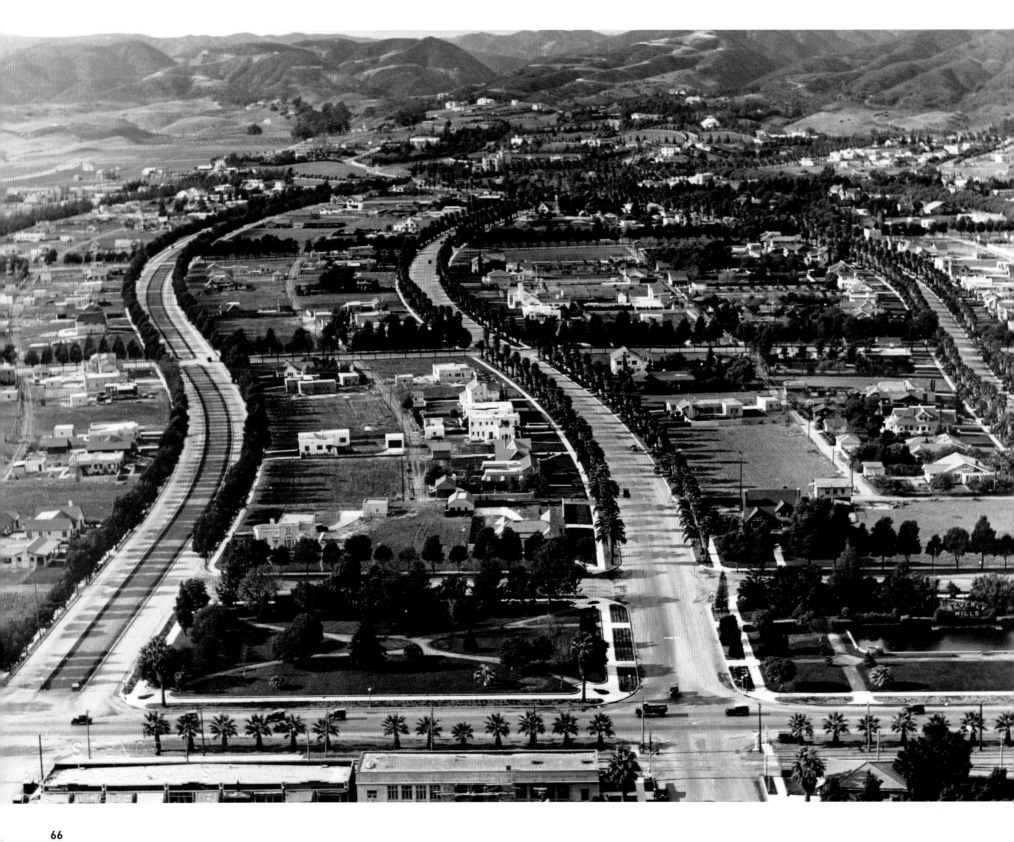

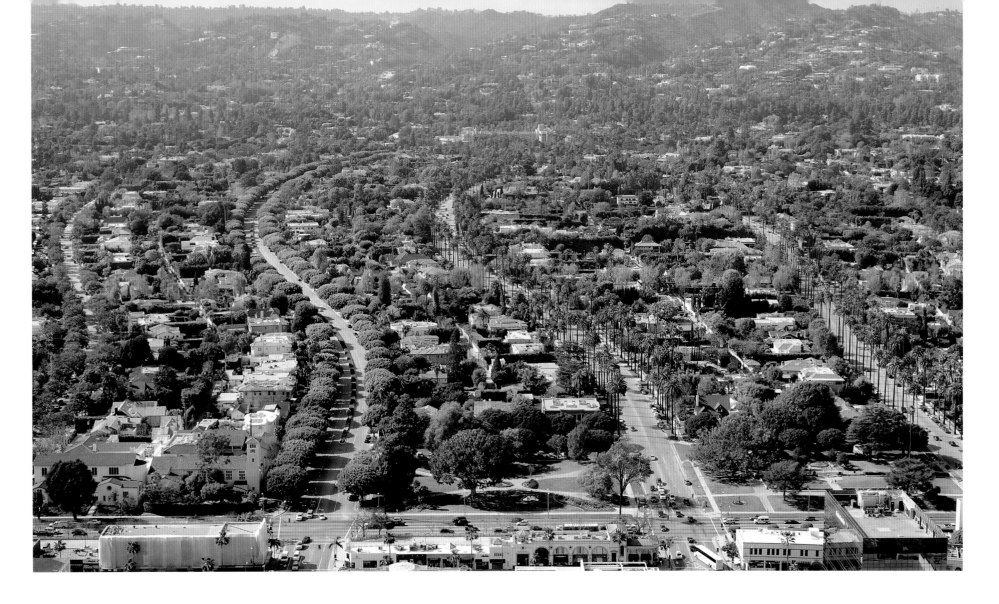

RODEO DRIVE

Left: In 1906 Amalgamated Oil president Burton Green purchased this property and drilled for oil. When that failed, he drew plans for a mixed-use subdivision. With a nod to Rancho Rodeo de las Aguas, which originally stood on the land, he and his associates named their company the Rodeo Land and Water Company and the development's main street Rodeo Drive. Looking south in this 1921 photograph, the Beverly Hills Hotel on Sunset Boulevard sits across from Will Rogers Memorial Park. Beverly Drive to the left, Canon Drive on the right, and Rodeo Drive on the far right arch their way to Santa Monica Boulevard. Land sales took off in 1910 and the community's first homes sprang up. Two years later, the Beverly Hills Hotel, the large building in the center of this photograph, opened and became the hub of social life in the area.

Above: The current Rodeo Drive shopping district began evolving in the 1970s. Giorgio Armani, Cartier, Chanel, Tiffany, Ralph Lauren, Hugo Boss, and Gucci grace the district; many of the most celebrated fashion designers of the world retail here. Designer Bijan's eponymous boutique has been called "the most expensive store in the world." One must have an appointment just to shop there. Once inside, customers are unlikely to spend less than $100,000 on men's fashions. When people think of Rodeo Drive today, they may picture Via Rodeo, a raised pedestrian thoroughfare that harkens back to a quaint Italian backstreet. Cobblestone streets, a blend of classical styles, romantic fountains, and wrought-iron streetlamps create almost a movie-set backdrop for shopping. Tourists often gather for photos at the Spanish Steps at one end of Two Rodeo, essentially an outdoor mall near the intersection of Wilshire Boulevard and Rodeo Drive.

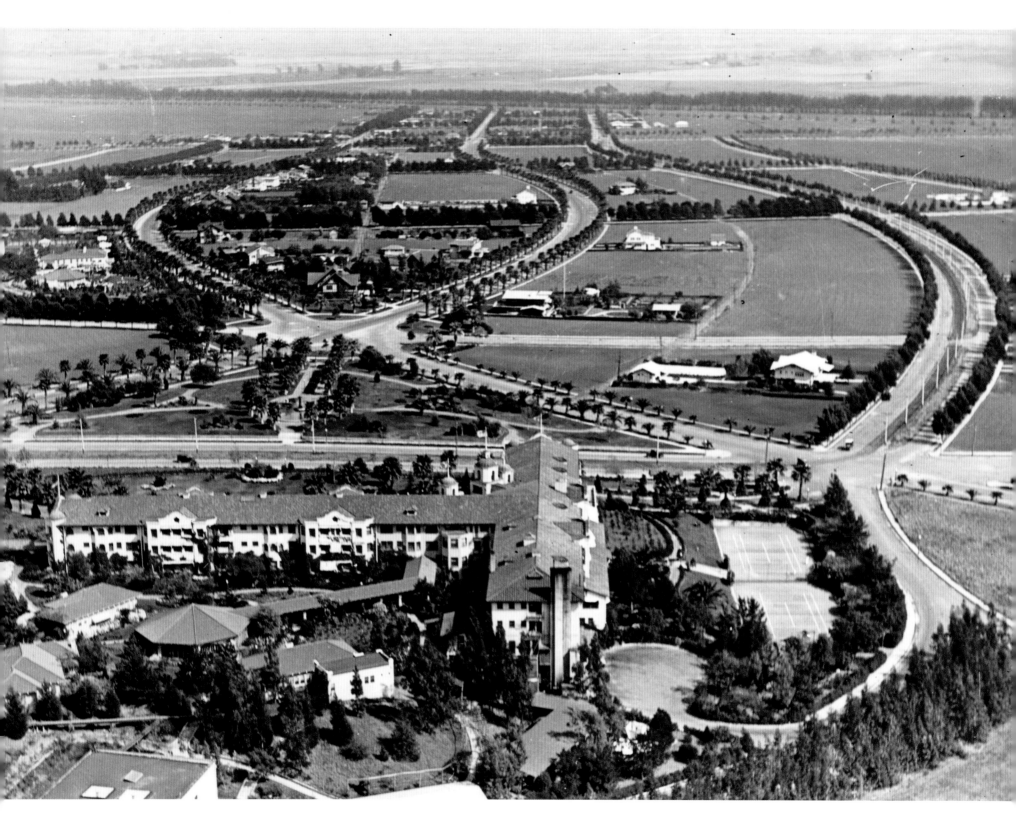

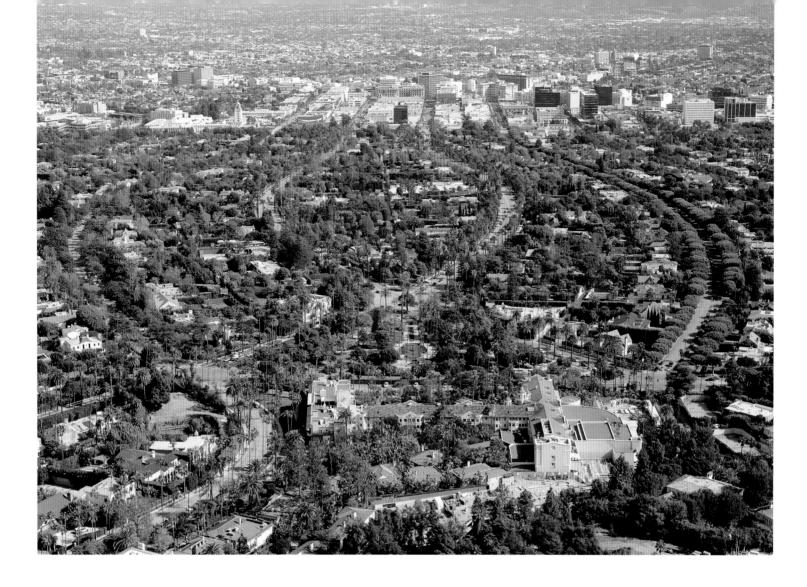

BEVERLY HILLS

Left: This circa 1920 photograph of Beverly Hills centers on the Beverly Hills Hotel that architect Elmer Grey designed in the Mission Revival style. The hotel was built between 1910 and 1911. The native Tongva tribe called this area "Meeting of the Waters." The Tongvas welcomed the first Spanish settlers in 1769, but the newcomers brought diseases that nearly wiped out the natives. The Mexican governor of California granted this area to Doña Maria Rita Valdez de Villa, the widow of a Spanish soldier, as Rancho Rodeo de las Aguas. An early feminist icon, Maria Rita ran her rancho like many of the men of the time, letting her massive herds of cattle run loose, except for the annual roundup under a eucalyptus tree that stood at today's Pico and Robertson boulevards. After an Indian raid in 1850, Maria Rita sold her property to American investors. The land was used for farming and sheep and cattle grazing, and even some oil speculation took place here.

Above: Beverly Hills began to blossom as a modern settlement in 1900 when the Amalgamated Oil Company commissioned a new round of oil exploration in the area. After struggling to find oil, they reorganized as the Rodeo Land and Water Company in 1906. One of the company's partners, Burton Green, and his wife wished to remember a prior home—Beverly Farms, Massachusetts—and renamed the area Beverly Hills. Green hired landscape architect Wilbur D. Cook to design a new subdivision. Cook, who was influenced by Frederick Law Olmsted, created a street pattern that followed the natural landform and the first streets: Rodeo, Canon, Crescent, Carmelita, Elevado, and Lomitas. Around 34,000 people live in Beverly Hills today. The daytime population is estimated to be 150,000 to 200,000 as employees and shoppers commute in to create the city's notable economy. The city's business and commercial base put it alongside cities several times its size. Beverly Hills provides public schools, public safety departments, sanitation, and water separate from Los Angeles.

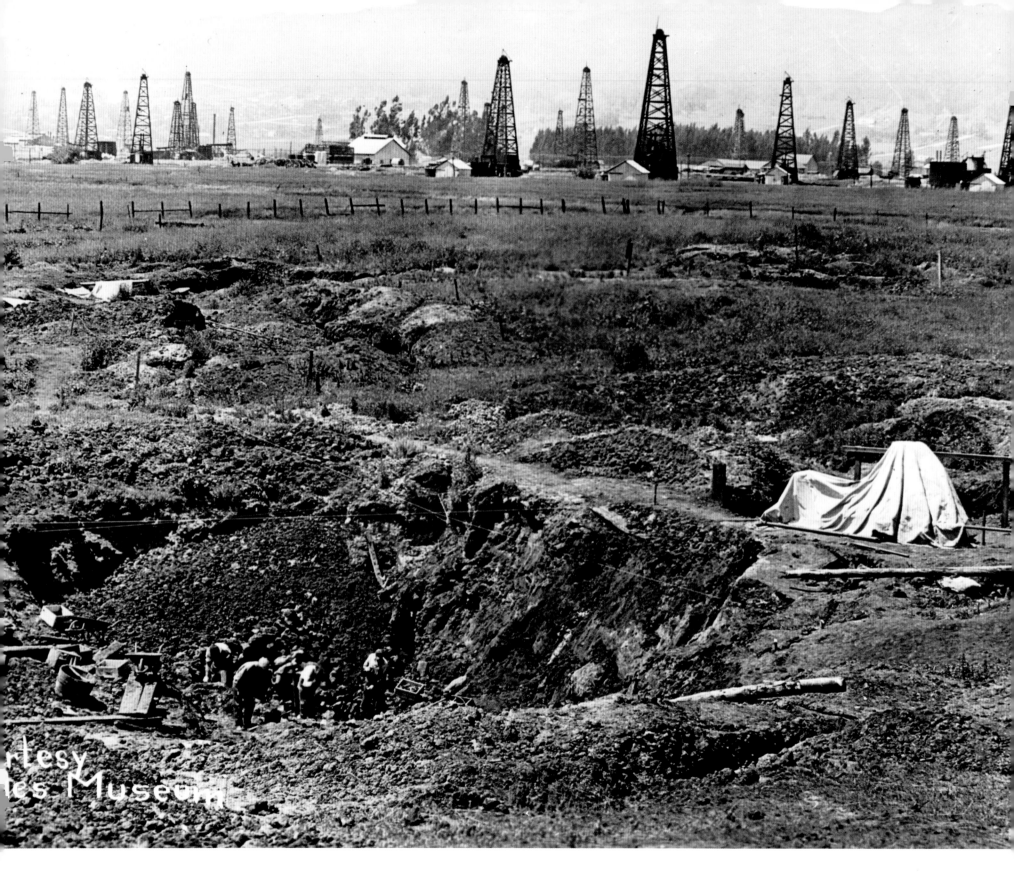

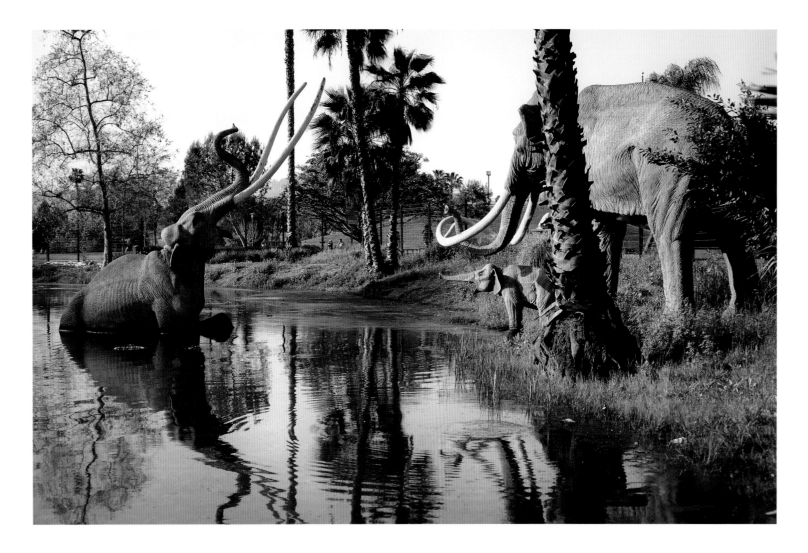

LA BREA TAR PITS

Left: Fossil miners work at the La Brea Tar Pits in this 1911 photograph. At Rancho La Brea, tar (*brea* in Spanish) has been seeping up for thousands of years. Over the centuries, animals that came to drink the water fell in, sank in the tar, and their bones were preserved. Humans found uses for the tar early on; Native Americans discovered the use of the tar for waterproofing purposes. Spanish explorers and settlers used the natural source of asphalt to caulk their ships and create waterproof roofing of early adobes. Around 1900, a worldwide fascination with dinosaurs, fossils, and anthropology emerged, but it wasn't until after World War II that new technologies made it possible for many more artifacts to be uncovered from the black depths of La Brea. A great number of large mammal skeletons were found, as well as the partial skeleton of a human woman thought to date back 9,000 years.

Above: Fossils of the dire wolf, saber-toothed tiger, woolly mammoth, short-faced bear, and ground sloth have been found in the La Brea Tar Pits, in enough quantities to keep researchers busy well into the next century. The George C. Page Museum on the site is dedicated to researching the tar pits and displaying specimens from the animals that have been found there. Page built the museum from the fortune he made shipping oranges to places like his home state of Nebraska. The museum displays the largest and most diverse collection of extinct Ice Age plants and animals in the world. Through windows at the Page Museum Laboratory, visitors watch specialists clean and repair specimens. Outside, in Hancock Park, life-size replicas of several extinct mammals are featured. Once a year, visitors can view volunteers excavating the pits under the supervision of paleontologists. Today's scientists value more than just the bones— everything down to grains of pollen are collected and cataloged.

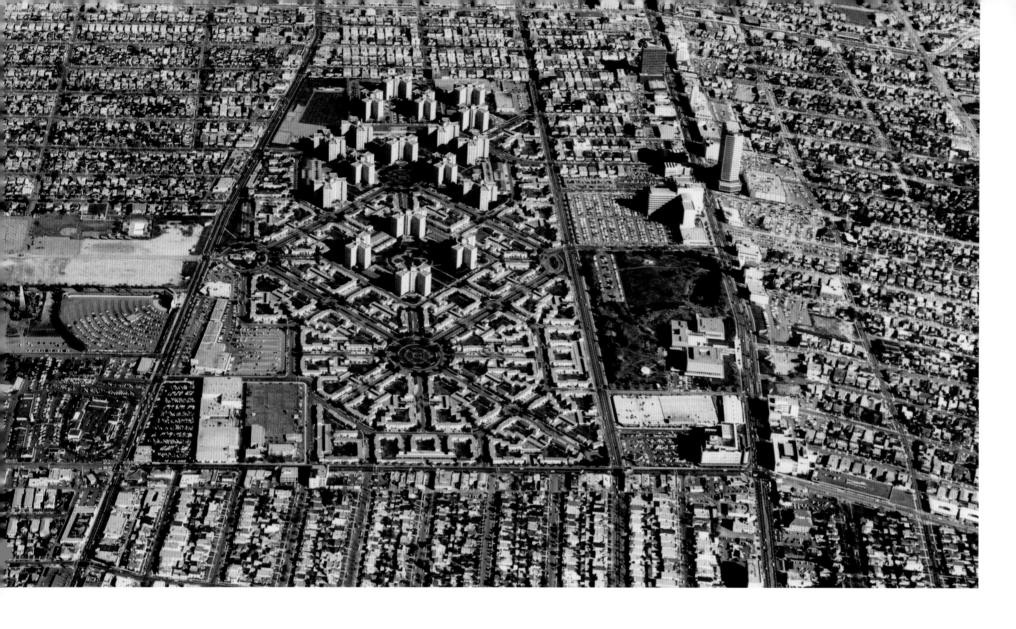

This photo from February 1965 takes in the Miracle Mile, which was developed in the 1920s when Wilshire Boulevard was still a dirt road. Developer A. W. Ross first visited the area around 1920 to find bean fields and dairy farms. Ross embraced the future. He knew his subdivisions would benefit from planning that took into consideration the use of the automobile. His planning included the nation's first left-turn lane. Ross also installed America's first timed traffic lights and insisted that merchants provide parking space for their customers. Ross's architectural manipulations helped define the Art Deco and Streamline Moderne styles. His innovations helped shape Los Angeles's urban environment as well as those of countless other communities. This stretch of Wilshire, sometimes called the American Champs-Élysées, earned the moniker "Miracle Mile" because of its sudden rise to prominence as the harbinger of America's city of the future. The Park La Brea towers, a residential community, rose up at a cost of $40 million and include eighteen apartment buildings, each thirteen stories high.

MIRACLE MILE

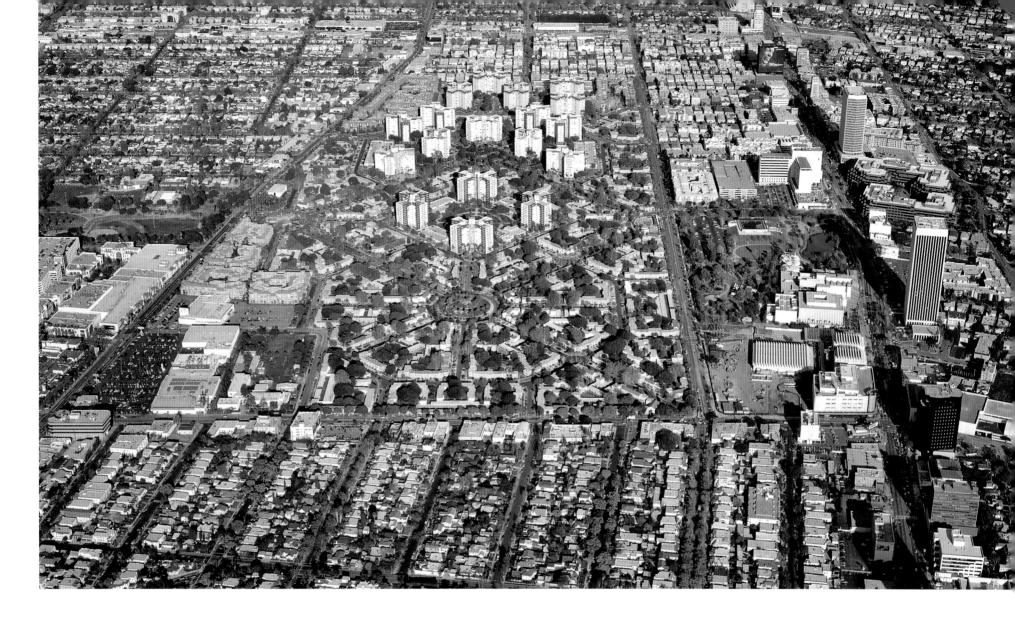

The Miracle Mile is considered to lie between Fairfax and La Brea avenues, but also encompasses the surrounding areas. The area's innovative design was a commercial success at first. At 5800 Wilshire Boulevard, Ross is remembered with a bust and an inscription: "A. W. Ross, founder and developer of the Miracle Mile: Vision to see; wisdom to know; courage to do." The boulevard boasts some of the city's most impressive high-rises and museums, and has its densest population. Ironically, the district has traffic that has been described as "bad even by Los Angeles standards," but a proposed $5 billion project, the "Subway to the Sea," aims at reducing the number of cars on the road by connecting this district with Santa Monica. The district has long supported the oil industry, which took advantage of the nearby tar pits. A buildup of methane gas associated with the tar pits caused an explosion that destroyed a department store in 1985.

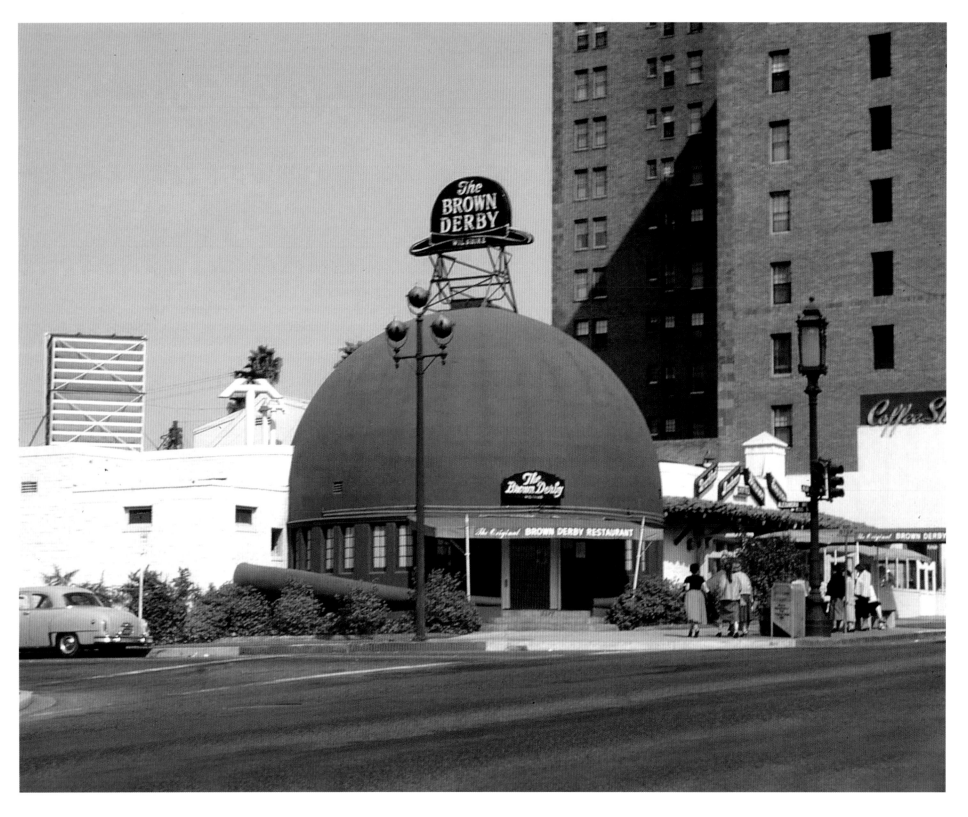

BROWN DERBY RESTAURANT

Left: An icon that was synonymous with the golden age of Hollywood, the Brown Derby restaurant, seen here in 1939, was shaped like a derby hat. The Brown Derby was a chain started by Bob Cobb and Herbert Somborn, who opened their first restaurant on Wilshire Boulevard in 1926. The Brown Derby is considered an example of the representational architecture movement popular in Southern California during the 1920s and 1930s. The whimsical hat design was intended to catch the attention of motorists speeding by. This original location garnered success from its proximity to other hot spots like the Ambassador Hotel and the Cocoanut Grove. The building was moved in 1937 farther down Wilshire Boulevard; in 1980 it was replaced by a shopping center called the Brown Derby Plaza. Other Brown Derby locations were at Hollywood and Vine in Hollywood, at 9537 Wilshire Boulevard in Beverly Hills, and at 4500 Los Feliz Boulevard. The Los Feliz Brown Derby is the only one still standing today.

Above: The Blink Café and Bar now anchors the Brown Derby Plaza, whose name recalls the old restaurant. While the original Brown Derby has been replaced, the location that still operates on Los Feliz Boulevard owes its existence to pioneering Hollywood director Cecil B. DeMille. DeMille purchased a chicken restaurant named Willard's and converted it to a Brown Derby in 1940. In 1960 the restaurant was renamed Michael's of Los Feliz. In 1987 a licensing program began for Brown Derby restaurants to re-create the Hollywood mystique in other parts of the world. The Walt Disney Company built replicas of the hat-shaped restaurant at Hollywood Studios in Orlando, Euro Disney, Tokyo Disney, and Disneyland in Anaheim. By 1992 new owners converted it into a nightclub named the Derby. Some say the Derby was the location of swing's rebirth in the 1990s. The club closed in 2009, but the building is protected as a Historic-Cultural Monument of the City of Los Angeles.

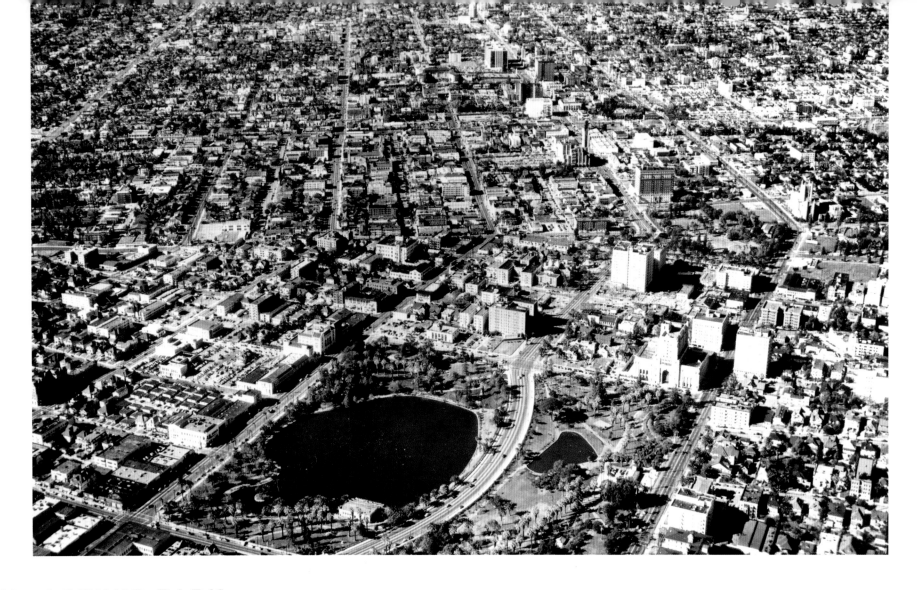

MacARTHUR PARK

Above: MacArthur Park began life as Westlake Park in the 1880s. In the mid-1800s, the area was a swampland; by the 1890s, Angelenos had converted it into a vacation destination. By the twentieth century, they were calling the area around MacArthur Park the "Champs-Élysées of Los Angeles." Both Westlake and Eastlake parks contained spring-fed lakes built as drinking-water reservoirs. Once Los Angeles constructed its piping system, the lakes and surrounding areas were converted to parks. By the 1890s, hotels surrounded the lakes, which both became resort destinations for a time. Wilshire Boulevard once ended at the lake, but in 1934 a berm was built so the boulevard could cross the park and run into downtown Los Angeles. This divided the lake; the northern half was drained and converted into a park, which was renamed for General Douglas MacArthur in 1942, about the time this photograph was taken. At the same time, Eastlake Park was renamed Lincoln Park to honor Abraham Lincoln.

Right: MacArthur Park is now a Los Angeles Historic-Cultural Monument. Wilshire Boulevard divides the park in two; the southern portion has the lake, while the northern half includes an amphitheater, a band shell, soccer fields, and a recreation center. The band shell—rededicated as the Levitt Pavilion for the Performing Arts— hosts jazz, big band, salsa, and world music concerts in about fifty open-air free concerts each summer. Workers laid an artificial bottom to the lake while they were building the Metro's Red Line, which opened in 1993 and runs beneath the park. From its early days when it was considered the nation's premier urban oasis and vacation spot, to the latter half of the twentieth century when it became one of the nation's worst sites for urban crime, the park has reemerged as a destination for family recreation through the efforts of the police department and dedicated community groups. MacArthur Park is one of the most popular parks in the city. Its community center offers a wide range of recreational opportunities for people of all ages.

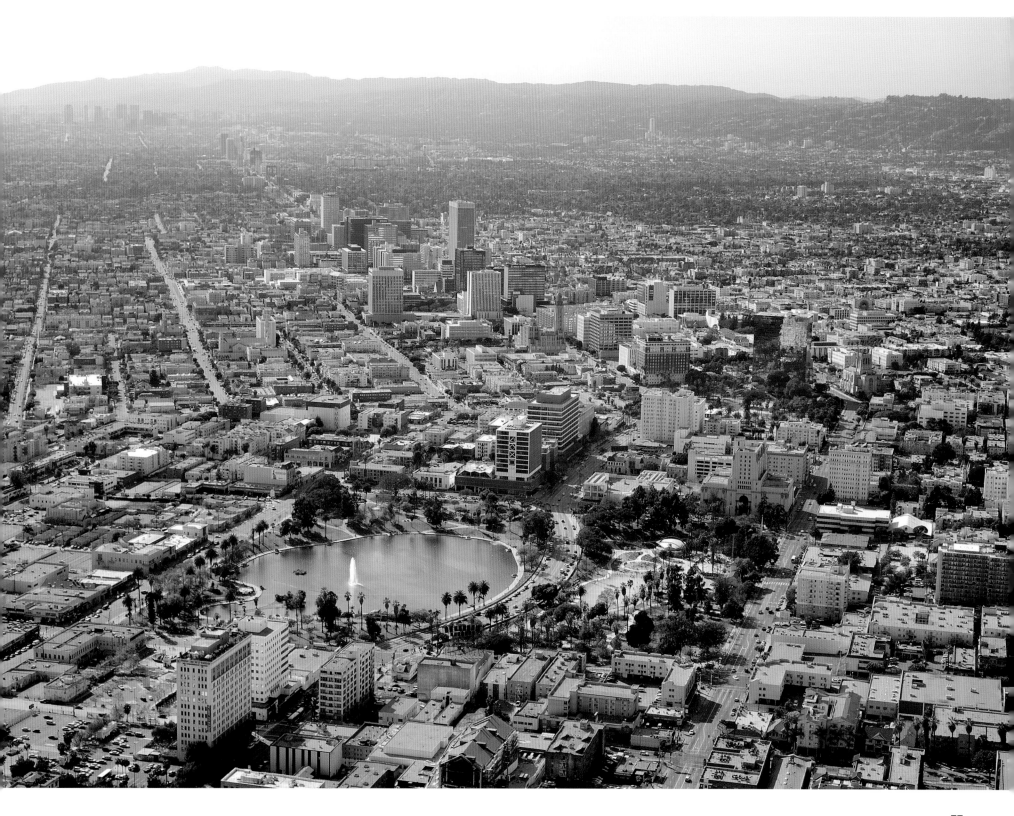

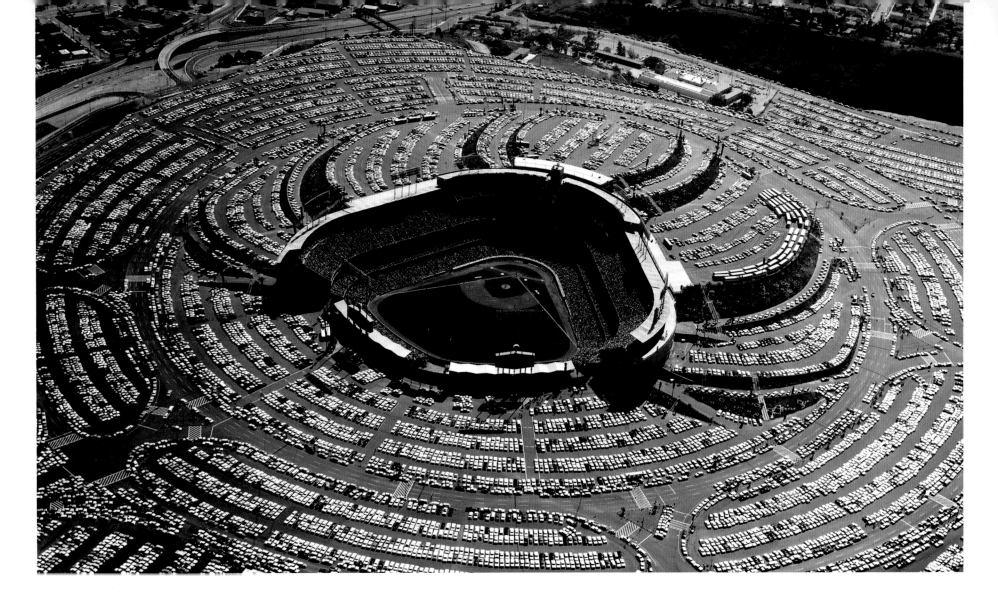

DODGER STADIUM

Above: In the 1940s, Chavez Ravine was a poor Mexican American community in Sulfir Canyon. Named for Julian Chavez, a nineteenth-century city councilman, the canyon was home to Hispanic families who lived there due to housing discrimination in other parts of Los Angeles. The Los Angeles City Housing Authority earmarked Chavez Ravine's 300-plus acres as a prime location for redevelopment. In July 1950, all residents of Chavez Ravine received letters from the city telling them that they would have to sell their homes. Construction of Dodger Stadium began nine years later, and the Los Angeles Dodgers played their first game in Chavez Ravine in 1962. The parking lot, full of cars in this 1963 photograph, offers room for 16,000 cars on twenty-one terraced lots. Since its opening, the stadium has welcomed an average of 2.8 million fans per season. Its seating capacity of 56,000 is the largest of any current stadium in Major League Baseball.

Right: The 1978 season saw Dodger Stadium become the first ballpark to host more than three million fans in a season. Pope John Paul II celebrated Mass at Dodger Stadium on September 16, 1987. Entertainers from around the world have performed there, including the Rolling Stones, the Beatles, the Bee Gees, Michael Jackson, U2, and Bruce Springsteen. After the 1995 season, a new turf known as Prescription Athletic Turf was installed. It uses state-of-the-art technology to manage field moisture through controlled drainage and irrigation. By the 2000 season, the Dodgers had added new field-level seats down the foul lines beyond the dugouts and a new expanded dugout section, among other improvements. In 2003 a new scoreboard and a "DodgerVision" video board were added. After the 2005 season, all the seats within the primary seating bowl were replaced with seats that returned the stadium's look to its original 1962 color palette of yellow, light orange, turquoise, and sky blue.

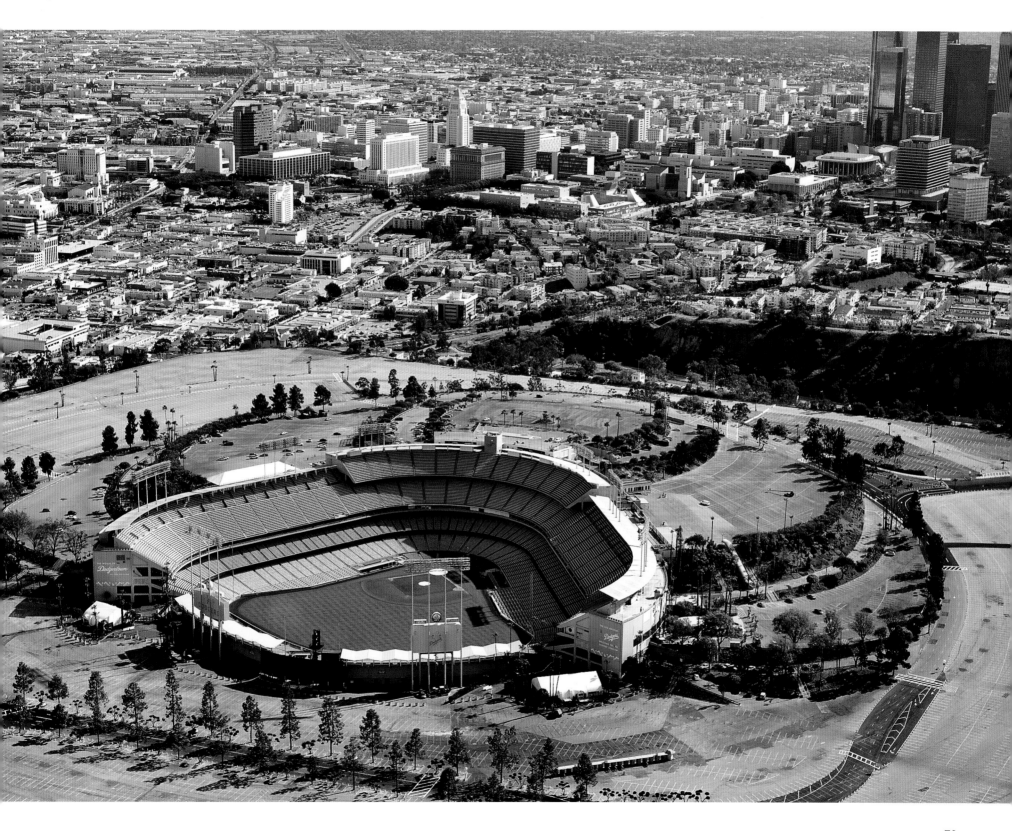

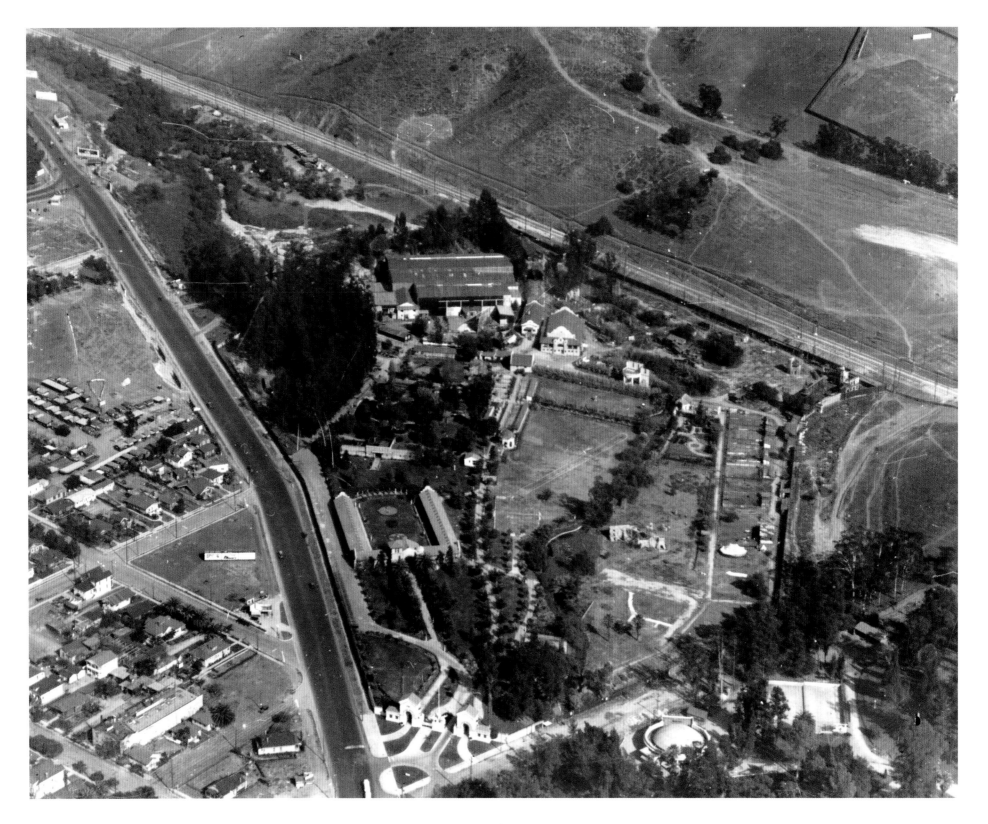

SELIG ZOO

Left: The Selig Zoo, seen here in 1924, was originally a movie studio in Lincoln Heights. The neighborhood dates back to the 1830s and is one of the oldest in Los Angeles. By 1913, William Selig, founder of the Selig Polyscope Company, had gathered a large collection of animals for his films. He acquired and developed thirty-two acres in Lincoln Heights and opened a large public zoo. Jackie, one of the MGM lion mascots who roared at audiences at the beginning of MGM's films, lived at the Selig Zoo. Selig's company produced the first motion pictures featuring stars Tom Mix and Roscoe "Fatty" Arbuckle. Selig had great plans for the spot. He hoped to develop Selig Zoo Park into a resort complete with a Ferris wheel and a swimming pool with a sandy beach and a wave-making machine. Guests would stay in his hotel, be entertained in his theater, and eat in his restaurants—all at Selig Zoo Park.

Above: Today the site of the former Selig Polyscope Company studios sits in a mostly industrial area. Some who work there—and many who drive by—know little about Selig's zoo and the animals who lived there. The zoo was known as the Luna Park Zoo from 1925 to 1931. The Great Depression and a flood spelled its end and Selig sold the zoo. He donated some of his beloved animals to Los Angeles County. The animals found a home at the Griffith Park Zoo. The property was used as a jalopy racetrack during the 1940s and early 1950s. The zoo's carousel survived until 1976, when it was destroyed by fire. In 2000 the Los Angeles Zoo and Botanical Gardens remembered William Selig by establishing the Selig Legacy Society to encourage contributions to the modern-day Selig Zoo Park. The front gate with its lion sculptures crumbled over the years, but in 2003 they were restored and now grace a spot at the Greater Los Angeles Zoo.

CHINATOWN

Above: Members of Los Angeles's Chinese community gather in 1949 to celebrate the grand opening of the Long Kong Tin Yee Building on Broadway in New Chinatown. The city's first identifiable Chinatown of some 200 souls grew up around the Calle de Los Negros, a short alley between El Pueblo Plaza and Old Arcadia Street. The city evicted the residents to make room for Union Station. A variety of negative cultural elements led to the neighborhood's decline. Once investors decided to condemn the whole neighborhood, it was home to opium dens, gambling houses, and gang warfare. Over seven years, the neighborhood was demolished and residents were displaced. By the 1930s, Chinese community leader Peter Soo Hoo Sr. stepped in and helped design a new Chinatown along Broadway that blended Chinese and American sensibilities.

Right: The Chinese social club's meeting hall still stands on North Broadway near Old Chinatown Plaza; the building houses four businesses. A smaller building constructed in the same style stands next door. In the 1960s, residents put up a statue in the plaza that honors Dr. Sun Yat-sen, the revolutionary leader whom many consider the founder of modern China. During the 1980s, Chinatown greatly expanded with many new buildings along Broadway. Spring Street, Hill Street, College Street, and Broadway define today's Chinatown, which is located directly north of downtown. Tourists can always be found on Chinatown's Broadway with its many Chinese restaurants and merchants. Oddly enough, Chinatown was home to a restaurant held dear by Italian Americans. The Nuccio family served Italian food at the corner of Broadway and College Street from 1908, well before Chinatown appeared on the map. The business closed in the 1990s.

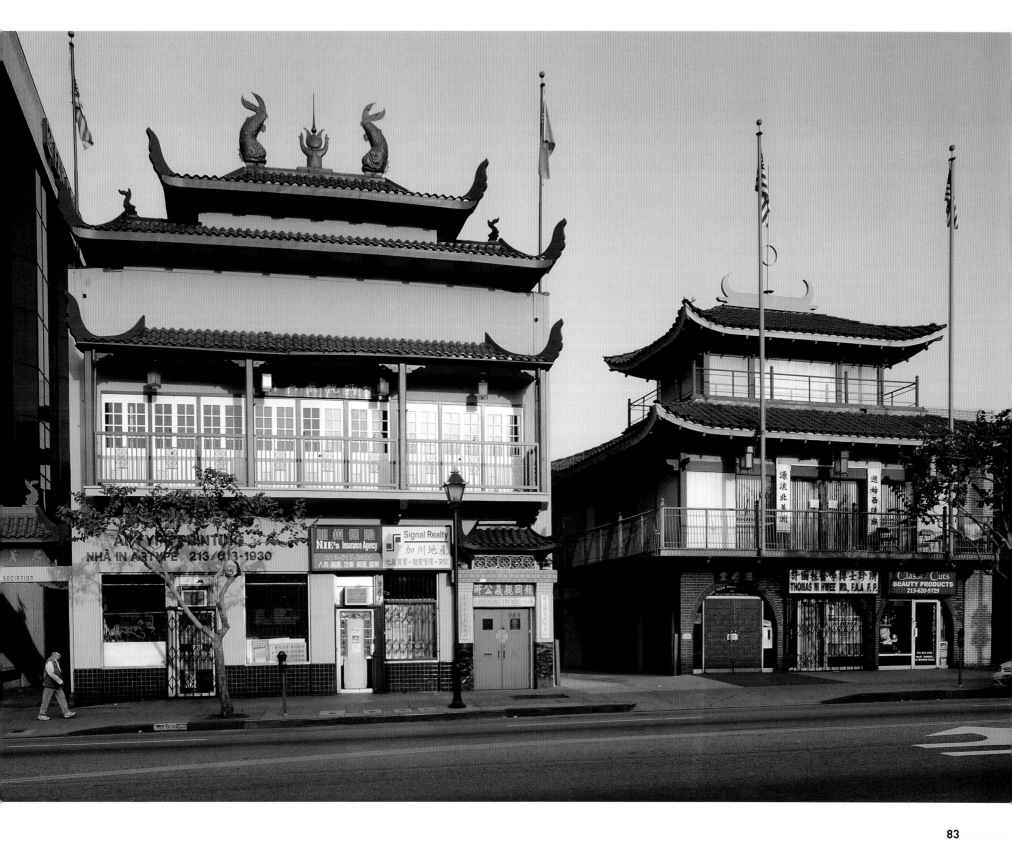

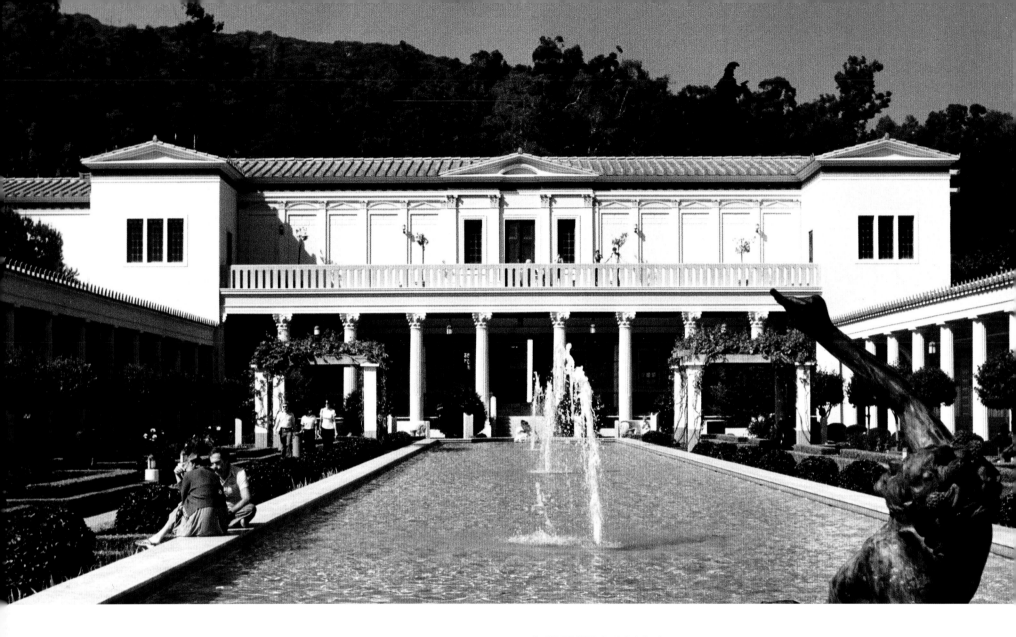

GETTY VILLA

The Getty Villa stands near the home of oil tycoon J. Paul Getty in Pacific Palisades. Getty was born into a wealthy family and given the early leg up; at age twenty-four, he earned his first million dollars. He went on to amass what was likely the world's first billion-dollar fortune. One of his passions was collecting arts and antiquities. Getty opened an informal gallery next to his home for some of his fine collection of artwork and artifacts. While the home clearly lies within the borders of Los Angeles's Pacific Palisades district, the museum has long perpetuated that its address is in the more glamorous Malibu. Getty quickly ran out of room, so he opened a second museum in 1974, known as the Getty Villa. Inspired by the Villa of the Papyri at Herculaneum, the building houses Greek, Roman, and Etruscan antiquities.

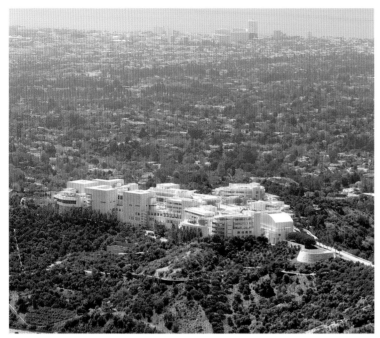

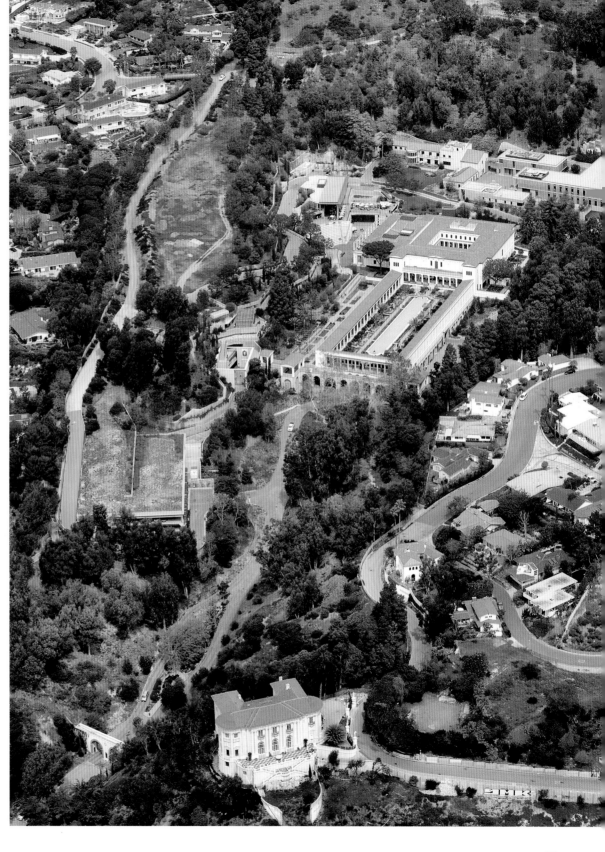

The Getty Villa in Pacific Palisades is one of two locations of the J. Paul Getty Museum. The Getty Villa was renovated in 1997 and reopened in 2006. In the meantime, many artifacts went on display at the Getty Center Museum's newer location in Los Angeles (inset), which contains Western art from the Middle Ages to the present. Built at the crest of a hill near Bel-Air, the Getty Center Museum can be accessed only by a private tram. Its stated mission is to "further knowledge of the visual arts and to nurture critical seeing by collecting, preserving, exhibiting, and interpreting works of art of the highest quality." The museum welcomes 1.3 million visitors annually, making it one of the most visited museums in the nation. Getty left $661 million to support the museum's efforts when he died in 1976.

PACIFIC PALISADES

Left: This photograph, taken in the 1930s, looks south along the Roosevelt Highway, today's Pacific Coast Highway. The beach here was once part of the 1839 Rancho Boca de Santa Monica that belonged to Ysidro Reyes and Francisco Marquez. In 1911 film director Thomas Ince used the Pacific Palisades as a backdrop for his Western films. The property later passed to the Reverend Charles H. Scott and the Southern California Methodist Episcopal Church. In 1922 Reverend Scott founded the town of Pacific Palisades, hoping to create an elaborate religious-intellectual commune. Within three years, the new community had about a hundred cabinlike homes. Eventually, bungalows replaced the cabins. Visible in the distance is the landmark lighthouse that doubled as a bathhouse. The Pacific Palisades Association built the structure in 1927 and billed it as the country's largest bathhouse. By the time this picture was taken, the building had likely been sold to Will Rogers.

Above: After Will Rogers bought this land—some 186 acres—in the 1920s, he developed a ranch along the coast, only to die in a plane crash in 1935. When his widow Betty died in 1944, the ranch became a state park. Today, multimillion-dollar homes with amazing views stand in place of the bungalows. Over the years, famous residents have included Ronald Reagan, Arnold Schwarzenegger, Anthony Quinn, Tom Hanks, Goldie Hawn, and Anthony Hopkins. The neighborhood includes parklands laced with numerous hiking trails. A footbridge where Porta Marina Way meets the Pacific Coast Highway allows pedestrian access to Will Rogers State Beach. The breakwater just to the south is the site of the old bathhouse. The beach extends almost two miles along the coast and has facilities for volleyball, gymnastics, and bicycling. The bike path here is part of the South Bay Bicycle Trail, which runs more than nineteen miles along the Pacific Ocean to Torrance.

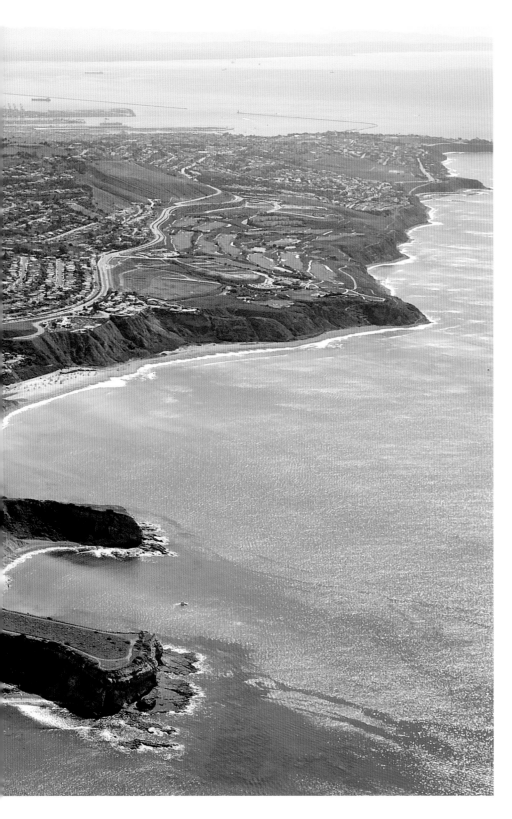

PALOS VERDES

Palos Verdes Drive winds its way south along the Pacific Ocean past Portuguese Bend—named for Portuguese whalers who used the beach as a whaling station— through swanky Rancho Palos Verdes, and into the city of San Pedro. This view stretches south from Abalone Cove to the ships waiting to enter Los Angeles Harbor beyond Point Fermin. The Tongva natives once camped in places like Abalone Cove, where they fished and harvested abalone from the ocean. A pair of nearly twin capes makes up Portuguese Point. This entire shoreline was once part of the Juan Jose Dominguez land grant, the first in California. Dominguez was a member of the 1769 Gaspar de Portolá expedition. Golfers can tee off at the Donald Trump National Golf Course to the south of Portuguese Bend; the course offers a view of the ocean from all eighteen holes. The lighthouse on Point Fermin has warned ship captains of danger since 1874.

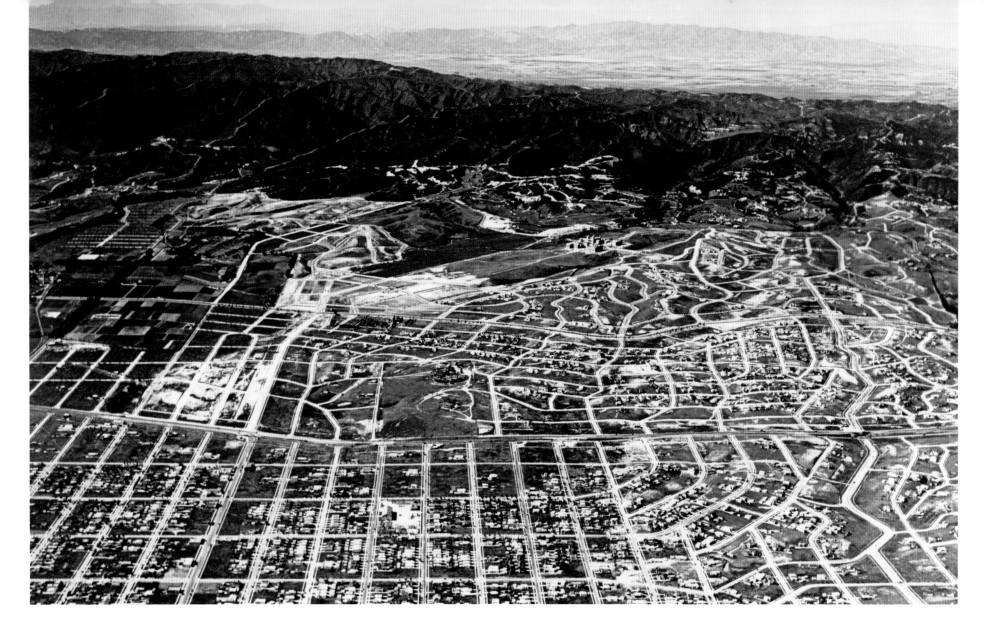

WESTWOOD

Above: The development of Westwood, the nearby Holmby Hill, and UCLA began in 1919 when Arthur Letts Sr. purchased 400 acres of land here, originally part of the Mexican land grant Rancho San Jose de Buenos Ayres. Forty-niner John Wolfskill had bought 3,300 acres for $10 an acre in 1884 and built a ranch house. Letts purchased a portion of Wolfskill's land, hoping to create a mixed development of retail, apartments, residences, and estates along with the university. He christened the developments Westwood and Holmby Hills, which recalls the name of his birthplace, a small village in England. Letts died suddenly in 1923, before he could realize his vision. Harold Janss, who had married Letts's daughter Gladys in 1911, continued to develop the area. This 1929 photo shows the extent of Letts's dream and Janss's work.

Right: The Los Angeles Mormon Temple on Santa Monica Boulevard quietly presides in front of the string of high-rises that stand along Wilshire Boulevard. Locals call this portion of the boulevard with its residential high-rises just to the east of Westwood Village the "Millionaires' Mile," the "Golden Mile," or the "Wilshire Corridor." The Wilshire Federal Building brings the string to an end on the far left and defines the grassy Los Angeles National Cemetery near the Santa Monica Freeway. Westwood is home to around 50,000 residents today. This area is also home to the Westwood Village Memorial Park Cemetery, which dates back to the 1880s. Marilyn Monroe, Natalie Wood, and Rodney Dangerfield rest there. The adjoining neighborhood of Holmby Hills has been home to Hugh Hefner's Playboy Mansion since 1971.

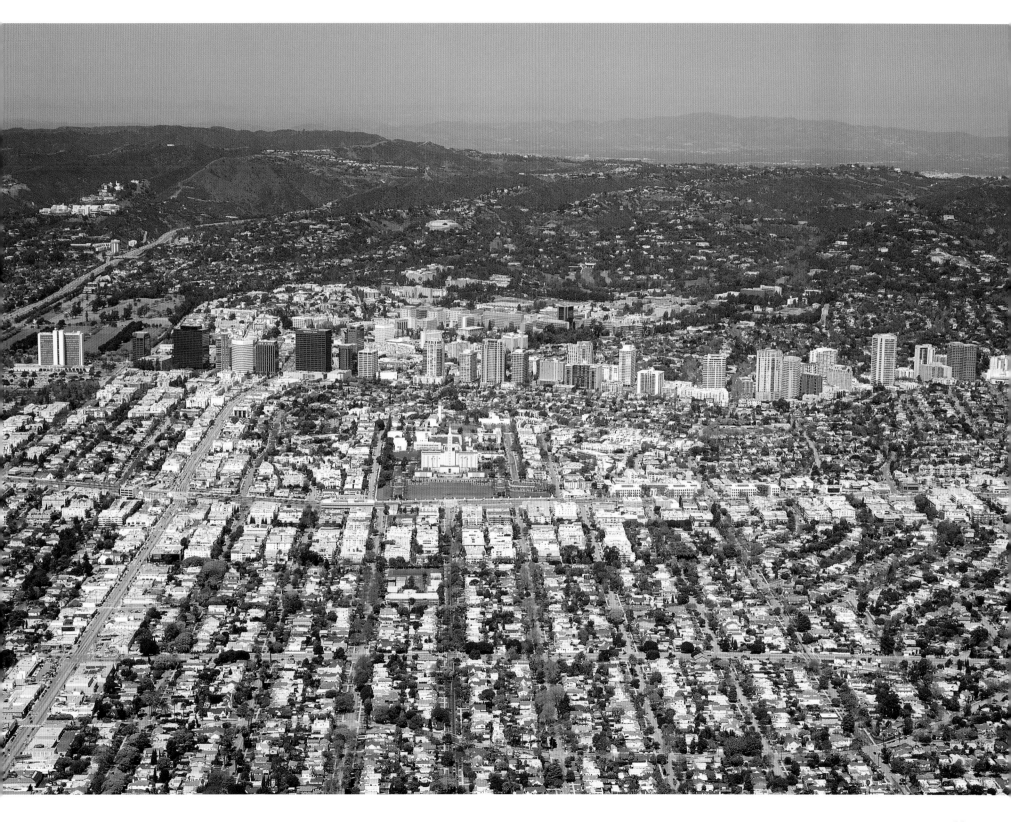

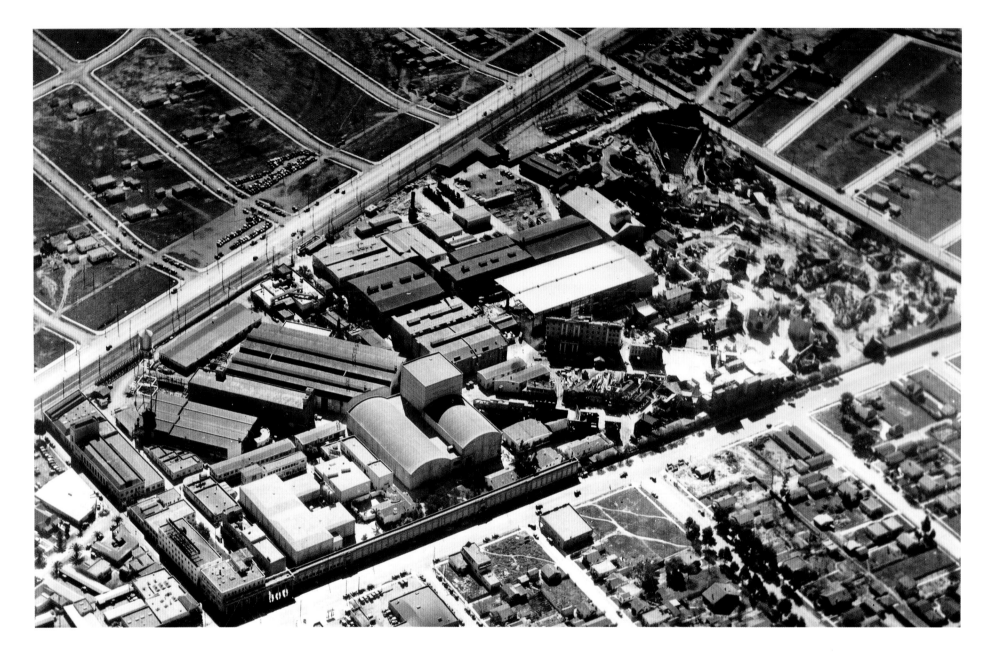

MGM STUDIOS

These studios were born in 1914 when Triangle Pictures began filming here. The first building on this lot, with its classical colonnades, rose up before MGM purchased the studios in 1924. Movie theater magnate Marcus Loew bought Goldwyn Pictures and the Metro Pictures Corporation to make movies for his theater chain, Loew's Theatres. Louis B. Mayer invited President Calvin Coolidge and performer Will Rogers to the studio's grand opening; they both showed up. MGM chose to locate its studios some seven miles away from Hollywood Avenue and Vine Street in Culver City. The Culver City studios produced numerous pictures that were nominated for Best Picture at the Academy Awards. In 1939 they produced two, *Gone With the Wind* and *The Wizard of Oz*. *Gone With the Wind* took home Best Picture that year, along with eight other Oscars, while *The Wizard of Oz* won two Oscars.

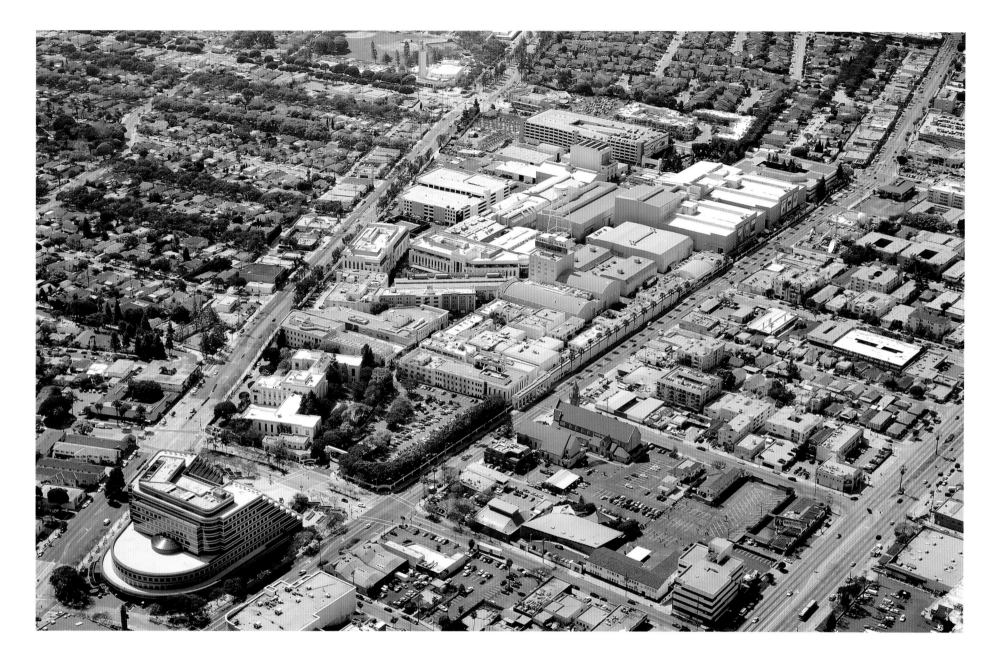

Sony now occupies the MGM Studios Culver City site. Kirk Kerkorian, former owner of the MGM Grand Hotel in Las Vegas, purchased the studio in 1969. He began selling off more than 150 acres of MGM's property. By the time he was finished, the site's original 183 acres had been whittled down to a mere thirty acres. Sony Pictures purchased the Culver City studios in 1991 and spent over $100 million to renovate the site. MGM relocated in June 2003 to a new headquarters building, the MGM Tower in Century City. The handsome Sony Pictures Plaza (bottom left), formerly known as the Filmland Corporate Center, anchors the intersection of Duquesne Avenue at Culver and Washington boulevards today.

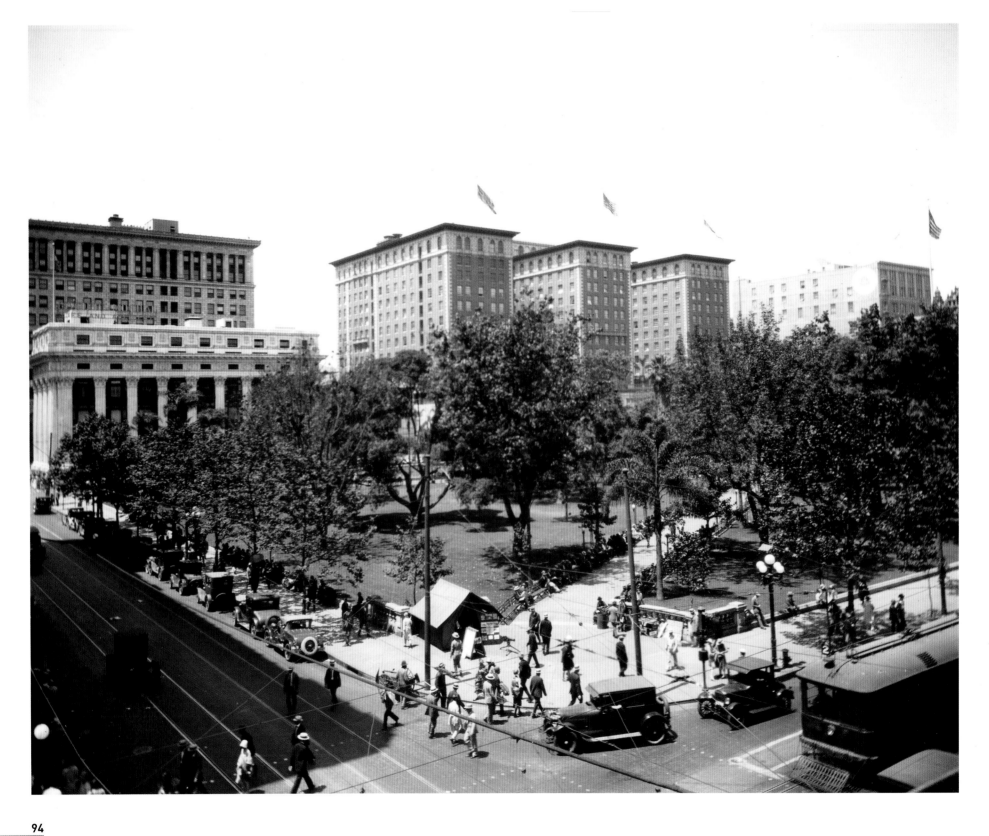

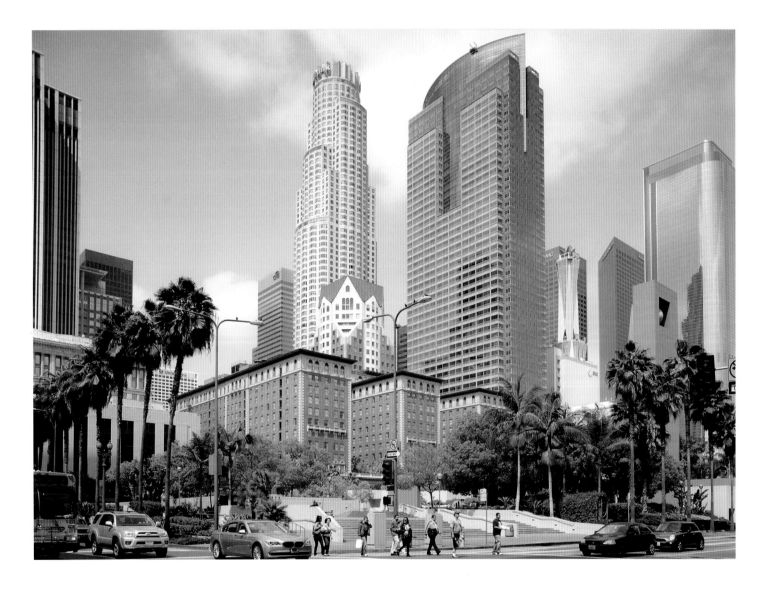

PERSHING SQUARE

Left: Pershing Square, shown here in 1930, was laid out as a public park exactly one square block in size. The Pacific Mutual Building and the Biltmore Hotel make a grand backdrop for the park. In 1866 city fathers declared the area a public square. It was signed into being by Mayor Cristobal Aguilar, and called La Plaza Abaja, or "the Lower Plaza." George "Roundhouse" Lehman, a German immigrant and owner of a local beer garden, planted small cypress and fruit trees and shrubs around the park early in its history, and maintained them until his death in 1882. In the early 1900s, the park hosted militia receptions and public orations. In 1918 the park was formally dedicated as Pershing Square in honor of U.S. Army general James J. Pershing. Pershing served in the Spanish-American War and rose to the rank of general in World War I.

Above: After its renaming, not much changed at Pershing Square until the 1950s, when a parking garage large enough to accommodate 1,800 cars was constructed underneath it. In 1989 a renovation and redesign took place; the "new" park opened in 1994. That same year, the action film *Speed* with Keanu Reeves and Sandra Bullock featured Pershing Square. Some of the new park's features include a ten-story purple bell tower, a walkway meant to resemble an earthquake fault line, a concert stage, and a seasonal rink for ice-skating. During the holidays, the park hosts a number of winter-themed events around the ice rink. A miniature train village, a snow zone for sledding and romping, and a winter holiday festival all work to bring a taste of the season to a city that enjoys an average of 352 days of sunshine per year.

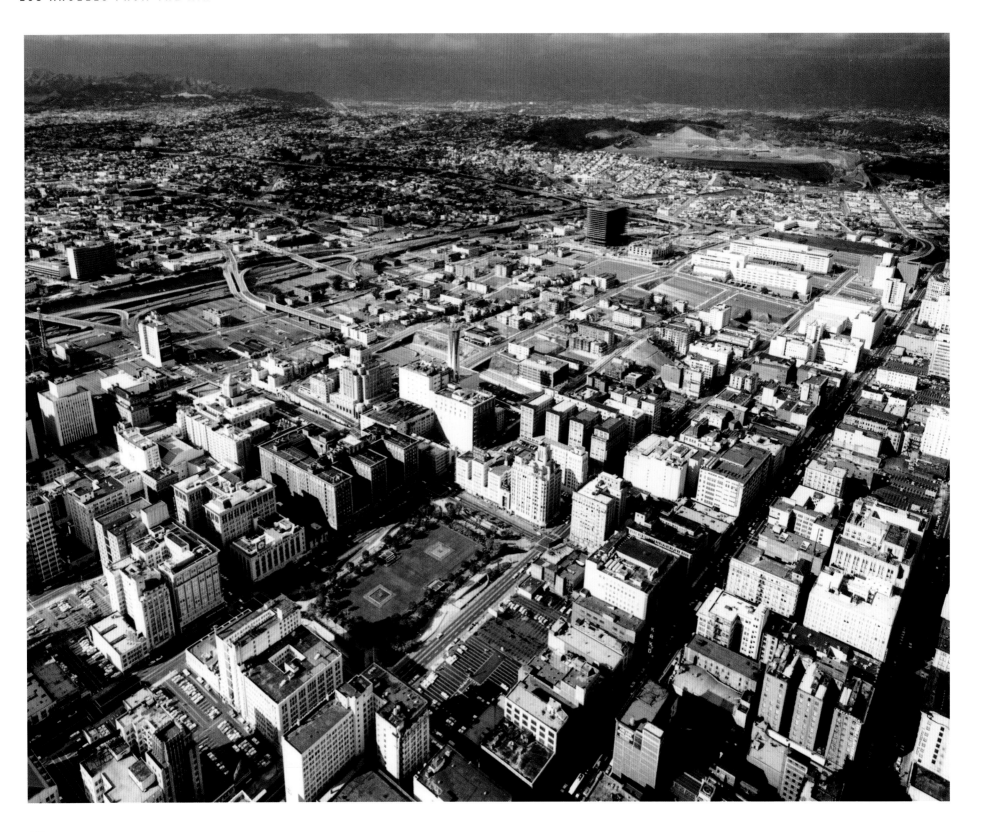

PERSHING SQUARE

Left: In 1849 Lieutenant Edward C. Ord dubbed the five-acre plot of land that Pershing Square now occupies "Plot 15." In 1866 Mayor Cristobal Aguilar dedicated Plot 15 as La Plaza Abaja. The plaza then went through a series of name changes. First it was known as Los Angeles Park, then Central Park. In 1918, flush with the victory that World War I brought to the American shores, Angelenos renamed the park again, this time for the general who led the American Expeditionary Force, John Joseph Pershing. In this 1926 photograph the Biltmore Hotel—a fourteen-story affair that cost $7 million to build—stood near the square's northwest corner. It was the largest hotel west of Chicago. The columned Pacific Mutual Building, today's Pacific Center, stands next to the Biltmore. Other buildings on Pershing Square when this photograph was taken include the Renaissance Revival–style Heron Building and the Art Deco–style Title Guarantee and Trust Building.

Right: Today, looking northwest over Pershing Square reveals the western portion of the city's skyline. The redbrick Biltmore Hotel still hugs the square. The cylindrical U.S. Bank Tower, the tallest building west of the Mississippi, towers above the Biltmore one block over. The building to its right is 555 West Fifth Street. A large glass crown gleams atop the U.S. Bank Tower with varying color patterns at night, setting the mood for the city. During the Christmas season, the crown is red and green; passersby on Valentine's Day will notice the crown glowing red. The building is also known as the Library Tower because it was built as part of the $1 billion Los Angeles Central Library redevelopment plan after a fire destroyed the library in 1986. The city sold air rights to the tower's developers to help pay for the reconstruction of the Los Angeles Central Library, which is visible next to the Maguire Gardens, a public park and sculpture garden.

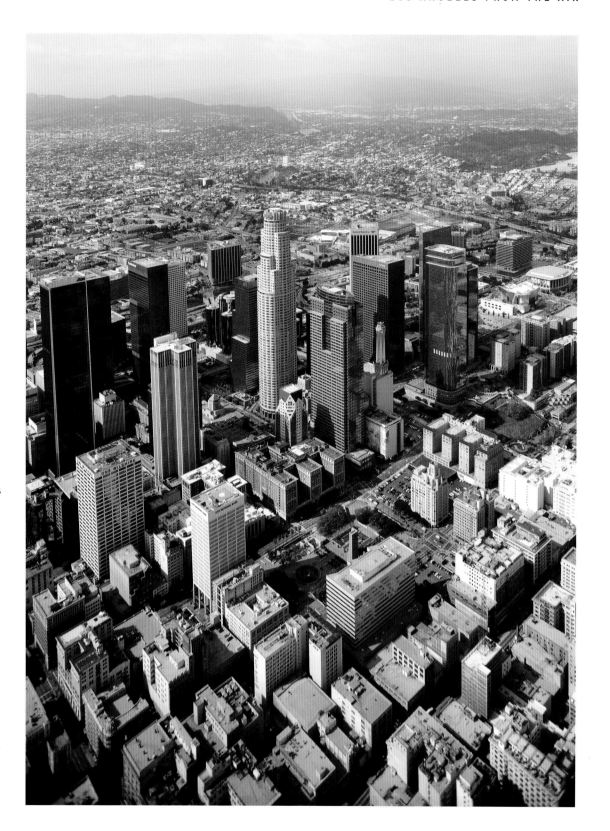

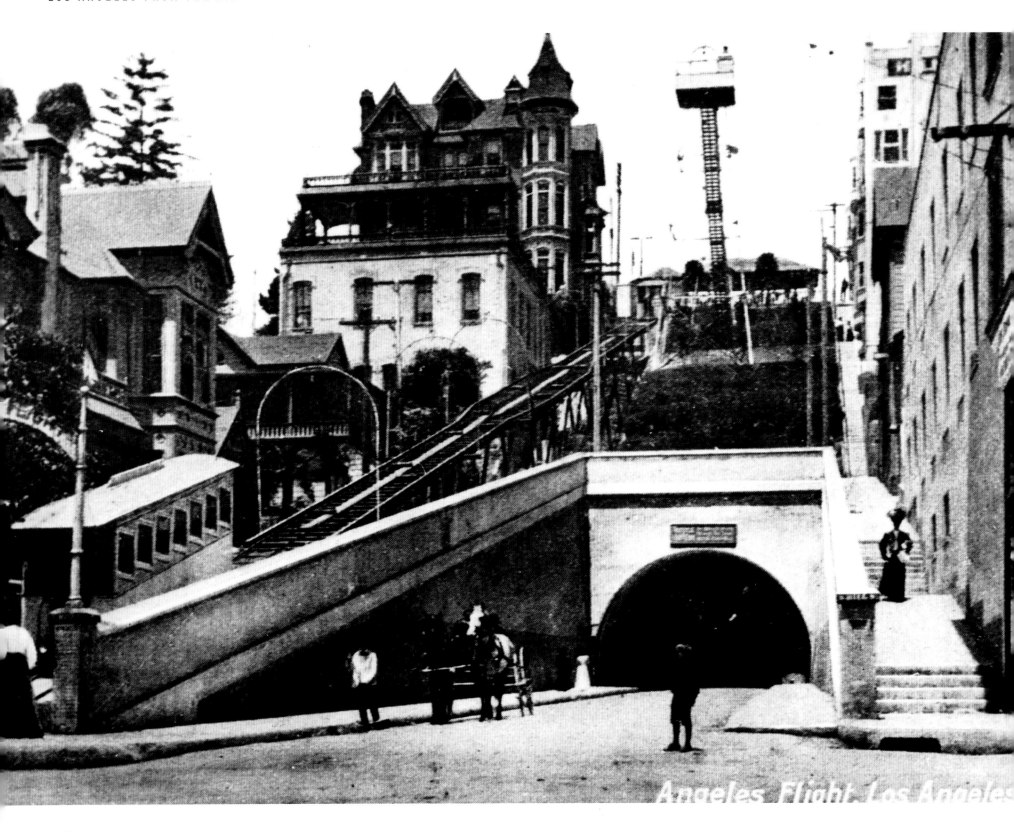

Angeles Flight, Los Angeles

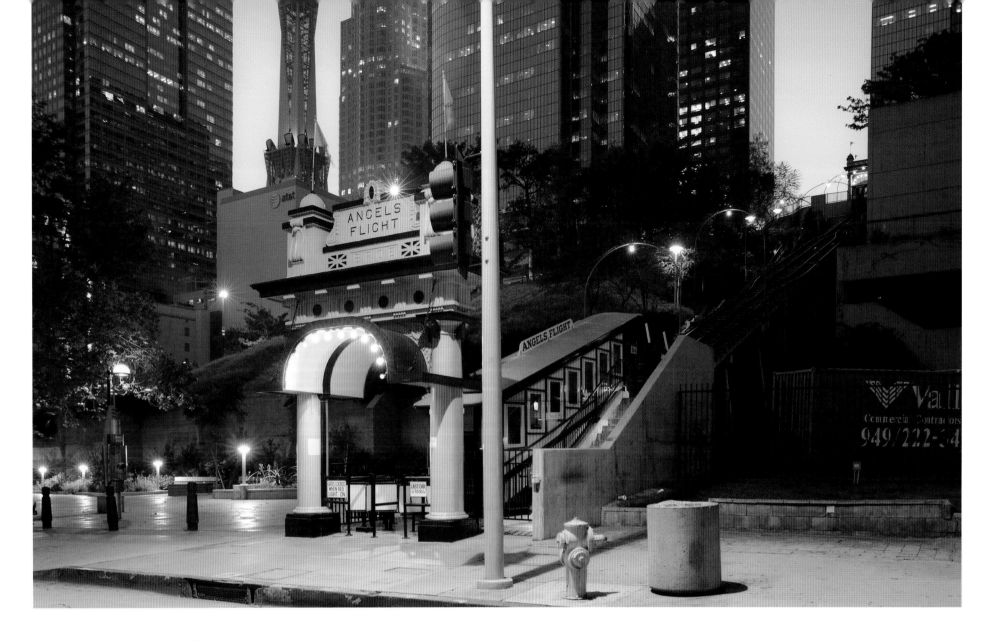

ANGELS FLIGHT

Left: This photograph, taken around 1902, shows a horse and carriage moving along Third Street. The cable car at the bottom of the rail ran up to the observation tower at the top of Olive Street on Bunker Hill, on the right in the photograph. Colonel J. W. Eddy, described as "lawyer, engineer, and friend of Abraham Lincoln," built the Los Angeles Incline Railway from the west corner of Third and Hill streets. Engine-driven metal cables pulled the carriages up the hill. As one car ascended, the other descended using gravity. An archway with a sign proclaiming "Angels Flight" greeted passengers boarding at Hill Street. Angels Flight became the official name of the railway in 1912 after it changed hands. It operated until 1969 with a near perfect safety record. The 123 steps provide an alternate route to the top of the hill.

Above: The first Angels Flight operated from 1901 until 1969, when its location was redeveloped. After twenty-seven years in storage, the second Angels Flight, located a half-block south of the old site, opened in 1996 with the original cars on a new 270-foot-long track with a 33 percent grade. A design flaw was blamed for a fatal accident in 2001 that killed an eighty-three-year-old man and injured seven people. The accident forced the railway's closure. It wasn't until March 15, 2010, that the railway, now more of a tourist attraction, reopened. Angels Flight has appeared in many films, including *The Money Trap*, *Criss Cross*, and *The Indestructible Man*. Angels Flight was added to the National Register of Historic Places on October 13, 2000.

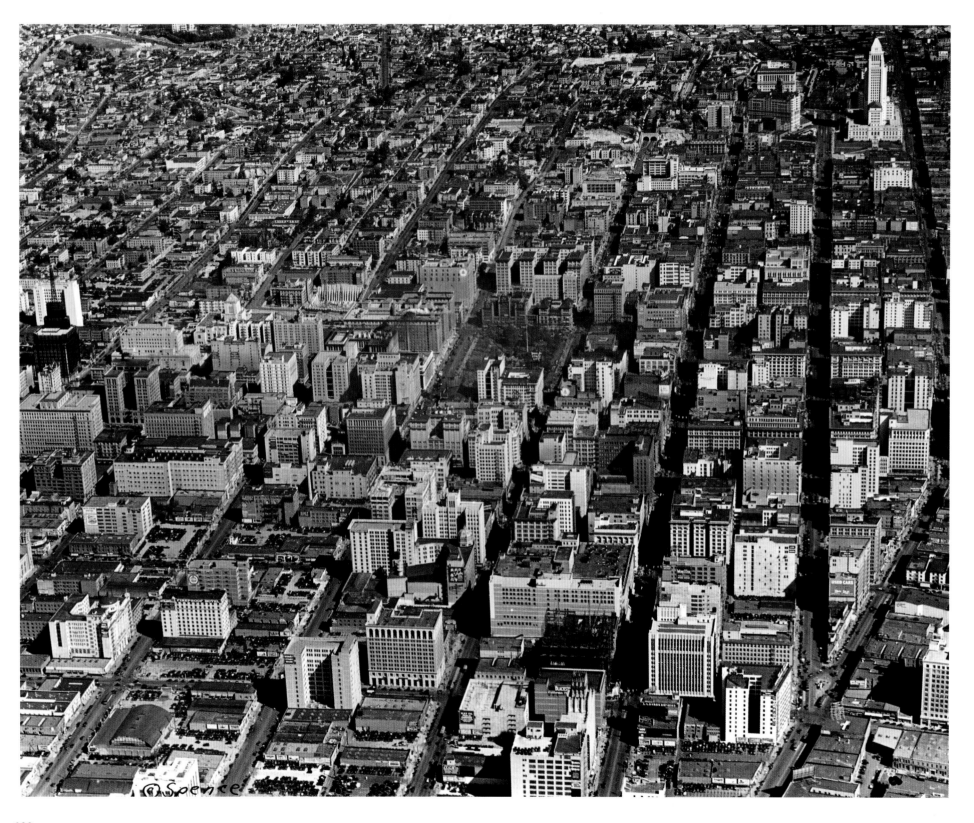

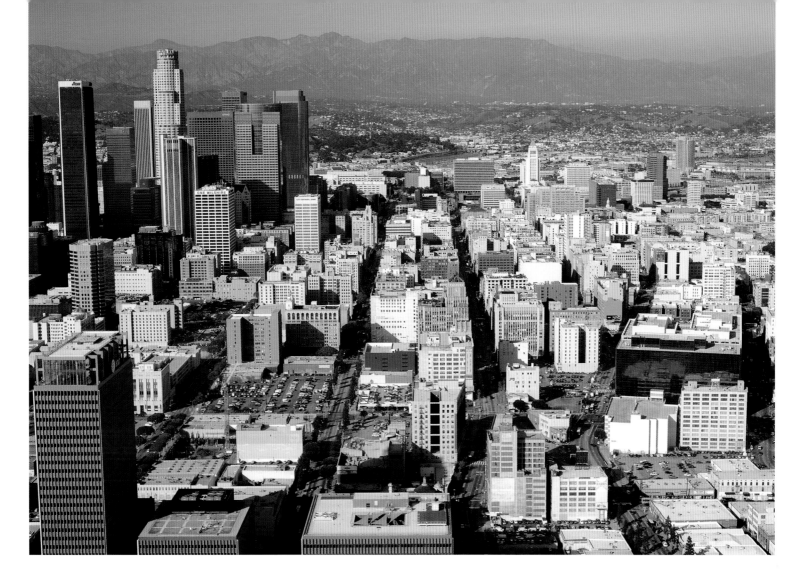

DOWNTOWN CENTRAL CITY

Left: The Roy C. Seeley Company commissioned this photograph in 1930, just two years after the completion of the Los Angeles City Hall. Seeley was the founder of the industrial real-estate company bearing his name and one of the founders of the Society of Industrial Realtors. South Main Street is just to the right of City Hall, and South Spring Street is to its left. South Spring dies out at the triangle where it meets South Main. In 1898 Thomas Edison rode down South Spring with a camera mounted on a wagon and filmed for sixty seconds. He called it "South Spring Street, Los Angeles, California," and that could be said to be the birth of the movie industry in Los Angeles. Broadway parallels Spring as the next street to the left and Hill runs to the left of Broadway; then comes Olive Street. Pershing Square is visible between Olive and Hill streets. Grand and Hope streets round out the north-south byways in the photograph. Shoppers on Broadway spent their money at places like Orbach's at Fifth Street or Bullock's at Seventh Street.

Above: The AT&T Center between South Olive and South Hill streets on the bottom left heads the march of downtown skyscrapers. The tree-lined area with the rose-colored buildings from another era just up Hill Street is Pershing Square. The seventy-three-story U.S. Bank Tower, the tallest building in the picture—and the tallest building in the world with a helipad on its roof—reigns over a cluster of high-rise buildings that includes the sixty-two-story Aon Building, in the background on the far left. The Aon Building calls to mind the former World Trade Center building in New York. Other skyscrapers to the right of the U.S. Bank Tower are the gray multilayered Gas Company Tower and the brown Wells Fargo Center in between. All of these buildings tower over City Hall, which stands alone as the tallest building on the far right on South Main Street. It's difficult to fathom that the thirty-two-story City Hall stood as Los Angeles's tallest building from 1928 to 1968.

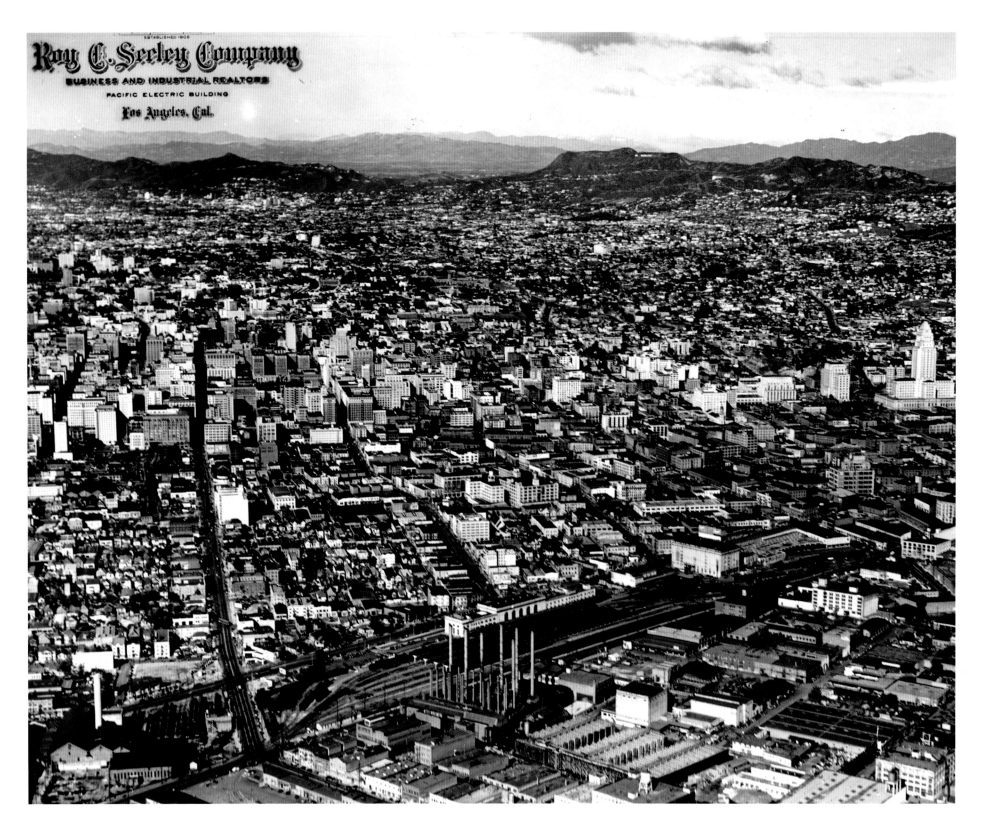

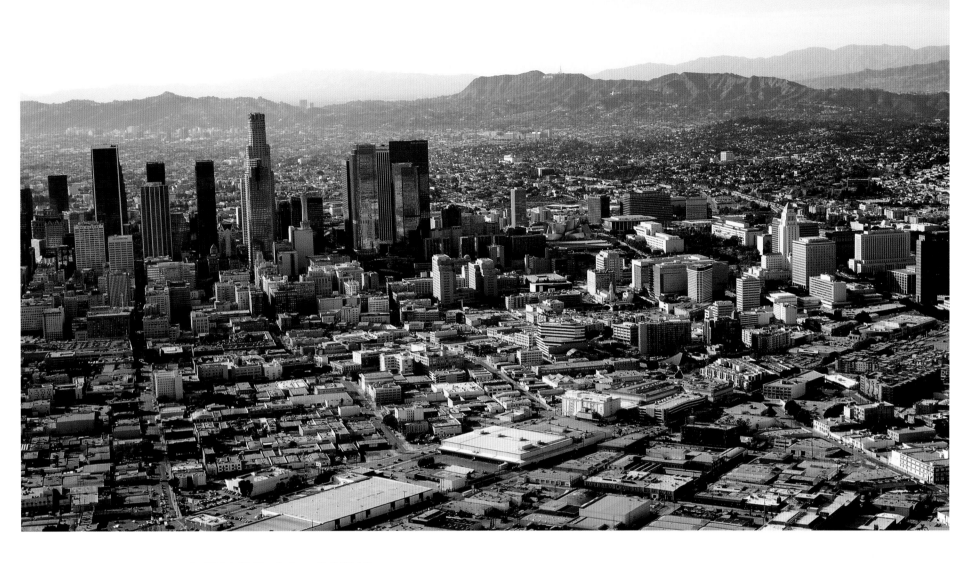

DOWNTOWN CENTRAL CITY

Left: In the bottom left of this 1939 photograph commissioned by the Roy C. Seeley Company, South Sixth Street bends as it reaches South Alameda Street to cross South Central Avenue and takes traffic downtown. The building standing alone to the right up South Central is Los Angeles Cold Storage, which provided block ice to homes and businesses in the days before home refrigerators. The company also supplied ice and "freezer buildings" for movie directors who needed winterlike settings in the Southern California climate. With the arrival of the home refrigerator and freezer, the demand for ice blocks lessened. City Hall stands as the city's tallest structure on the right-hand side of the photograph. The U.S. Court House, which was built in 1937, stands nearby. The famous Hollywoodland sign, built in 1923, is visible on Mount Lee in the Santa Monica Mountains in the distance.

Above: As in the previous photo, the Santa Monica Mountains provide the backdrop for this sweeping view of Los Angeles. The city's Wholesale District, with its flat-roofed warehouses, stretches along Alameda Street. The Los Angeles City Hall blends in with other government buildings in the Civic Center District. The Walt Disney Concert Hall, which opened in 2003, is visible just to the left of the Los Angeles County Court House. Architect Frank Gehry designed this gift from Walt Disney's family to the people of Los Angeles. The hall is home to both the Los Angeles Philharmonic orchestra and the Los Angeles Master Chorale. All these elegant structures blend together to shape today's downtown Los Angeles.

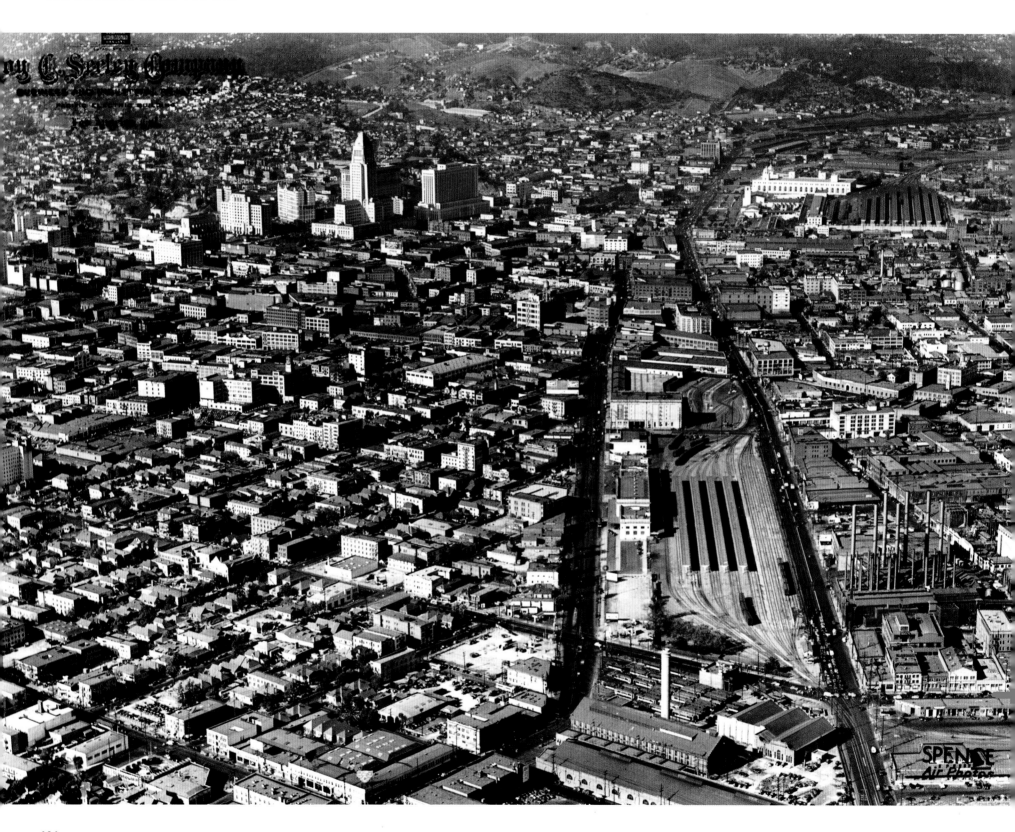

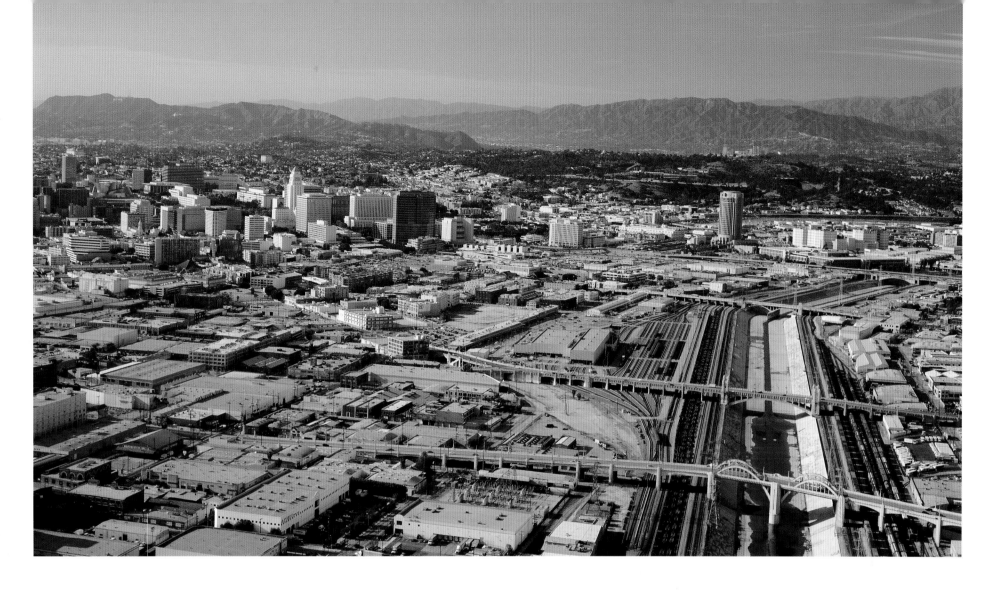

DOWNTOWN CENTRAL CITY /
LOS ANGELES RIVER

Left: Union Station stands out in the upper right-hand side of this photograph that Spence Air Photos captured in 1939. The train depot opened that same year as the last rail passenger terminal built in the United States. It was not the first railroad station in the city, however. In 1891 the Los Angeles Terminal Railway opened a station on First Street just east of the Los Angeles River; it burned in 1924. The Santa Fe Railroad's elaborate La Grande Station once stood on the Los Angeles River's left bank, just south of the First Street Bridge near the tip of the Santa Fe's rail yards, seen along the river in this photograph. The 1933 Long Beach earthquake severely damaged La Grande Station; its Moorish-style dome had to be removed. The opening of Union Station spelled the end for the grand old station; La Grande was closed and demolished soon after the new station opened.

Above: The Sixth, Fourth, and First street bridges line up to cross the channelized Los Angeles River. The Sixth Street Bridge with its twin spans is the most iconic of the trio. The Beaux Arts–style arches on the First and Fourth street bridges echo the City Beautiful movement. In 2008 the city designated all three bridges, which were built between 1929 and 1932, as Historic-Cultural Monuments. It's under these bridges that John Travolta races in the movie *Grease*. The fourth bridge in the picture was built in the 1960s to carry traffic on Highway 101 across the river. Just beyond the Highway 101 Bridge, the Gateway Transit Center towers over nearby Union Station. Metrolink provides service to Union Station in the form of three rail lines—Red, Purple, and Gold. Today's Union Station has fourteen train tracks that serve both Amtrak and Metrolink; around 400 trains depart from the station daily.

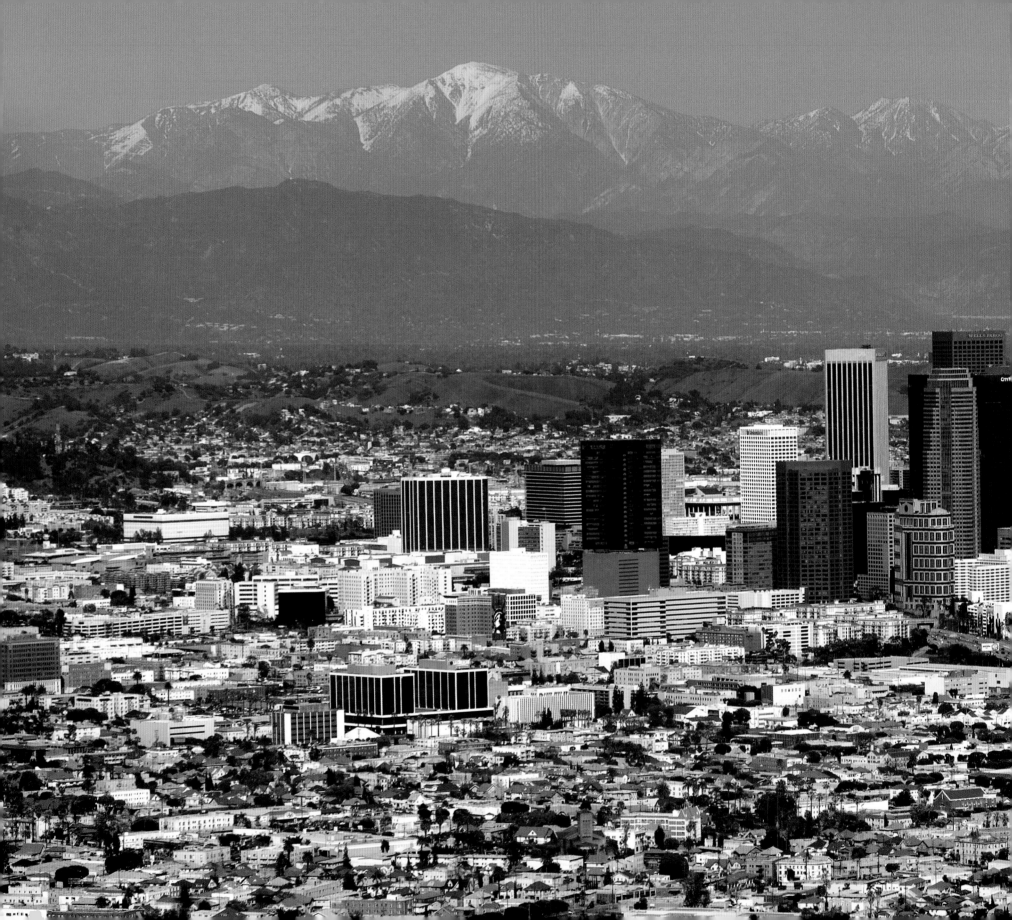

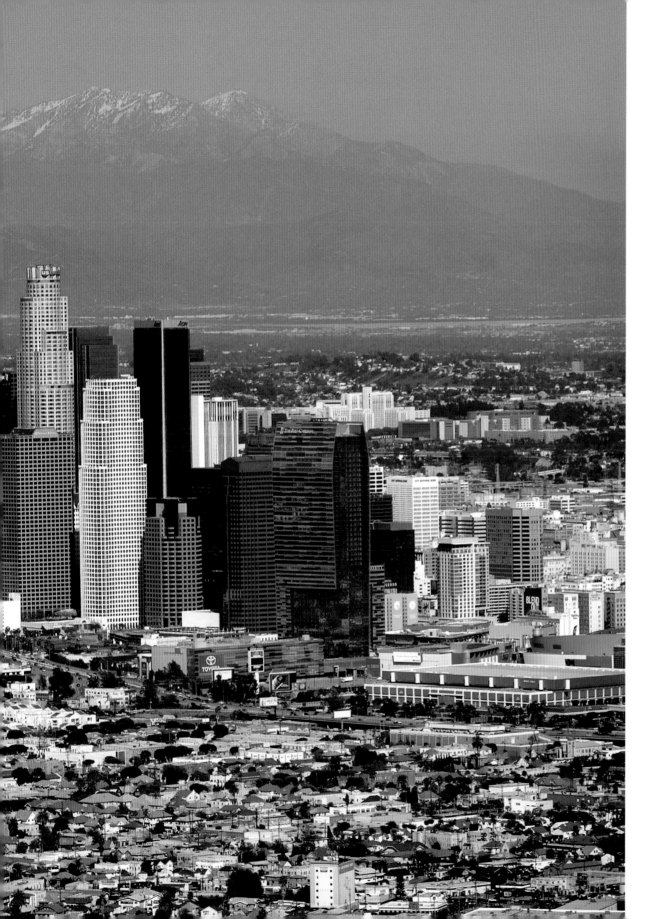

DOWNTOWN

Mount San Antonio, also called Mount Baldy for its lack of trees, and nearby Thunder Mountain in the San Gabriel Mountains wear their seasonal dusting of snow to form a backdrop to the Los Angeles skyline. The native Tongva people's name for Mount Baldy was Yoat, which means "snow." Despite the city's reputation for being spread out, its dense downtown skyline is among the nation's most compact. JW Marriott's LA Live Hotel glistens blue just behind the Staples Center. This 2010 addition to the skyline stands just in front of the dark brown TCW Tower. The smaller 801 Tower, with just twenty-four stories and twin top floors, is the next high-rise to the left. The stepped white 777 Tower is just up the street, with the Bank of America Center towering in between. The numbers 801 and 777 refer to the addresses the buildings occupy on South Figueroa Street. The light brown Ernst & Young Plaza takes its spot in front of the U.S. Bank Tower, the city's tallest building.

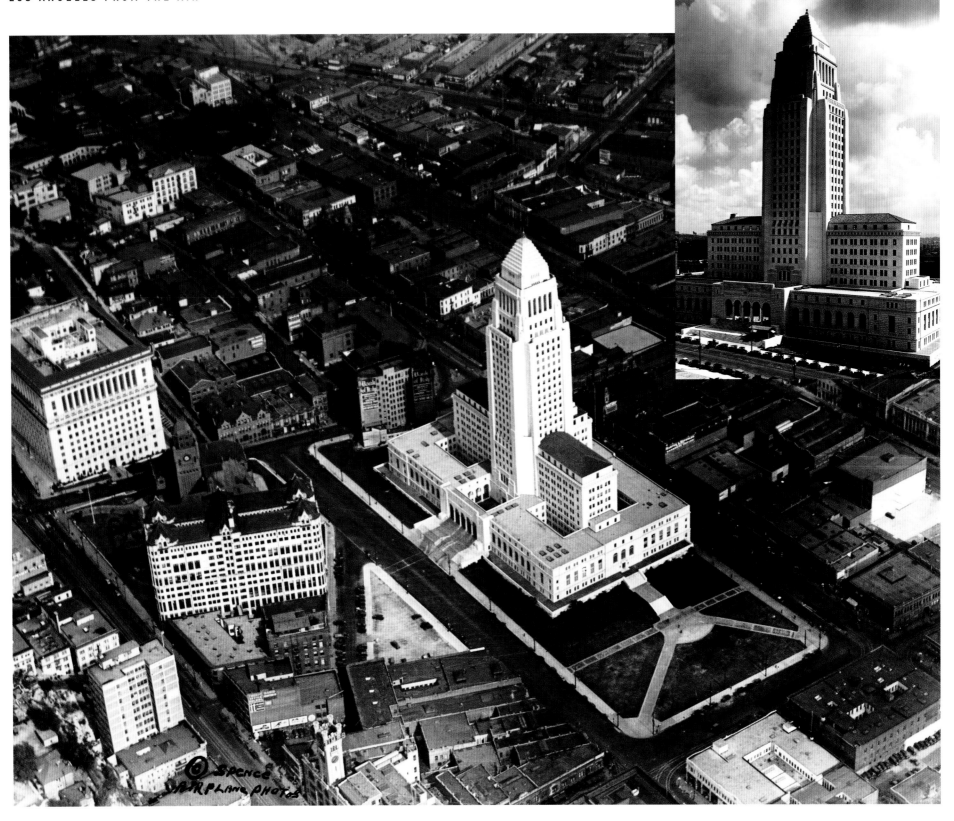

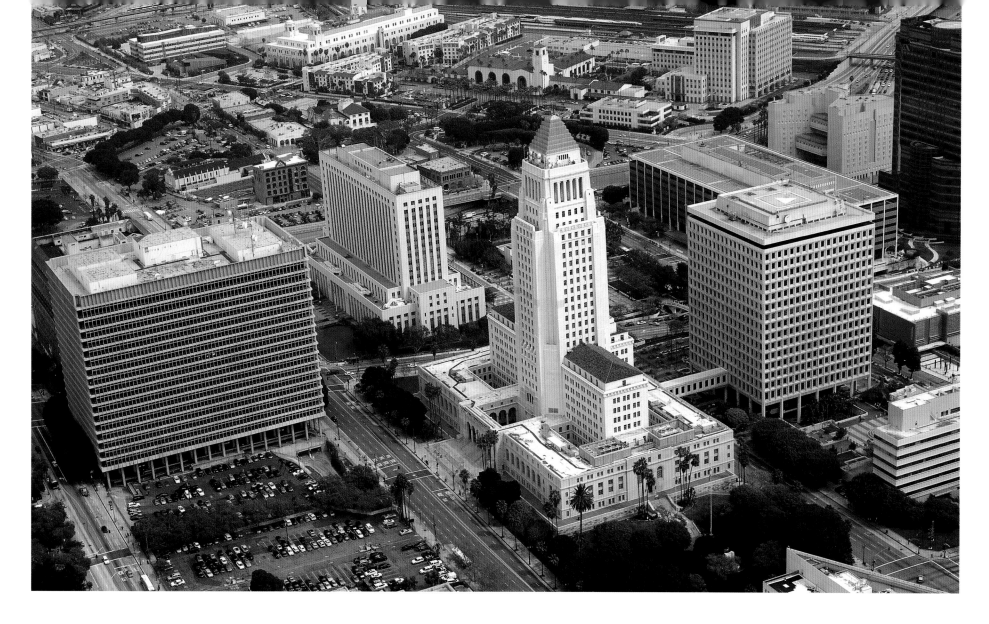

CITY HALL

Left: City Hall began scraping the sky just as the 1920s were coming to end. Architects John Parkinson, John C. Austin, and Albert C. Martin Sr. designed the thirty-two-story building that, at 454 feet, stood as the tallest building in Los Angeles until 1968, when the 514-foot Union Bank Building rose up. The building is Los Angeles's third city hall building. The first, the Rocha House, stood on the northeast corner of Spring and Court streets; the second, a grand Romanesque Revival affair, stood on Broadway between Second and Third streets. Builders fashioned the concrete in its tower using sand from each of California's fifty-eight counties and water from the state's twenty-one historical missions. An image of City Hall has graced the Los Angeles Police Department's badges since 1940 and became a television icon when Joe Friday (played by Jack Webb) kept the city free of crime in the 1950s on the television series *Dragnet*.

Above: City Hall boasts an observation level, which is open to the public, on the twenty-seventh floor. The Metro Red Line's Civic Center Station serves City Hall and the adjacent federal, state, and county buildings. The 1971 Sylmar earthquake, the 1987 Whittier earthquake, and the 1994 Northridge earthquake all damaged City Hall to varying degrees. Between 1998 and 2001, the building underwent a seismic retrofit that should allow it to sustain minimal damage and remain functional in the event of a magnitude 8.2 earthquake. Making the building as safe as possible is nothing new. The building's original architects separated each floor with flexible compression zones that mimic the human spine in their ability to twist, shake, and return to their original form. Government functions have grown over the years to necessitate the building of a sixteen-story City Hall East and an eight-story City Hall South.

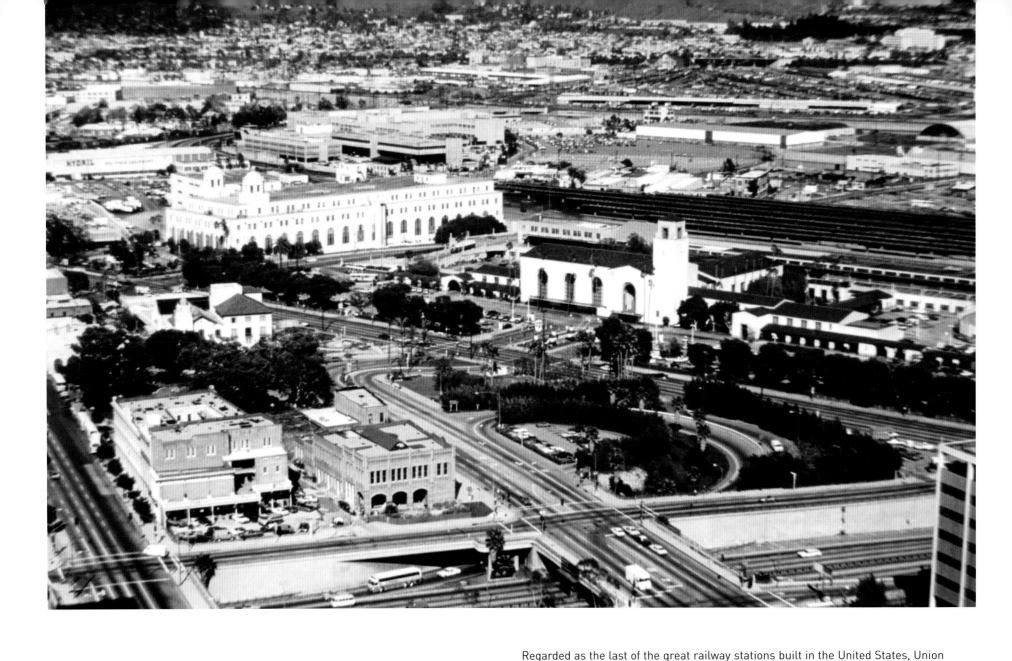

Regarded as the last of the great railway stations built in the United States, Union Station opened in May 1939. The main terminal can be seen just right of center with its Mission Revival–style tower in this 1978 photo taken from the top of City Hall. The Post Office Terminal Annex looms over the terminal. The Los Angeles Plaza, site of the original pueblo, can be seen at the lower left, including the rear of the 1870 Pico House, one of the oldest buildings in town. Decorative elements of the station include enclosed garden patios flanking the waiting room, walls covered in travertine marble, and terra-cotta tile floors with a strip of inlaid marble. The station originally served the Atchison, Topeka, and Santa Fe Railway; the Southern Pacific Railroad; and the Union Pacific Railroad, as well as the Pacific Electric Railway and Los Angeles Railway. After heavy use during World War II, the station saw declining use as air and automobile travel became more common.

UNION STATION

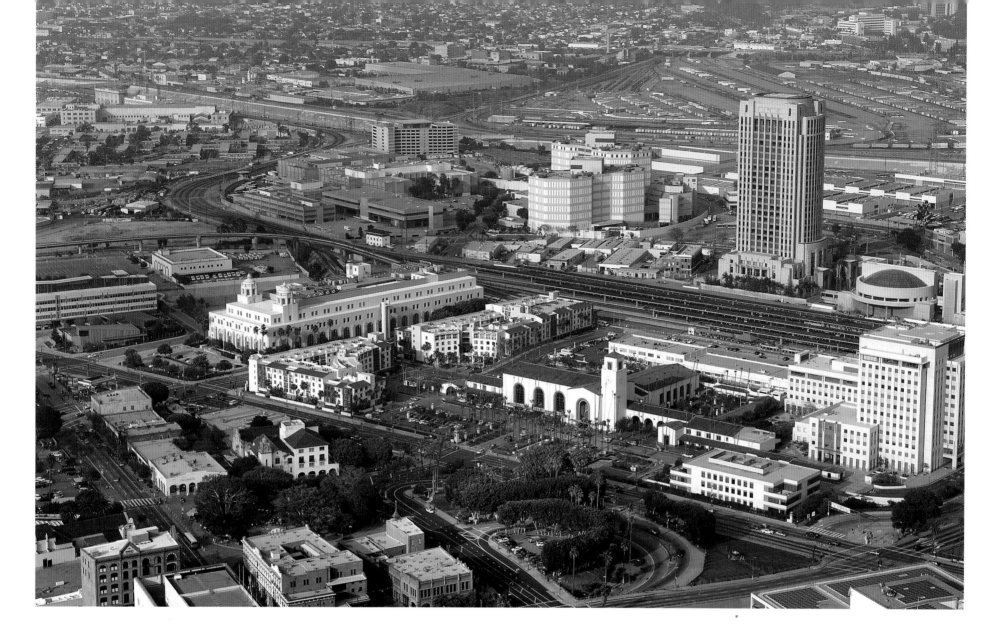

The 1990s brought Union Station back into prominence. The arrival of the city's Metrolink subway service returned passengers to the platforms. With service branching out to Oceanside, Riverside, San Bernardino, Antelope Valley, Orange County, and Ventura County, and the cost of driving an automobile increasing, ridership on Metrolink has bloomed to an estimated ten million annually. A record 16 percent jump in ridership occurred in 2008 when gas prices rose dramatically. The station also serves passengers on Amtrak, the consolidated national rail company. Using Amtrak, travelers can take long-distance trains to Chicago via San Antonio, or to Orlando via New Orleans. Bus service connects Union Station with Orange County, Santa Clarita, Santa Monica, and other surrounding regions. Many films have used Union Station as a backdrop, including *Silver Streak*, *Blade Runner*, *Speed*, and *Pearl Harbor*, and the television shows *24* and *Quantum Leap* also featured the railroad station.

WILSHIRE BOULEVARD

Wilshire Boulevard is one of the city's principal roads. It was named for Ohio native Henry Gaylord Wilshire, who made—and lost—fortunes in real estate, farming, and gold mining. In the 1890s, Wilshire cleared out a path in his barley field and initiated what was to become his eponymous street. The artery connects five of the city's major business districts with Beverly Hills and Santa Monica. Along its sixteen miles, through three cities from downtown Los Angeles to the ocean, Wilshire Boulevard is lined with buildings representing virtually every major architectural style of the twentieth century. Many of the city's skyscrapers are along Wilshire; one of the oldest and tallest is known simply as One Wilshire. In this 1928 photo, the Wilshire Boulevard Christian Church appears at the right, with the Brown Derby restaurant just nudging into the frame below it. Billboards took advantage of heavy traffic to promote movies like *Four Sons*, a silent drama directed and produced by John Ford.

The Brown Derby restaurant is a memory, but the Wilshire Christian Church still presides over the scene, dwarfed by condos and office towers. The church's congregation merged with two others in 1940 and dropped the "Boulevard" from its name. Today the church thrives with a robust slate of activities. The Wilshire Christian Church sits at the corner of South Normandie Avenue, just across the street from the former site of the Ambassador Hotel. The center has a diverse residential population of about 130,000 and there is a large concentration of Korean-owned businesses in the area.

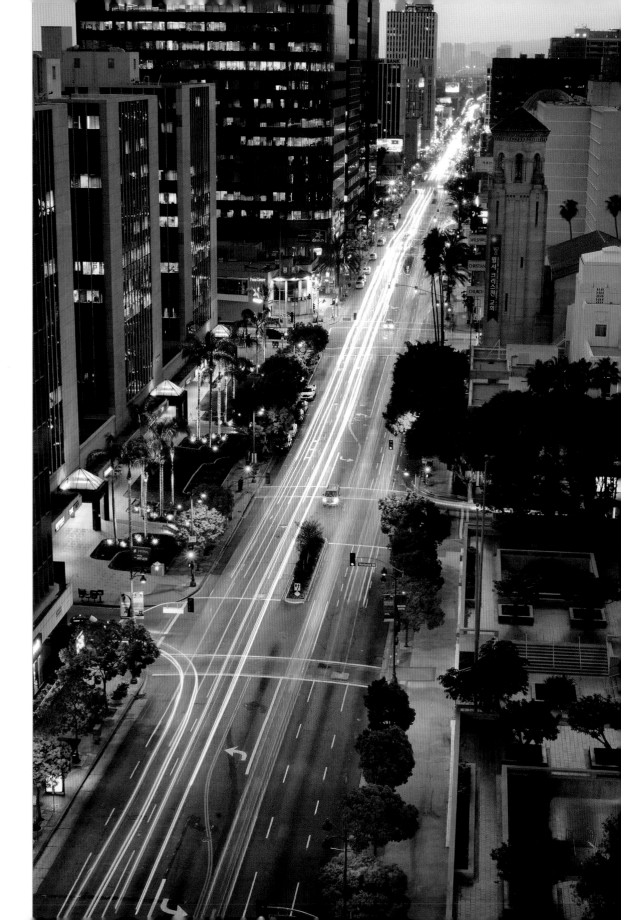

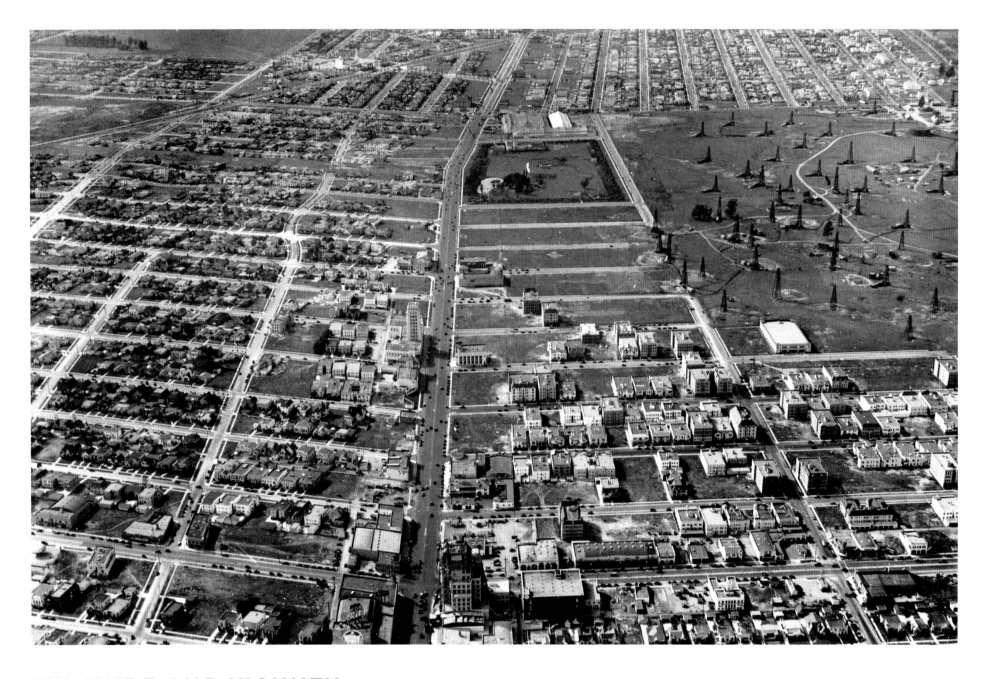

WILSHIRE AND VICINITY

Los Angeles legend tells of the visionary Edward L. Doheny, who first noticed the abundance of a particular gooey black substance caked onto the wheels of a passing cart. The year was 1892. Doheny asked the cart's driver where he'd come from. The driver pointed to an area near today's Dodger Stadium and Echo Park. Doheny quickly purchased a thousand acres, which then lay outside the city limits. Before long, he was producing forty-five barrels of crude oil a day, and was well on his way to becoming a wealthy man. His discovery caused the city's first real-estate boom. Doheny's oil field has long since dried up, but he started an avalanche, and by the turn of the century some 200 oil companies serviced about 2,500 wells in the area. A cluster of oil derricks can be seen on the right-hand side of this 1930 photograph of the Wilshire area.

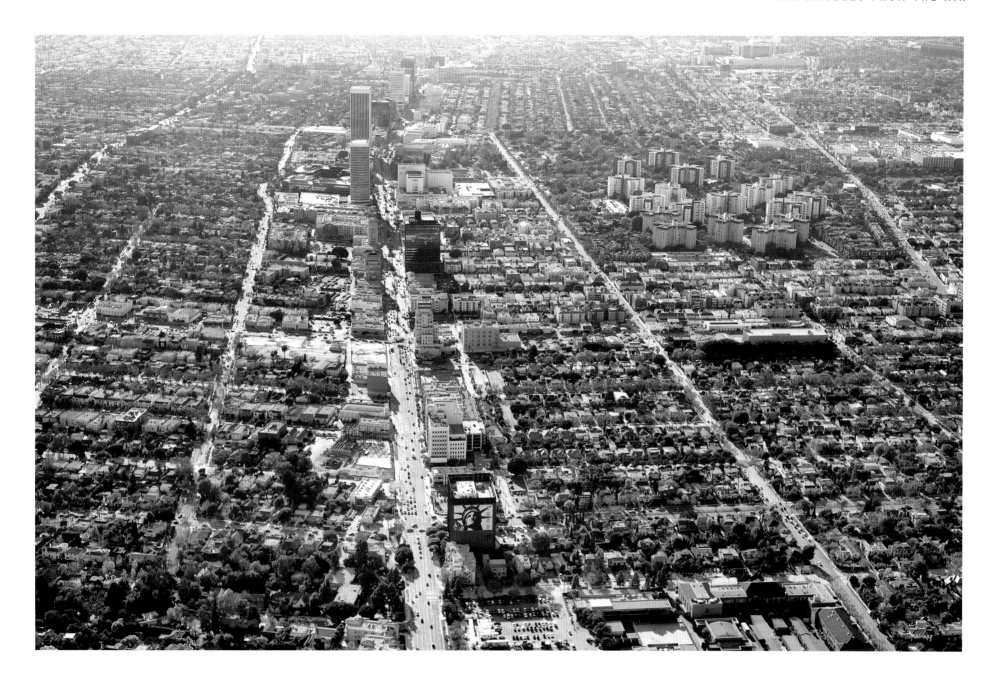

Oil derricks no longer stand out on the landscape that stretches along Wilshire Boulevard to the foot of the Santa Monica Mountains. The street has been home to many oil companies, including Occidental Oil and Gas at 10889 Wilshire, which is one of the boulevard's largest oil companies. "Oxy," as it is known, is the fourth-largest U.S. oil and gas company. Since many of the oil industry's production facilities stand not too far from Beverly Hills and other high-end addresses, the derricks have largely been covered with soundproof, windowless structures to avoid offending anyone's eyes. Today's landscape features several churches and libraries that oil pioneer Edward Doheny donated to the community in which he made his fortune.

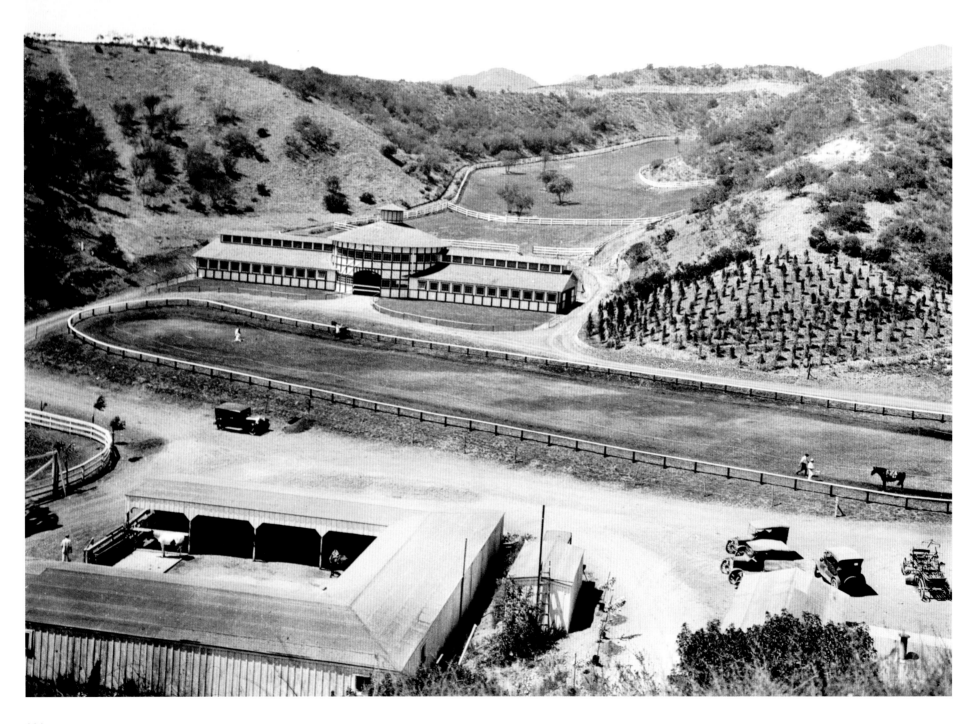

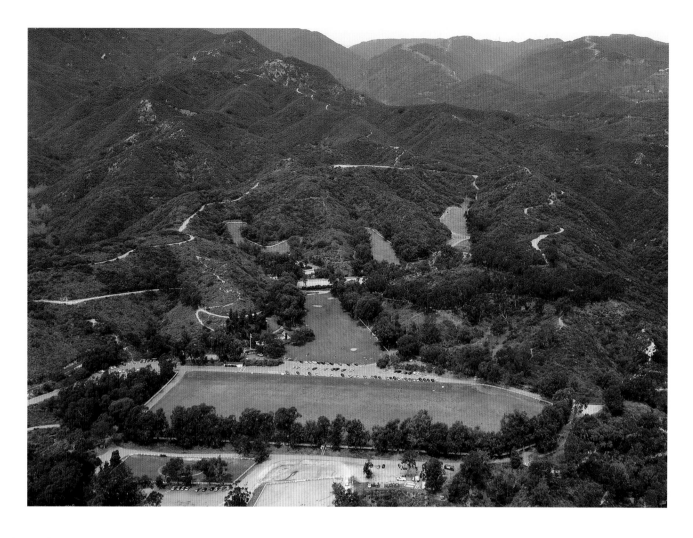

WILL ROGERS RANCH

Left: This 1928 aerial view of the riding ring on Will Rogers's ranch shows the polo stable in the background and western stable in foreground. Rogers's house on the site boasted thirty-one rooms, eleven bathrooms, and seven fireplaces, and the estate included a golf course—all on 186 acres. In the 1930s, Rogers was the highest-paid and most popular actor in Hollywood. His cowboy roping act launched a career that took him from vaudeville to newspaper columns, and then to radio and movies. Rogers's unique take on philosophy yielded practical commentary that is still hilarious today; for example, "If you find yourself in a hole, stop digging." Rogers befriended pioneer aviator Wiley Post, who ran his planes out of Burbank Airport. In 1935 Rogers asked Post to give him a tour of Alaska to help find material for his newspaper columns. While en route to Point Barrow from Fairbanks, they set down in a lagoon to establish their location. On takeoff, an engine failure caused the plane to stall, and the right wing sheared off as it crashed back into the lagoon; both occupants were killed instantly.

Above: Following the untimely death of her husband, Betty Rogers made the State of California the main beneficiary of her will. When she died in 1944, the Rogers ranch became a state park. Tours of the ranch house are offered, and the park promotes itself as a fully functioning ranch with horseback-riding lessons available and a roping and riding arena for would-be cowpokes. Adventurous horseback riders, hikers, and mountain bikers can access the Santa Monica Mountains through hiking trails maintained at the park. In January 2005, the park began offering free Wi-Fi service for those who brought high-tech devices like laptops and smart phones to the wilderness. Perhaps while lounging on the slope overlooking a match on the polo grounds, these visitors will pull out their phone and find a Will Rogers quote such as, "You know horses are smarter than people. You never heard of a horse going broke betting on people."

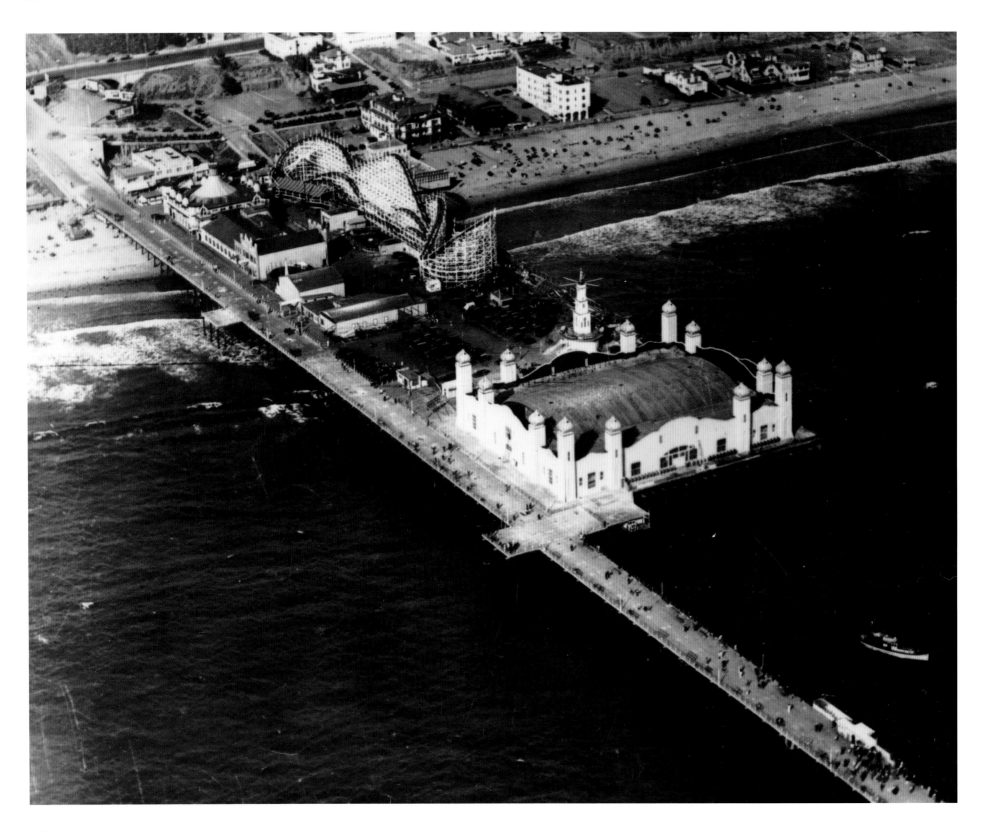

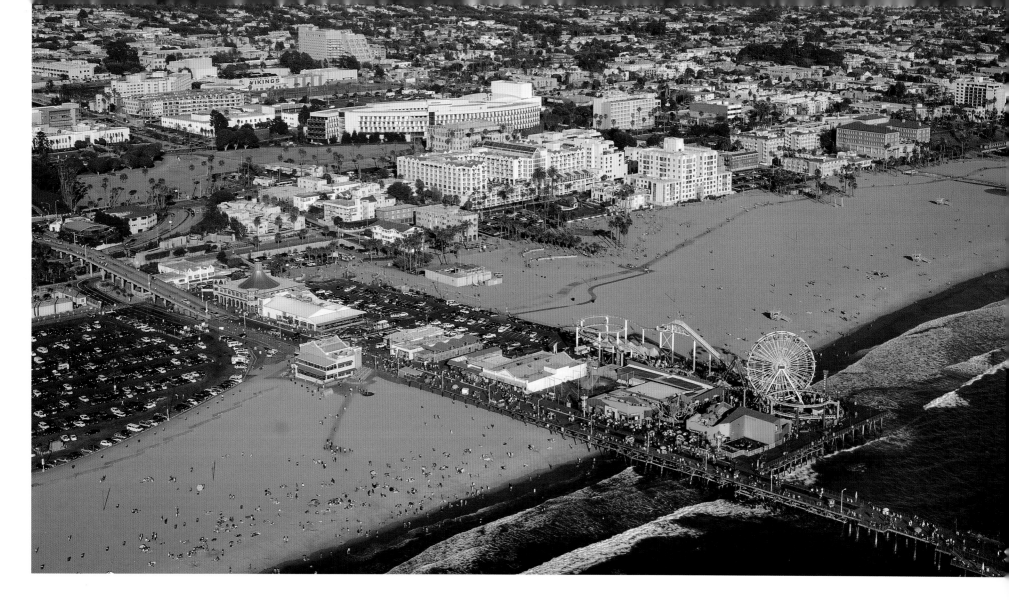

SANTA MONICA PIER

Left: Construction of the Santa Monica Municipal Pier began in May 1908. The pier opened to the public sixteen months later on September 9, 1909. Thousands swarmed onto the 1,600-foot-long concrete structure to enjoy band concerts and swimming races. This first pier was built to satisfy the city's sanitation needs, but quickly attracted fishermen. Soon plans were afoot to build an amusement pier right next door. Famous carousel manufacturer Charles I. D. Looff arrived in February 1916 and bought the land just south of the Municipal Pier. He then built the adjoining Pleasure Pier with a hippodrome to house a carousel; the building still stands as Santa Monica's first National Historic Landmark. Looff passed away in 1918, and his family ran the pier until 1923, when they sold it to the Santa Monica Amusement Company, whose plans included expanding the pier's thrill rides. This 1924 photograph shows the impressive La Monica Ballroom, which had just been built at the time of this shot.

Above: The 1930s brought "Muscle Beach" to the pier with bodybuilders like Jack LaLanne and Joe Gold of Gold's Gym fame. In 1940 the neon sign at the top of the pier ramp lit up for the first time. The world's first Hot Dog on a Stick restaurant appeared on the pier in 1946, and the Playland Arcade made its appearance in the 1950s. The La Monica Ballroom survived until 1962, spending its last years as a roller-skating rink. The pier survived various attempts by the Santa Monica City Council to raze it—including one that envisioned an island with a 1,500-room hotel—but the threat was finally revoked in 1973. Ten years later, a pair of violent storms almost accomplished what the city council couldn't, and the pier dodged another bullet. Today's visitors can still soar over the pier on a vintage Ferris wheel that dates back to the 1920s. They can visit an aquarium, try their luck in the arcade, and enjoy a drink or dinner in one of the pier's pubs or restaurants.

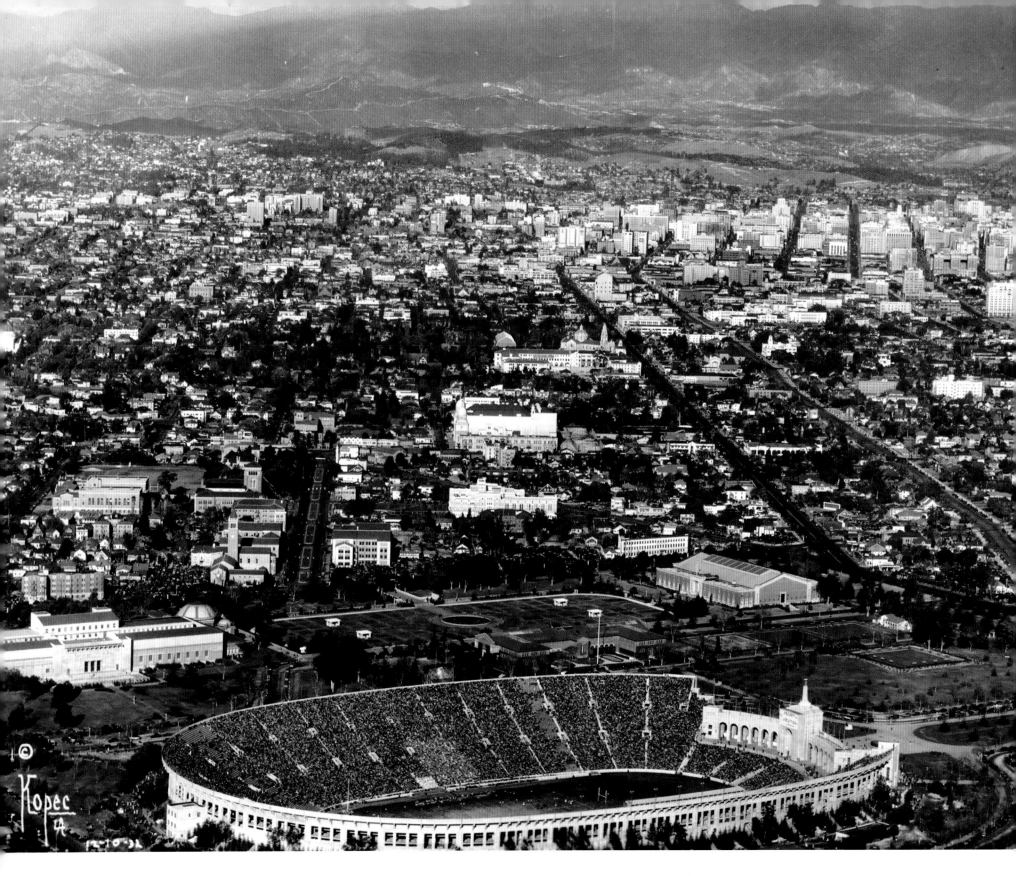

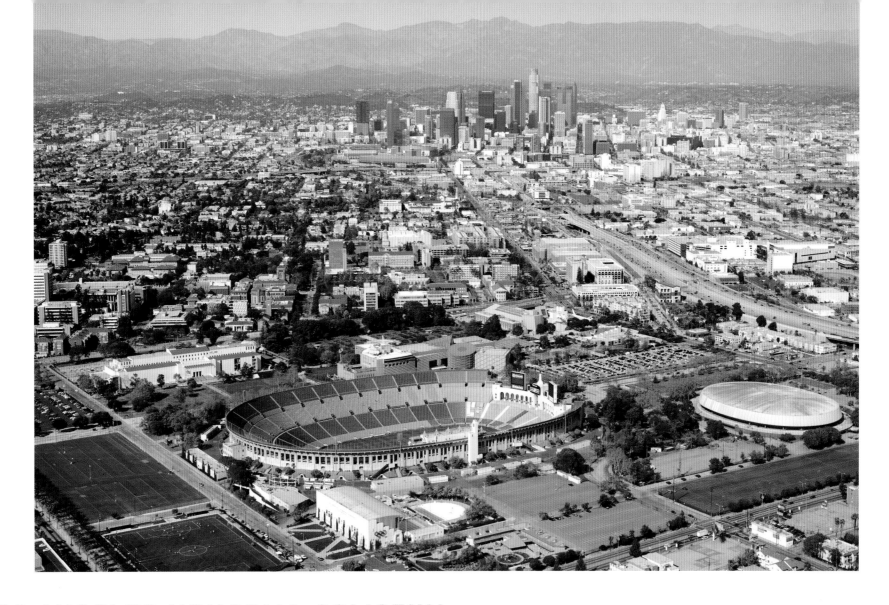

LOS ANGELES MEMORIAL COLISEUM

Left: Commissioned in 1921 to remember veterans of World War I, the Los Angeles Memorial Coliseum opened in 1923. At a cost of just under $1 million, the venue offered a seating capacity of 75,144. The first football game held in the stadium took place on October 6, 1923, when the University of Southern California Trojans beat Pomona College, 23–7. By 1930 Los Angeles had emerged onto the world stage and earned the honor of hosting the 1932 Olympic Games. The city scrambled to accommodate everyone, expanding the Coliseum's seating to 101,574. Fifty-two years later, the stadium did it again, hosting the 1984 Olympics. The Olympic cauldron torch remains on site, as do other Olympic symbols and statues. At the Coliseum's Court of Honor, visitors can learn about Olympic history through plaques and a full list of the 1932 and 1984 gold medalists.

Above: The State of California, Los Angeles County, and the City of Los Angeles jointly own the Los Angeles Memorial Coliseum, located in today's University Park neighborhood. It is the only stadium in the world to have hosted two Olympic Games, as well as the only Olympic stadium to have also hosted the Super Bowl and the World Series. The Coliseum became a National Historic Landmark on July 27, 1984, the day before the opening ceremony of the 1984 Olympics. In dramatic Hollywood fashion, the Olympic cauldron still sees regular use. In solidarity, the torch is lit during Olympics held in other cities. When tragedy strikes, the torch may stay lit for days, as it did after the 1986 space shuttle *Challenger* disaster. The torch burned for a full week after the September 11, 2001, terrorist attacks, and again in honor of President Ronald Reagan after his 2004 passing. The Los Angeles Memorial Sports Arena was built next to the Coliseum; it opened on July 4, 1959.

VENICE BEACH

Venice Beach has long been a place of revelry and recreation. From the earliest amusement piers, to the beat poets, to today's street performers, pedestrians, and cyclists, the beach and beachside promenade are considered a significant center of Los Angeles culture. Prominently displayed in this photograph, the Venice Beach fishing pier reaches just over 1,300 feet into the Pacific. First opened in 1964, the pier had to be closed in 1983 and 2005 after sustaining damage from storm swells. The Venice Breakwater, farther in the distance, gave rise to the famous Venice Beach surf spot, and beachfront basketball courts are visited by some of the best college and professional basketball players during the off-season. At its north end, Venice blends into Santa Monica Beach, and the Santa Monica Pier appears in the far distance. Today, Venice's downtown features much in the way of hip culture: bars, nightclubs, art galleries, and edgy apparel shops abound. Among the city's prominent residents are actresses Julia Roberts, Kate Beckinsale, and Anjelica Huston.

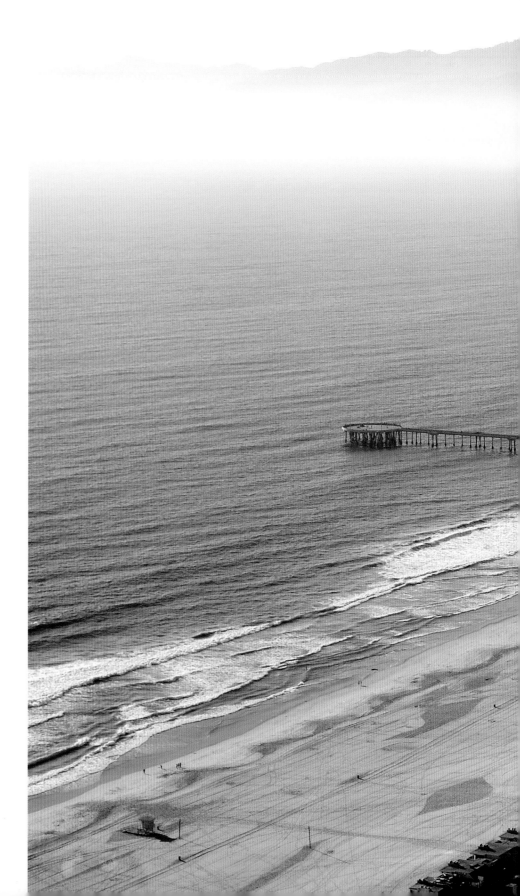

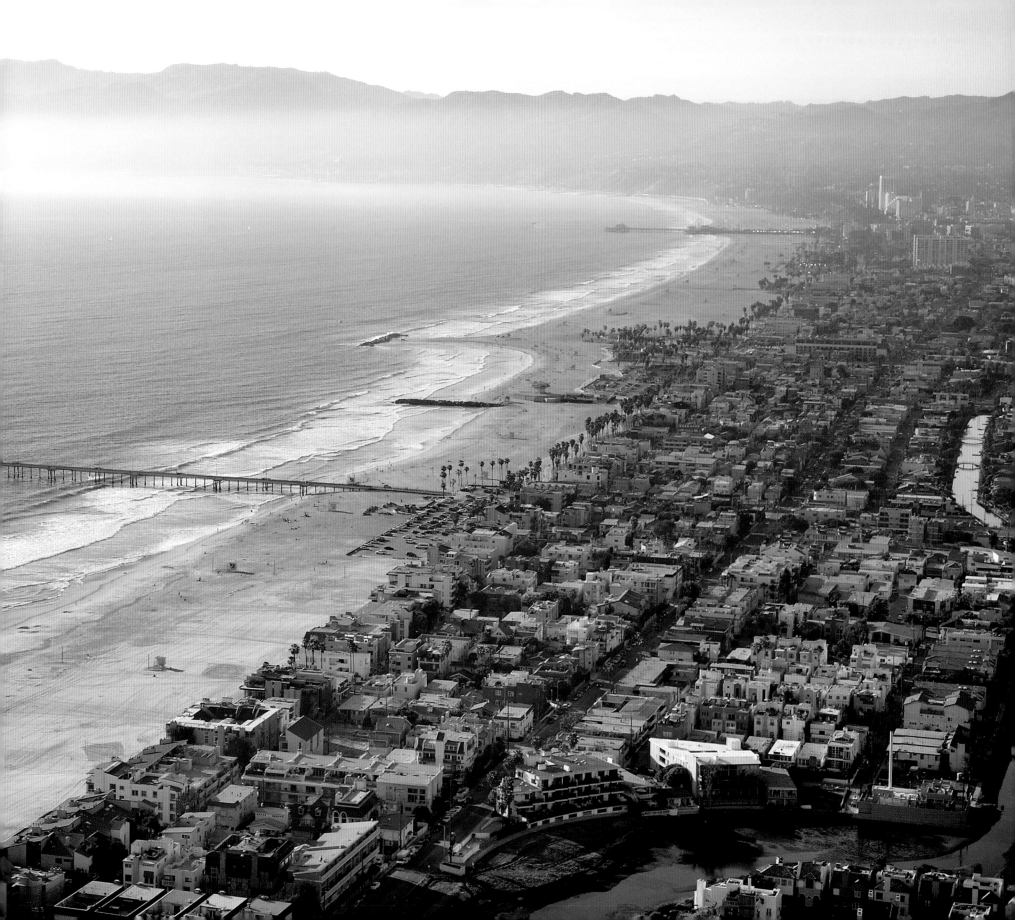

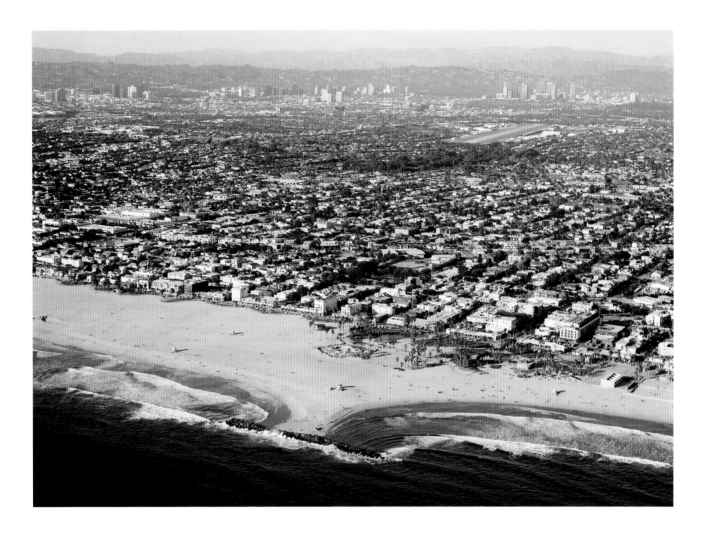

VENICE BEACH

Left: Venice Beach dates back to 1905, when it started life as a beach resort called Venice of America. Abbot Kinney used his tobacco millions to buy two miles of oceanfront real estate. He hoped to turn the marshy land at the property's southern end into a resort as impressive as Venice, Italy. He dug miles of canals and drained the marshes so he could offer building sites on dry land, but that was just the start. He hired gondoliers, put up rental cottages, and built the main attraction, the 1,200-foot-long Kinney Pier, seen here in this 1925 photograph. It was already the second pier on the site, the first having burned in 1920. It was chock full of amusements, an auditorium, a restaurant, a dance hall, and a hot saltwater plunge. The town had a block-long arcaded business street with Venetian architecture and a miniature railroad. Kinney's town had more than 3,000 residents after just five years and grew to 10,000 soon after. On some weekends, an estimated 150,000 tourists arrived. He ruled his town with an iron fist until his death in 1920.

Above: Sand on the shoreline seems to point the way to the site of Abbot Kinney's long-disappeared pier. Los Angeles annexed Venice Beach five years after Kinney's death, and closed the pier as soon as the lease ran out. By 1929 the majority of the canals had been paved over. Discovery of oil nearby added to the decay of the place as a resort. Today, the few remaining canals set Venice Beach apart, and the circuslike Ocean Front Walk continues a spirit of amusement. Walking, bicycling, and working out at the famed Muscle Beach are popular activities at the seafront. Muscle Beach is famous for its beachside weight pen, which has been frequented by notable bodybuilders such as California governor Arnold Schwarzenegger. Venice is where Jim Morrison met Ray Manzarek to form the Doors. An endless series of movie scenes have been shot here, starting with Charlie Chaplin's *Kid Auto Races at Venice* and *The Circus*, all the way to *Million Dollar Baby*.

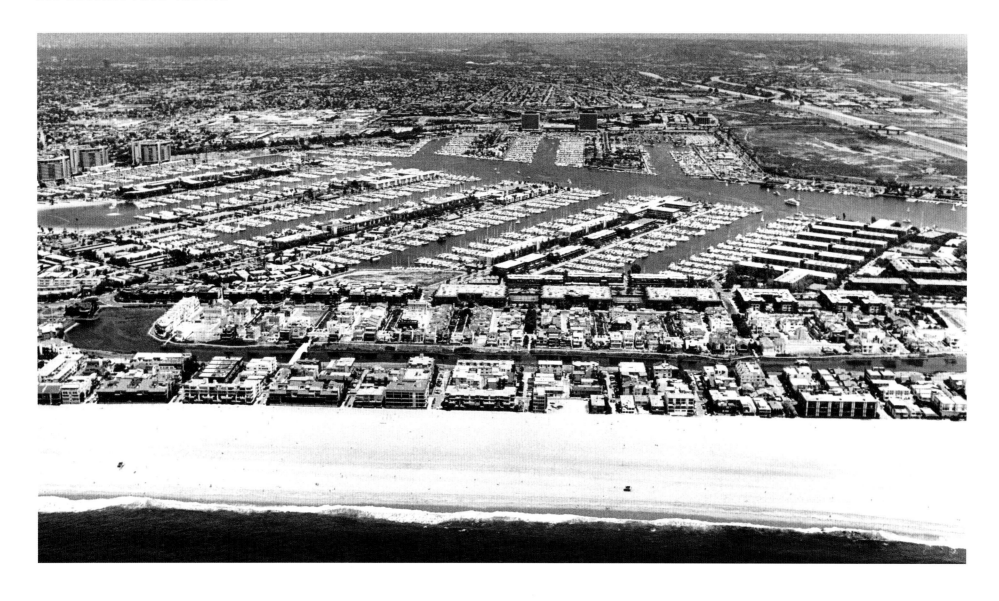

MARINA DEL REY

The Los Angeles River once met the Pacific Ocean near here. Over time, the river shifted and began emptying into Los Alamitos Bay in Long Beach. As the river meandered southward, it left behind the two-mile-wide Del Rey Lagoon. The area became part of the Rancho La Ballona, an 1839 Mexican land grant to the brothers Ygnacio and Augustin Machado and the father-and-son team of Felipe and Tomas Talamantes. Three droughts plagued the region between 1854 and 1864, decimating the rancho's cattle. In 1871 squatters began settling here. The first was Will Tell, who created "Tell's Place" to accommodate American hunters. In 1888 M. C. Wicks hoped to create a commercial port and formed the Ballona Development Company. The company failed three years later. Two attempts to create a harbor here in the early twentieth century failed. Success finally came with the completion of the marina's breakwater in January 1965 and the formal dedication of Marina del Rey four months later.

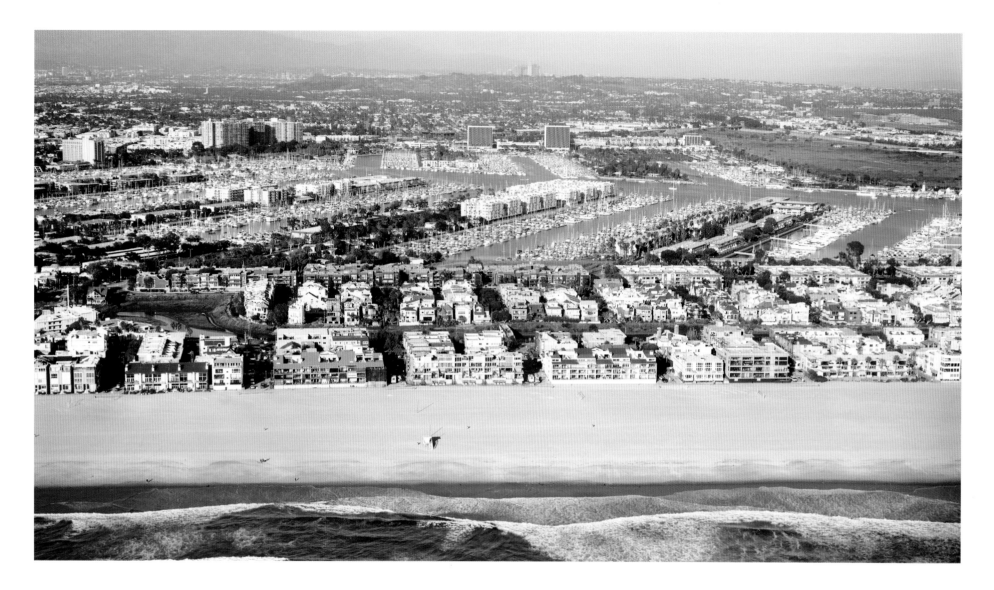

Today high-rise condos, hotels, apartments, shops, and restaurants serve boaters and landlubbers alike. Marina del Rey purportedly provides the most restaurant seating in a single square mile anywhere other than New York City. Boaters launch their crafts here around 100,000 times each year; 1,900 feet of guest docks encourage boating visitors to stop and enjoy the ambience. Fishers also enjoy their pastime on Marina del Rey's 180 feet of dock space set aside just for them. Los Angeles County governs this unincorporated area, which includes Burton Chace Park with its Marina del Rey Summer Concert Series. Recreational opportunities include boat and bicycle rentals, as well as ferry rides to Catalina Island. The University of Southern California's Information Sciences Institute and the Internet Corporation for Assigned Names and Numbers—the company that regulates Internet address and domain names—both call Marina del Rey home.

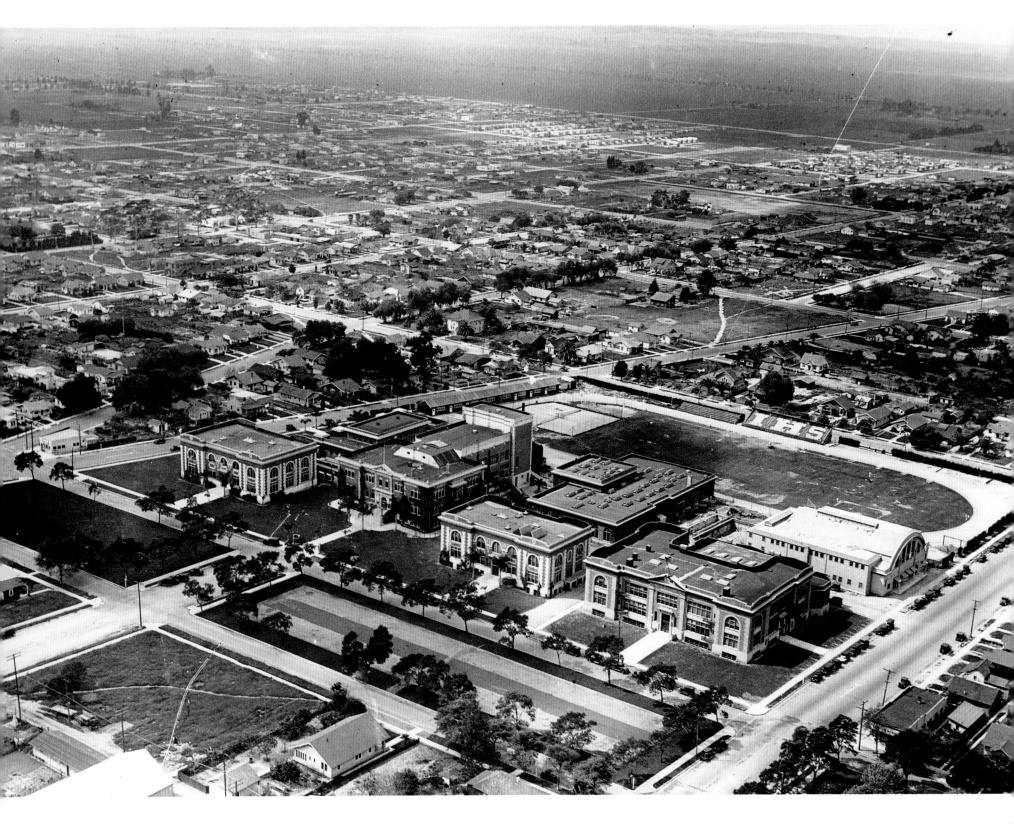

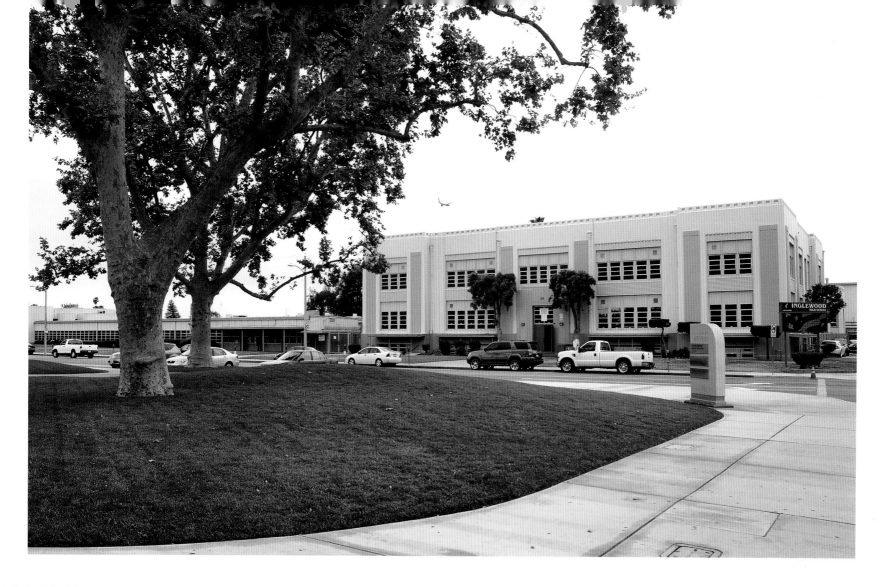

INGLEWOOD

Left: This 1926 photo features Inglewood High School prominently in the foreground. Inglewood's earliest residents were likely Native Americans who used the natural springs that ran from today's Edward Vincent Jr. Park—known until 1910 as Centinela Park—to the Pacific Ocean. In 1822 Ignacio Avila received a permit to build a corral and hut for herders. He named his 2,220-acre holdings Rancho Aguaje de la Centinela for the sentinels who watched over the livestock. Avila later built a three-room adobe overlooking the creek formed by Centinela Springs. In 1834 Ygnacio Machado built the Centinela Adobe. Two years later, the Mexican government granted Machado the Rancho Aguaje de la Centinela. Increasing numbers of American settlers moved in, and by 1888 they had established a school district. In 1904 a movement for secondary education gave birth to Inglewood High School, which graduated its first class (one boy and four girls) in 1908. By 1914 residents voted to expand the school, adding four more buildings and a power plant.

Above: In 1933, in the midst of the Great Depression, the Long Beach earthquake severely damaged Inglewood High School. The federal government's Works Progress Administration stepped in to help rebuild. According to one account, the school lost its magnificent stairway and all its fireplaces. In the meantime, students attended classes in temporary classrooms on Olive Street, which the students bemoaned as being "all too cold in winter and too hot most of the time." By 1937 Inglewood High School had 3,000 students. The Hollywood Park Racetrack was built nearby in 1938 and now also offers casino games. The track's most famous finish came in 1951, when Citation became the first horse to win $1 million. Randy's Donuts, topped with its giant donut sculpture, has been a landmark resident of Inglewood near today's Interstate 405 since 1953. Foster's Freeze, the first soft-serve ice cream chain in California, claims Inglewood as its 1946 birthplace.

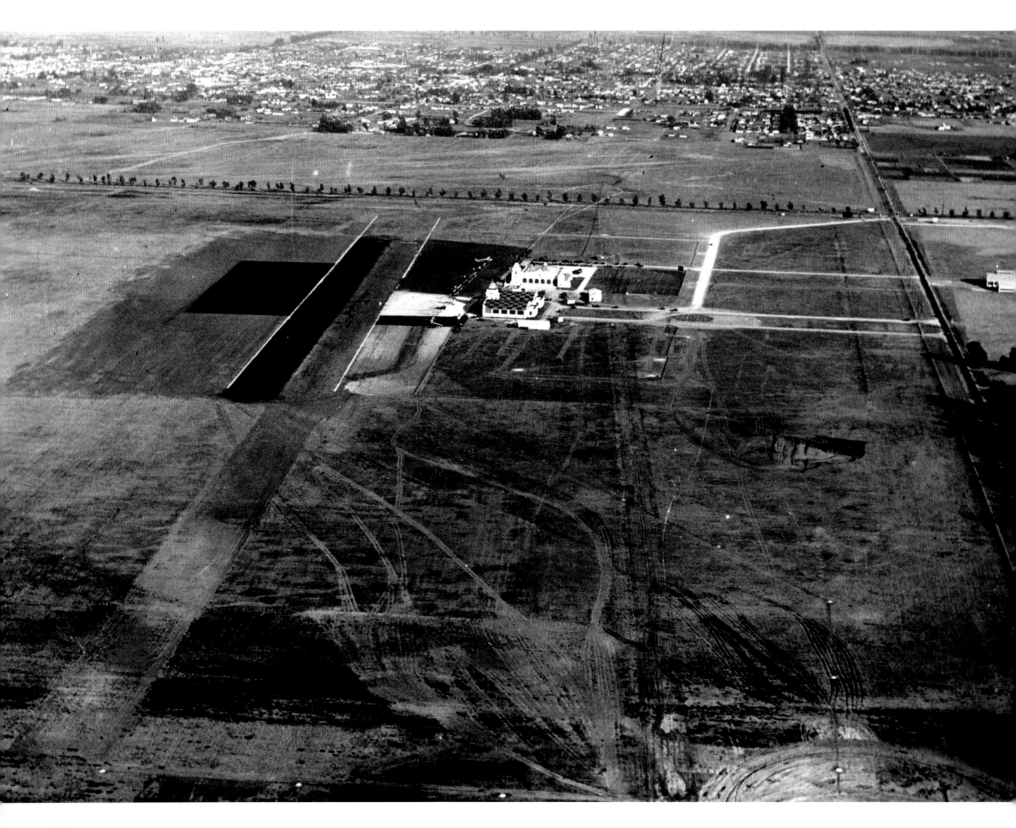

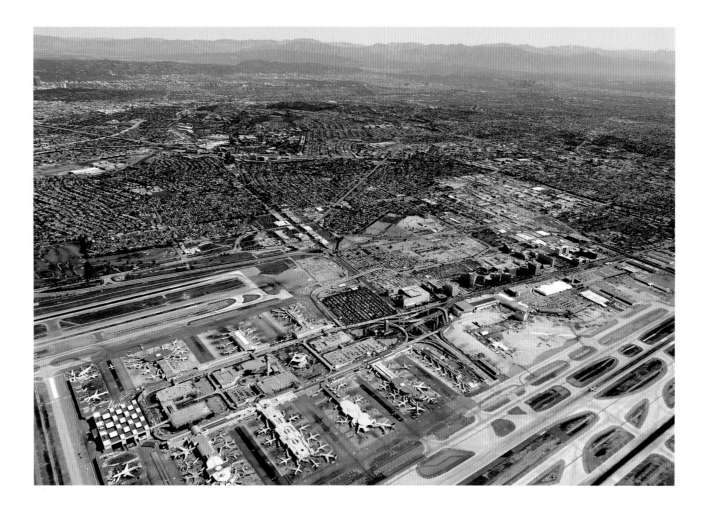

MINES FIELD / LOS ANGELES INTERNATIONAL AIRPORT

Left: Los Angeles International airport, or LAX as it is better known, began life in 1928 when the Los Angeles City Council designated a one-square-mile plot of land that was once the Rancho Sausal Redondo. The rancho had become Robert Burnett's property in 1868. Wealthy Canadian lawyer Daniel Freeman acquired the title to the property in 1885. Freeman first attempted to raise sheep on the land, but a lack of water forced him to turn to the drier practice of barley farming. Andrew B. Bennet leased 2,000 acres from Freeman in 1894. By 1922 Bennett owned 3,000 acres and was growing wheat, barley, and lima beans. In 1929 a portion of this land became dirt landing strips for Mines Field, named for William Mines, the real-estate agent who arranged the sale of the land to the City of Los Angeles. Hangar No. 1 soon made its appearance and the new airfield was dedicated and opened as the official airport of Los Angeles in 1930, about the time this picture was taken.

Above: Mines Field became a municipal airfield in 1937. Four years later, the city changed the airport's name to Los Angeles Airport, and then to Los Angeles International Airport in 1949. The airport is better known by its three-letter identifier, LAX. The facility expanded westward, reaching the shore of the Pacific Ocean in the 1950s. The coming of the jet age in the early 1960s led to a complete redesign. Architect Paul Williams's "Theme Building," which resembled a flying saucer, opened in 1961 and was designated a city landmark in 1992. In order to accommodate passengers during the 1984 Olympics, LAX underwent a $700 million expansion. With nine passenger terminals serving approximately sixty million passengers each year, LAX is one of the busiest airports in the world.

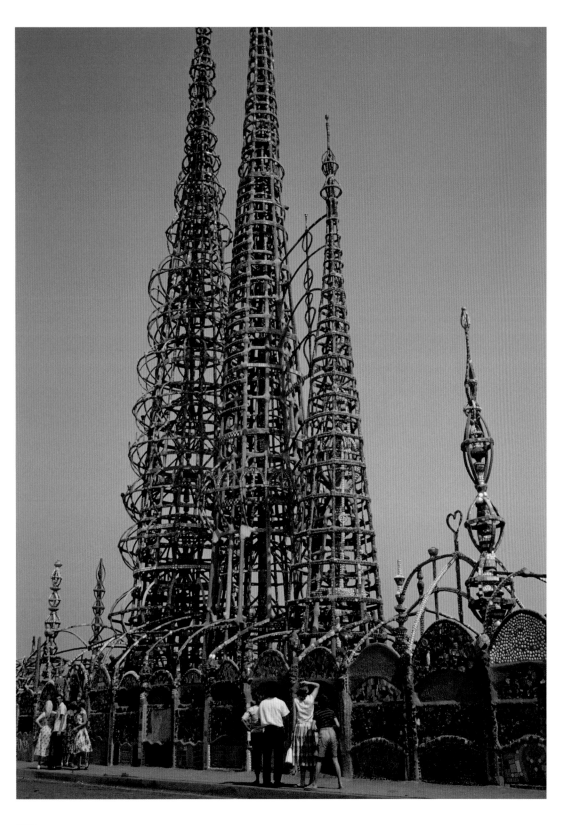

WATTS TOWERS

Simon Rodia's Watts Towers in the city's Watts District is a collection of seventeen interconnected structures, two of which are almost a hundred feet high. Rodia, an Italian-born construction worker, built the towers in his spare time. He began working in 1921 and completed the towers in 1954 without any plans for their design. The work is an example of nontraditional vernacular architecture and American naive art. Rodia began the sculptures by using steel pipes and rods to create an armature. He then wrapped the armature with wire mesh and coated it with mortar. He covered the structure's main supports as a mosaic with pieces of porcelain, tile, and glass applied to the mortar. Found objects abound in the structure, including bed frames, bottles, scrap metal, and seashells. He reportedly used hired help, heavy equipment, and window-washer equipment to reach the towers' higher places. Rodia named his creation *Nuestro Pueblo* (Our Town).

Ownership of the property where the Watts Towers stand has changed hands several times. Actor Nicholas King and film editor William Cartwright decided the site needed preservation and purchased the property for $3,000 in 1959. The city had other ideas. Despite transfer to owners who wished to clean and restore the property, a demolition crew arrived. Artists the world over knew of the towers, and with King and Cartwright leading the way, they formed the Committee for Simon Rodia's Towers in Watts. The political will bought time for an engineering test of the structures' safety. A steel cable was run from a crane to each tower. The crane, exerting all its lateral force, could not budge either tower. The committee preserved the site until 1975, when it was deeded to the city and in turn to the state, which designated it the Watts Towers of Simon Rodia State Historic Park. The Watts Towers became a National Historic Landmark in 1990.

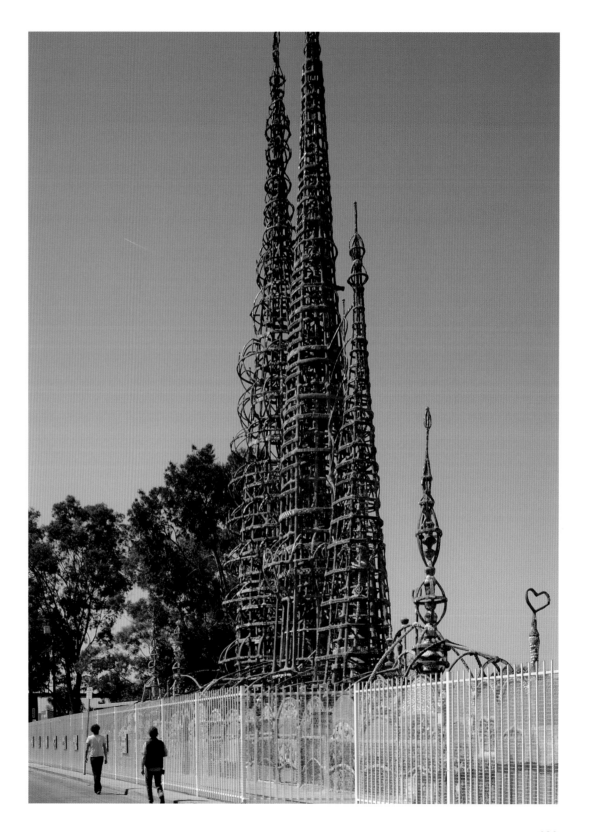

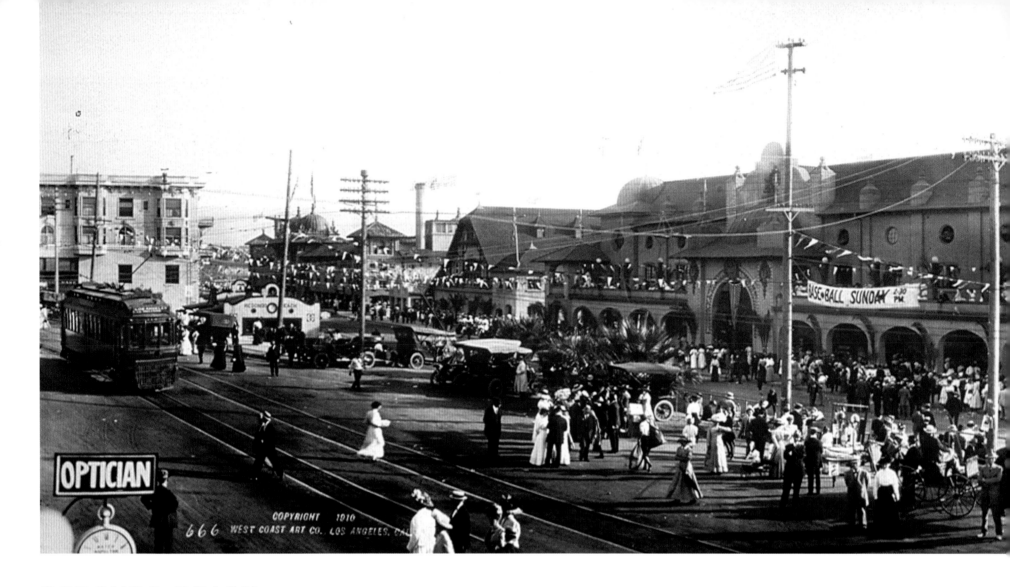

OPTICIAN

COPYRIGHT 1910
666 WEST COAST ART CO., LOS ANGELES, CAL.

REDONDO BEACH

Above: The West Coast Art Company copyrighted this photograph of the Mission-style casino, pavilion, and bathhouse on Redondo Beach on September 12, 1910, six years before the appearance of the Endless Pier. A Pacific Electric Red Car on the Balloon Route—so called because its route on a map resembled a balloon—enters the picture on the left. People scurry to cross the street to the casino that sports the sign "Base-Ball Sunday." The smaller building on the right invites pedestrians to bowl or swim in the indoor pool. The Hotel Redondo, which opened on May 1, 1890, also attracted visitors. The $250,000 hotel boasted an eighteen-hole golf course, tennis courts, and 225 rooms. Visitors who could not afford to stay at the hotel went to Tent City and rented a tent—complete with wooden floors and electric lights—for $3 a week or $10 a month. The hotel, casino, and bathhouse all helped raise awareness of Redondo Beach's attractive climate and spurred tourism and settlement.

Right: Prohibition spelled the end for the Hotel Redondo, but the casino lived on. The hotel closed its doors in 1925 and was torn down. Its scrap lumber fetched just $300. The hotel's demise did not spell the end to casino gambling, however. Local authorities turned a blind eye to the city's chip games and bingo parlors. The casino continued to entertain the Depression-weary populace; the building later became part of the Endless Pier and, later, the Horseshoe Pier. For more excitement, one could pony up 25 cents to catch a water taxi to the gambling ship *Rex*. The ship was anchored off Redondo Beach, just outside the three-mile limit that put it out of the reach of the police and tax collectors—at least until 1948, when Congress abolished gambling in coastal waters. Oceanside condominiums, the city's 1995 wharf, and boat slips have taken the casino's place along the Pacific Ocean. And little is left to remind visitors of those illicit gambling forays to the *Rex*.

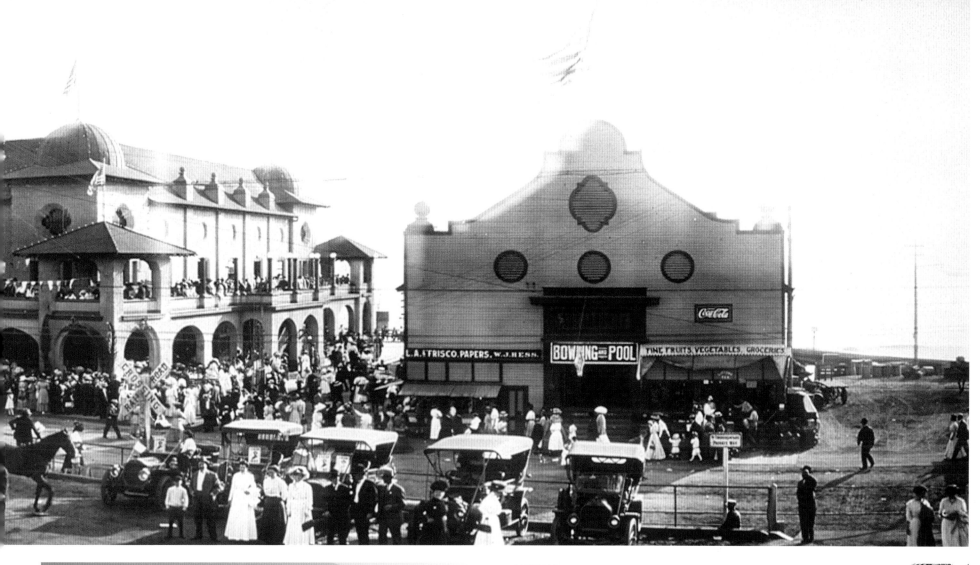

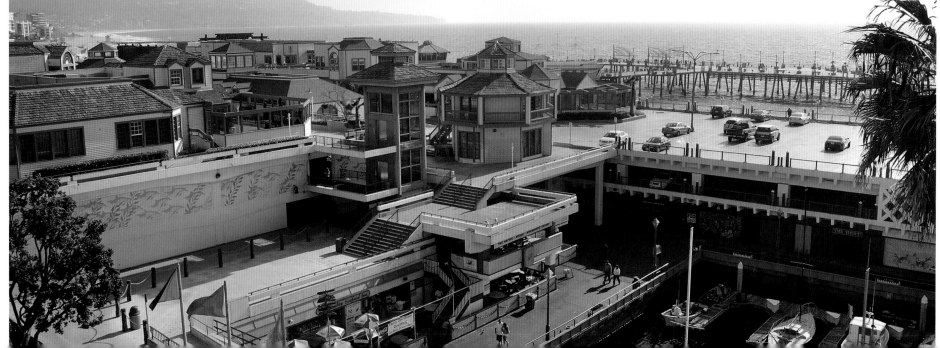

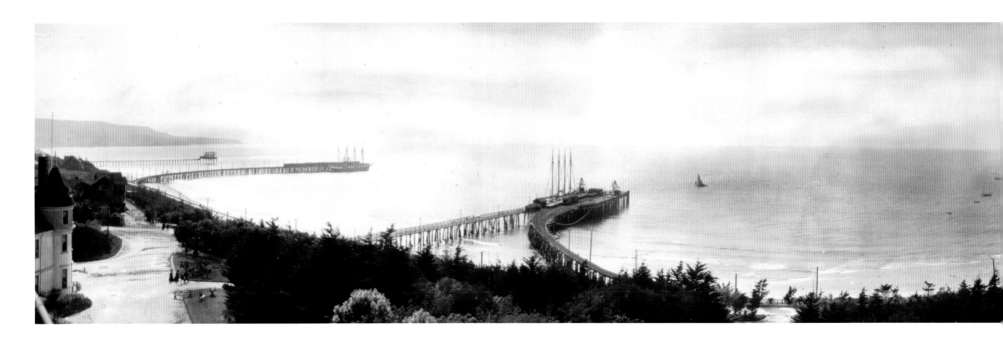

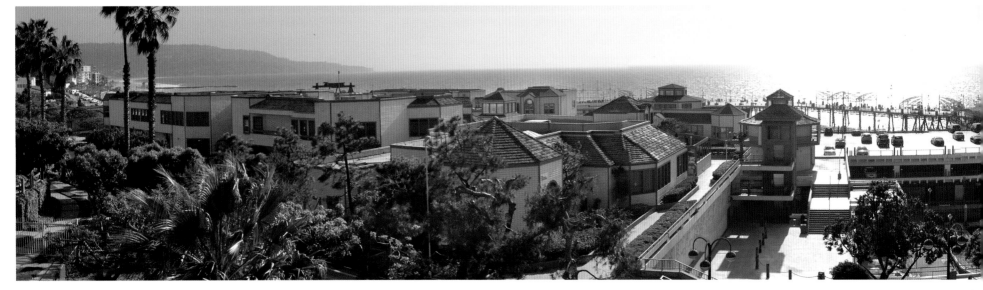

REDONDO BEACH

Top: The Haines Photo Company, which was famous for its panoramic photographs, copyrighted this scene of Redondo Beach showing the city's three wharves on March 16, 1908. Major storms repeatedly struck Redondo Beach's attempts to create a cargo harbor. San Pedro Harbor—built in 1899—outpaced Redondo Beach's efforts to become the port city for Los Angeles. Redondo Beach's wharves were converted to a more recreational setting. Wharf No. 1, off Emerald Street on the far right, was primarily used for fishing. It was the oldest of the three, built in 1889 and ripped apart by a 1915 storm that packed hurricane-force winds and poured fourteen inches of rain on the town. The Y-shaped Wharf No. 2, off Ainsworth Court in the center, had a pier for the railroad on the right and one for fishing on the left. Wharf No. 3, at the foot of Sapphire Street on the far left, allowed people to walk out to greet incoming passenger ships; it was built in 1903 and dismantled in 1925.

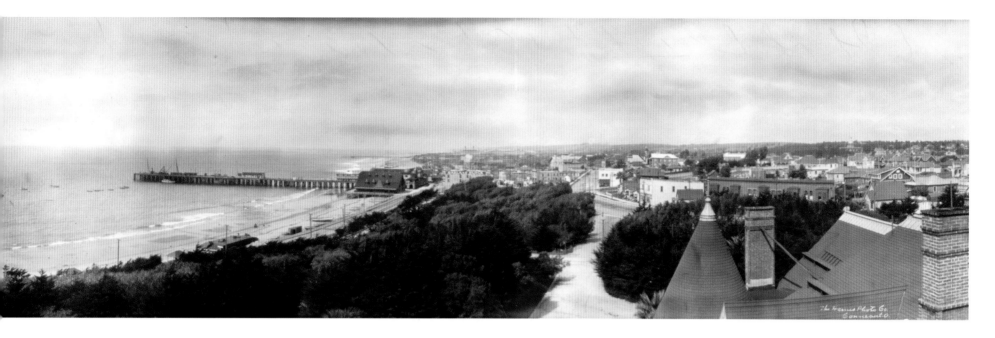

Bottom: Storms like the 1915 gusher, as well as redevelopment projects, have changed the face of Redondo Beach's shoreline. In 1916 George Harding built the reinforced-concrete Endless Pier on the site occupied by Wharf No. 1. A storm damaged this pier in 1919 and it was condemned in 1928. In 1925 Captain Hans Monstad built the Monstad Pier to handle fishing and pleasure-boat traffic. This pier is still operating. In 1929, after the Endless Pier was demolished, the Horseshoe Pier was built. It stood until 1988, when storms weakened the fifty-nine-year-old pier and a fire burned it to the waterline. On July 29, 1993, the city hosted a formal ceremony to announce the pier's reconstruction. Less than two years later, on February 11, 1995, the city announced another formal ceremony to reopen the pier. The new pier has more than 3,000 cubic yards of concrete decking and 202 concrete piles; the longest measures 120 feet.

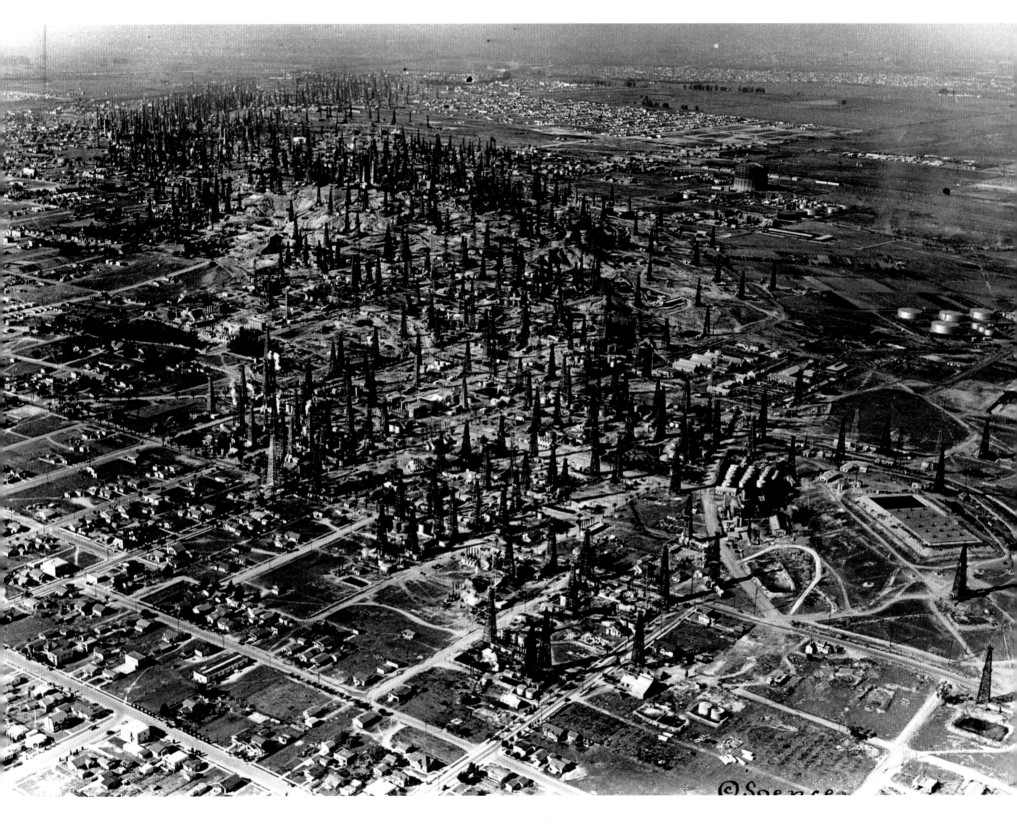

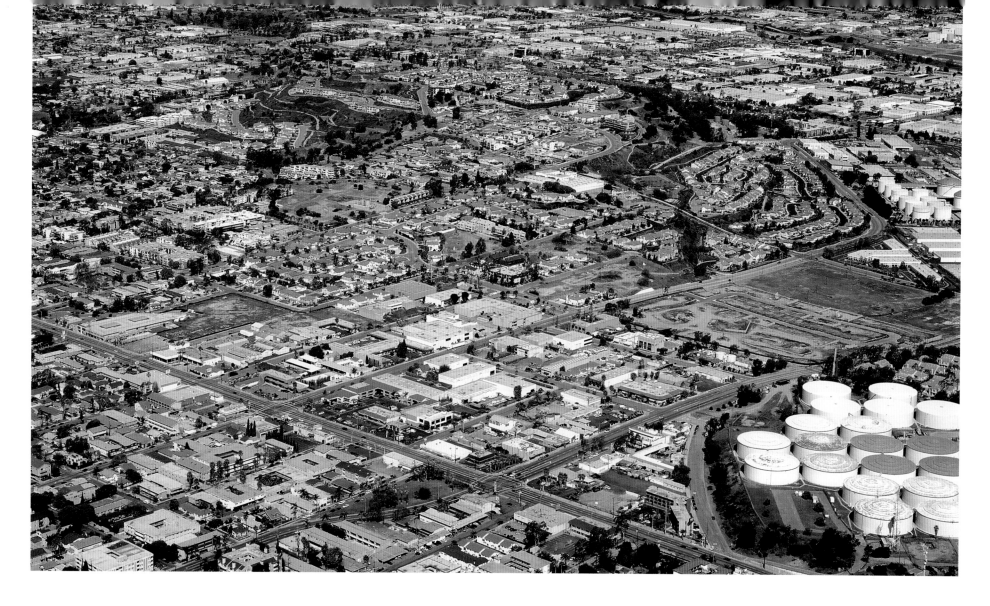

SIGNAL HILL

Left: Scores of oil derricks pierce Signal Hill like so many pins in this 1930 photograph taken nine years after the Shell Oil Company's Alamitos well No. 1 (also known as the Discovery Well) erupted on June 23, 1921. Named for the Native American fires originally used for communication among tribes, Signal Hill brushes the horizon at 365 feet, making it the largest hill near Long Beach. Early settlers used the hill for farming, housing, and even a movie studio, but black gold changed all that. Stories say that the Discovery Well spurted oil 1,400 feet skyward. More than a hundred oil derricks covered Signal Hill in its heyday. Locals called Signal Hill "Porcupine Hill" because of the prickly appearance that the derricks lent to the landscape. Soon after the discovery of oil on the hill, the derricks began to squirt foul-smelling black gold onto nearby homes. As time went on, locals either built derricks in their own backyards or sold out to oil companies.

Above: Not a spindly derrick remains in today's Signal Hill, a city of just under 10,000 people completely surrounded by the city of Long Beach. Signal Hill was once part of Long Beach, but in a move to avoid Long Beach's taxes, Signal Hill divorced itself from the port city by incorporating in 1924. The Long Beach Oil Field, of which Signal Hill occupies the southern third, once produced an estimated 20 percent of the world's oil supply. By 1950 the productive field ranked third in the nation for overall production, with the deepest well reaching bedrock at 14,950 feet below ground level. Of the 950 million barrels taken out of the field, just five million are thought to remain. Various independent companies continue to pump around 1.5 million barrels of oil per year. Rather than the wooden spindles of old, aboveground pump jacks do the job, sometimes randomly appearing in parking lots, freeway interchanges, or other unused spaces.

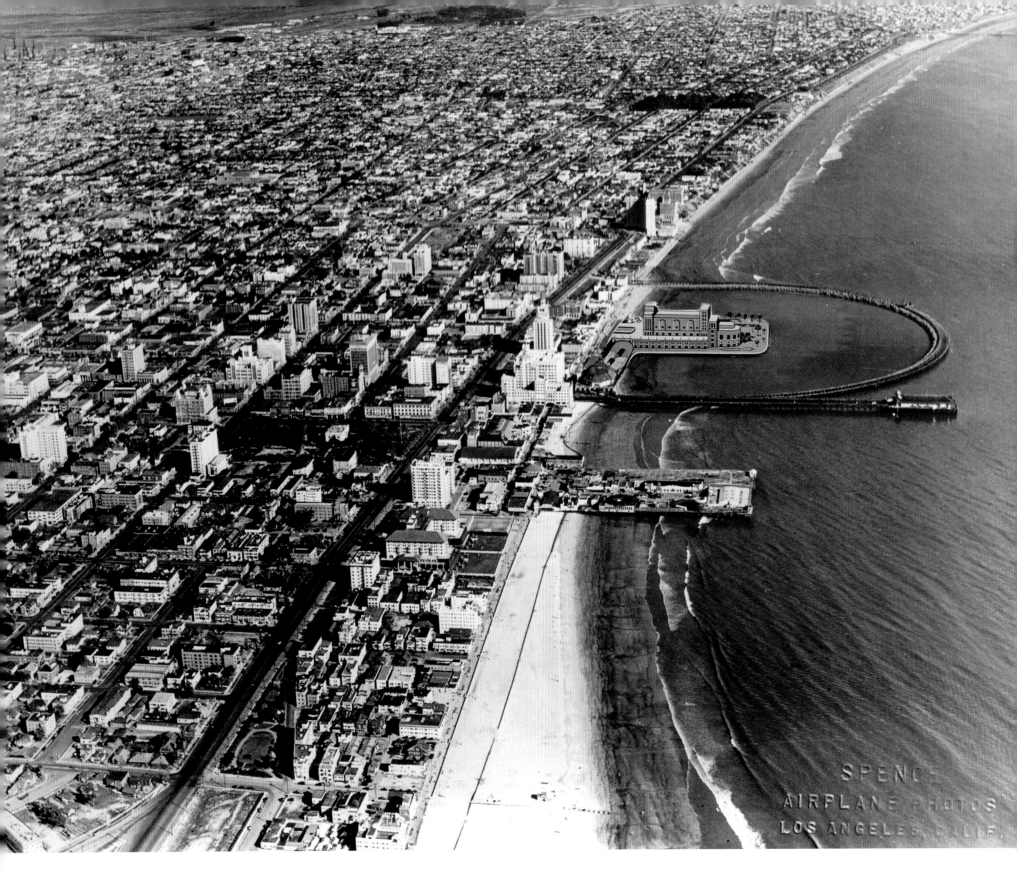

SPENCE
AIRPLANE PHOTOS
LOS ANGELES, CALIF.

140

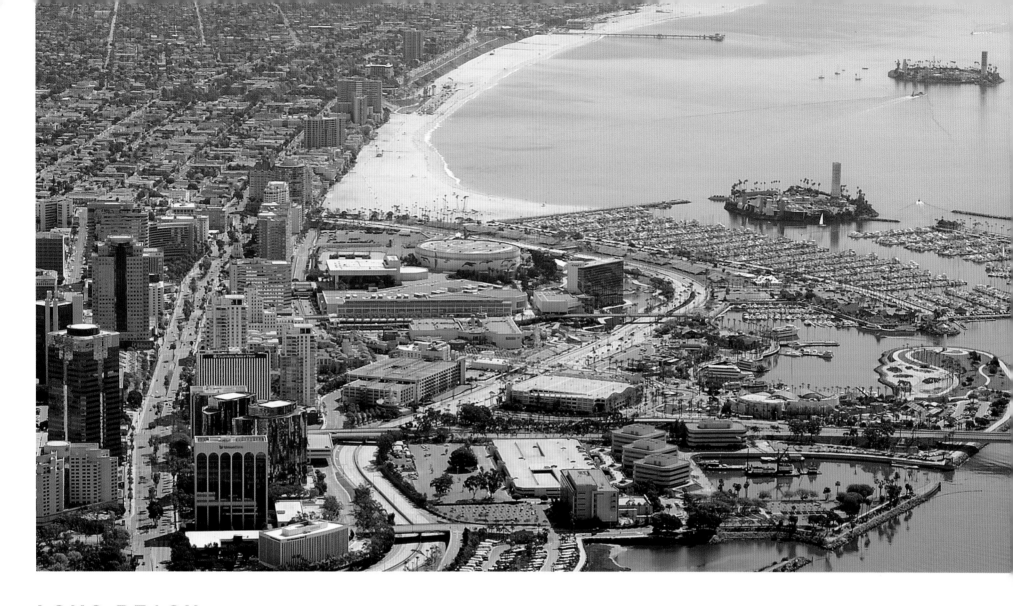

LONG BEACH

Left: This photograph, taken in 1930, shows the Long Beach waterfront looking to the east and includes an artist's impression of the city's impressive 1931 Municipal Auditorium along the waterfront. A rainbow-shaped breakwater, which created lagoons on three sides of the auditorium, protected the building from storms. The auditorium, which extended 500 feet into the Pacific Ocean, could seat an audience of 8,000. The pier featured a large platform (seen here below the breakwater) where friendly discussions took place, called the "Spit and Argue Club." Here anyone could take a stand and air their views or debate on matters of general interest. The tall building nearest the wharf in this aerial photograph is the Breakers Hotel. The fourteen-story building on Ocean Avenue opened in 1926. A year after this photograph was taken, the Great Depression and the March 10, 1933, Long Beach earthquake delivered the Breakers Hotel a one-two punch and pushed it into bankruptcy.

Above: Landfill has pushed the oceanfront away from the site of the old Municipal Auditorium. In 1962 the auditorium had a date with the wrecking ball to make way for the Long Beach Convention and Entertainment Center, which includes the Long Beach Arena. Today the Convention and Entertainment Center and Arena host hockey and basketball games, concerts, trade shows, and other meetings. The Rainbow Lagoon Park, whose name recalls the old auditorium's rainbow-shaped pier, offers visitors a scenic respite. The Shoreline Aquatic Park lies nearby, where these same visitors can catch a glimpse of the ocean liner RMS *Queen Mary*, which was purchased by the city in 1967 and now lies permanently docked across the way in the massive harbor complex. The city's impressive Aquarium of the Pacific is also worth a visit. The Breakers Hotel, which is now a retirement facility, no longer sits on the waterfront but across Ocean Drive from the complex that makes up the Convention and Entertainment Center.

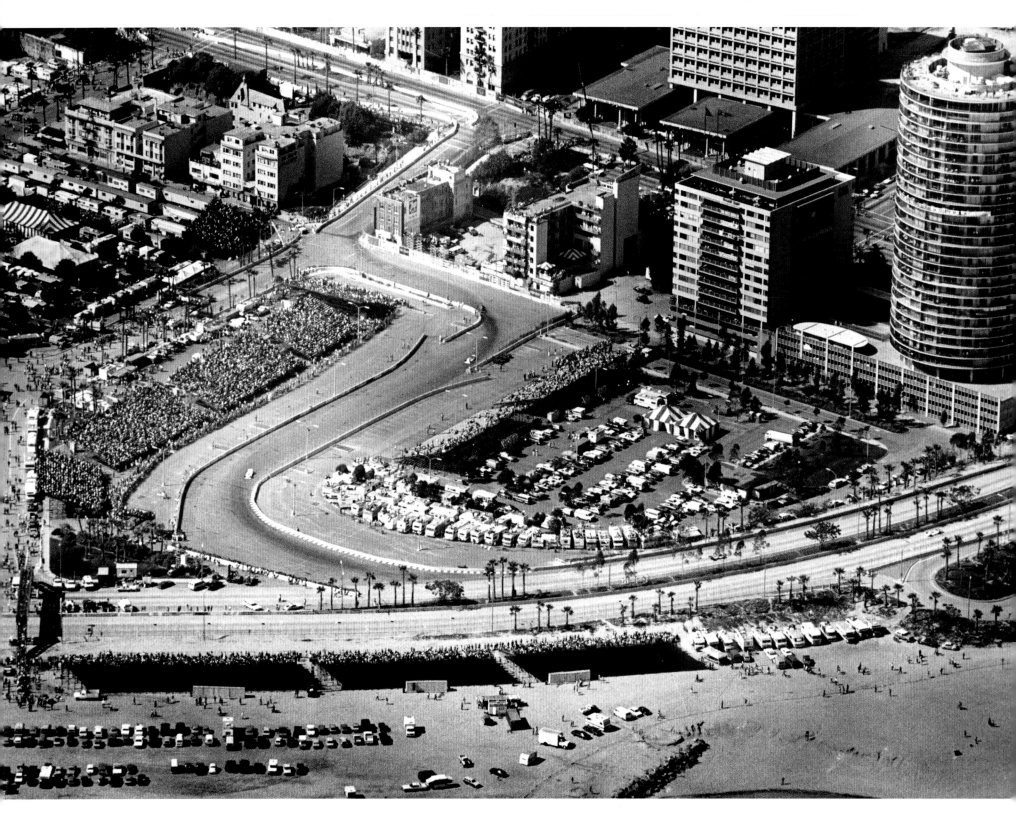

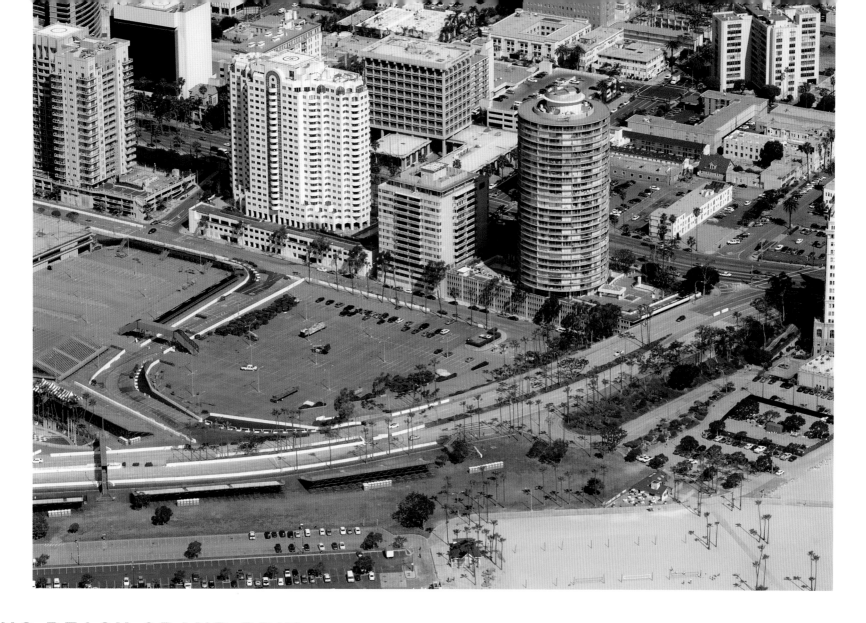

LONG BEACH GRAND PRIX

Left: *Los Angeles Herald-Examiner* photographer Anne Knudsen snapped this photograph of the Long Beach Grand Prix while it was underway on March 15, 1981. Australian Alan Jones finished nine seconds ahead of his teammate Carlos Reutemann that year; it was the third consecutive Long Beach Grand Prix victory for Jones. The photograph depicts a pair of racecars on the nearly two-mile course hurtling past the grandstand full of spectators. The first race was held in Long Beach on September 28, 1975, the brainchild of Chris Pook. That race attracted more than 46,500 fans who watched Brian Redman beat Vern Schuppan by 29.95 seconds. The race took on an international flair when world-famous drivers like Jacques Laffite, Emerson Fittipaldi, and Nelson Piquet began revving their Formula One Ferraris, Renaults, and Brabhams down Long Beach's boulevards.

Above: After a classic race in 1983, Long Beach lost its international prestige when Formula One demanded too large a fee to stage the 1984 race and moved on. But the city has continued to hold a grand prix for open-wheel single-seaters, whether they be Champ Cars or IndyCars. The International Tower still graces the city's skyline, just as it did in Knudsen's 1981 photograph. The blue-and-white Harbor Place Tower and the Aqua Zeus Towers have joined the International Tower on the city's East Ocean Boulevard. Toyota remains the grand prix's number-one sponsor. In 2008 event organizers entered an agreement with the City of Long Beach, guaranteeing that race fans will continue to visit Long Beach until at least 2015.